JOHN SINGER SARGENT

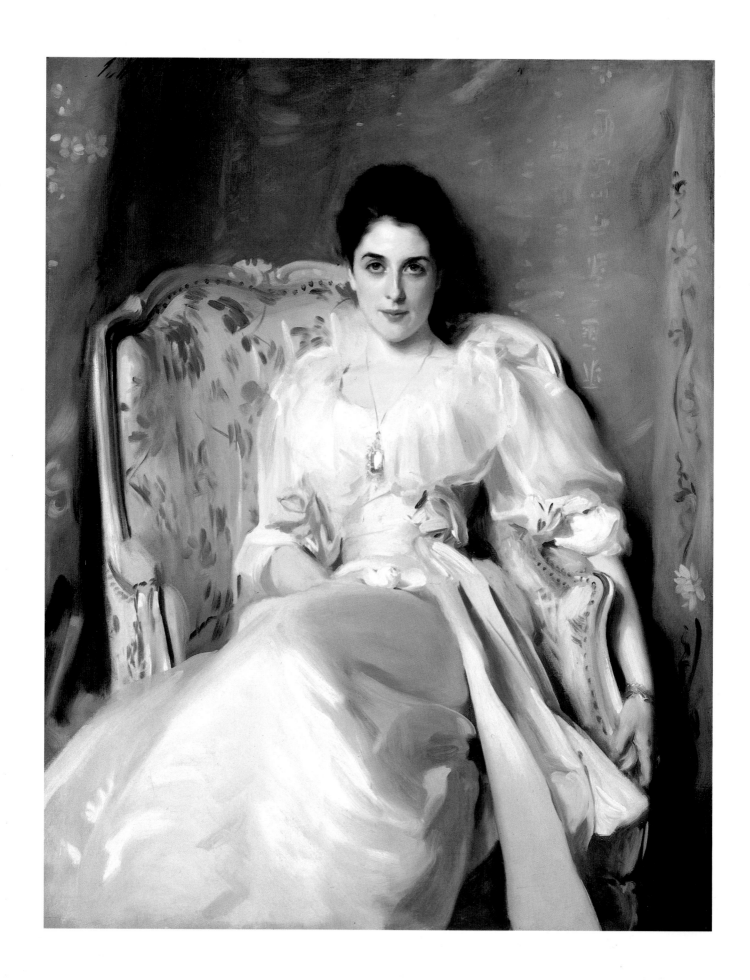

John Singer Sargent

TREVOR FAIRBROTHER

Harry N. Abrams, Inc., Publishers

IN ASSOCIATION WITH

The National Museum of American Art, Smithsonian Institution

To John Kirk
and to our parents

Series Director: Margaret L. Kaplan
Editor: Adele Westbrook
Designer: Ellen Nygaard Ford
Photo Research: Catherine Ruello

Library of Congress Cataloging-in-Publication Data

Fairbrother, Trevor J.
 John Singer Sargent / Trevor Fairbrother.
 p. cm.—(The Library of American art)
 "In association with the National Museum of American Art,
 Smithsonian Institution."
 Includes bibliographical references and index.
 ISBN 0–8109–3833–2
 1. Sargent, John Singer, 1856–1925. 2. Painters—United
 States—Biography. I. Title. II. Series.
ND237.S3F33 1994
759.13—dc20 93–11364
 CIP
[B]

Frontispiece: *Lady Agnew of Lochnaw,* page 82

Text copyright © 1994 Trevor Fairbrother
Illustrations copyright © 1994 Harry N. Abrams, Inc.

A Times Mirror Company

Printed and bound in Japan

Contents

Preface

John Singer Sargent (1856–1925) was an American who never resided in the United States. Born and educated in Europe, he was twenty when he first came to this country; he made a total of ten visits, only once staying longer than a year. Prodigiously talented, he sought fame and fortune in juried exhibitions and as a fashionable portraitist, winning the dual recognition accorded by his European and American success. Significantly, his ascendancy coincided with America's new mentality, symbolized by the expansionist agenda of the Spanish-American War of 1898; in fact, the Sargent phenomenon can be read as a manifestation of burgeoning nationalism. Sargent was a loyal "American abroad," whose achievement in the international arena strengthened the artistic heritage of his country: like the writer Henry James and the artist Mary Cassatt, his decision to live in Europe was both a personal and professional choice.

The number of Americans who crossed the Atlantic for a programmatic education in art schools and ateliers grew rapidly after the Civil War. Sargent had the advantage of growing up in Europe, which made him an inspiration to other young American students in Paris, such as Julian Alden Weir. In 1877 Weir wrote home to West Point, New York: "[Sargent is] one of the most talented fellows I have ever come across. His drawings are like Old Masters, and his color is equally fine. He was born abroad and has not yet seen his country. He speaks as well in French, German, Italian as he does in English, and has a fine ear for music, etc. Such men wake one up, and, as his principles are equal to his talents, I hope to have his friendship." While many Europeans maintained that the United States was too young to possess an authentic cultural tradition, Sargent and other American artists approached the issue from the opposite direction: they learned European practices firsthand and maintained the right, as independents, to make their own synthesis. Sargent's career was the realization of the eclectic new American culture envisioned by Henry James in 1867: "We can deal freely with forms of civilization not our own, can pick and choose and assimilate and in short . . . claim our property wherever we find it." The American cultural establishment of the day often looked to European models for their

6

values, and Sargent's triumph at the turn of the century was something they chose to tout.

Sargent straddled the French, British, and American art worlds, an insider and an outsider in each. In the 1880s he inspired speculation in all three countries—was he a synthesizer who took advanced practices in an independent direction, or was he a traditionalist who calculatedly and cautiously borrowed from the Realist, Impressionist, and Aesthetic movements while they were still considered "radical" by the mainstream? The latter was the more accurate analysis, for around 1900 the academic establishment embraced him as a modern Old Master, someone whose strongest values were those of the past, an heir to the seventeenth-century portraitists Velázquez and Hals. For such conservative critics as Royal Cortissoz he was "the greatest of living painters." At the same time, promoters of modernism, from Abstraction to Expressionism, were countering the traditionalists. They argued that Sargent's reputation was vastly overrated, and condemned the system that idolized him. Their attacks were invigorated by the socialist reforms of the new century, for Sargent clearly portrayed a glamorous and powerful ruling class. In essays and reviews the artists Walter Sickert and Roger Fry claimed that Sargent was frittering away the "undeniable genius" of his technical skills in the service of bourgeois taste and values. The modernist assessment soon prevailed: after Sargent's death his work was relegated to a minor role in the history of American art. A process of reevaluation did not begin until the 1950s.

I want this book to reflect the complexity of Sargent's affiliations and practices as an artist. I will try to provide a balanced representation of the man and his art, in the hope of understanding the unusual highs and lows of his reputation. It has long been easy and convenient to "bury" or to "praise" Sargent with ideologically loaded generalizations about his technical prowess, his professionalism, and his nationality. Thus, his handling of paint has been applauded as an exceptional gift or decried as a sign of laziness, carelessness, or "foreign" mannerism. His rapid ascent to worldly success has been viewed as a well-earned triumph or a negative paradigm of "Gilded Age" materialism. His ambitions and loyalties have been chauvinistically credited and discredited as too European or too American, depending upon the bias of the commentator. The effect of these presumptive points of view has been to divide and compartmentalize Sargent's work and reputation. The "truth" of the artist and his work is more likely to be glimpsed today if the multiple meanings of these opinions are taken into consideration.

The clichés of conventional biographers have long shaped the perception of Sargent's life and personality. If we identify him in terms of

his achievements, he was a "giant" of the Anglo-American art world: he painted almost six hundred oil portraits, specializing in the privileged and the celebrated; he created mural decorations for three cultural institutions in Boston; and even when "off duty" he painted about sixteen hundred watercolors and over six hundred landscapes and genre works in oil. The epitaph on his tombstone underscores this compulsive identity: *Laborare est orare* [To work is to pray]. On the other hand, the motivations of the man behind the celebrity's mask and the driving force behind the unmistakable intensity of his better works have rarely been examined closely. The Sargent literature usually affirms that he was a shy bachelor with a simple private life. This reading is suspect because it serves as a convenient and genteel foil for admirers to avoid the systems of exhibitionism and voyeurism that operate in his work. Stanley Olson, the most recent Sargent biographer, suggested that he was sexually unresponsive, and stressed his "emotional abbreviation." Since Sargent's personal life remains largely concealed, Olson perpetuates what appears to be an historically accepted and a willful misreading: "No one who knew him well or slightly has ever been tempted to suggest anything whatever about his private life." Sargent's art is the best "evidence" of his personality, and the homoeroticism of some portraits and many informal studies has been prudishly avoided by most scholars. If, indeed, Sargent balanced a public career with a repressed sexuality, his conflicted social-sexual identity may be a key to the successful tensions within his art: for example, his ability to paint a portrait that is ultimately respectable and yet is colored by showiness, grandeur, pride, or sensuality. I propose that the visual edge and emotional volatility of his work may have been shaped by his attraction to male beauty: it particularizes the work of Sargent as it does that of Michelangelo and Caravaggio, Marsden Hartley and Charles Demuth.

It must also be acknowledged that Sargent's oeuvre is bloated by mediocre and lackluster works in which the performance seems contrived and the image lacks his characteristic certainty and vitality. Only when one accepts his personal goal of an artistic form devoted to sensuous visual pleasure can one fairly evaluate the success of his work. A great Sargent begins and ends with his swift and decisive technique: when his eye and mind were intrigued he was fluent and expressive. If the subject interested him, both personally and formally, he excelled. A watercolor sketch of a laborer who caught his eye may be a "better" Sargent than a commissioned portrait of a nobleman. While Sargent's social class and training were allied to tradition and the academy, his imagination and sensuality pushed against the limits of the rules he accepted. A few times in his career he was in a position to participate in modern or avant-garde

developments, but his middle-class need for approval and conventional acclaim always got the upper hand. In the end he was tied to the status quo of the nineteenth century, and not supportive of the liberating and transgressive spirit of modernism. Nonetheless, if he is valued on his own terms, he had the remarkable gift of combining the painterly pleasure of brushmarks and pigment with stunningly accurate, and occasionally provocative, transcriptions of reality.

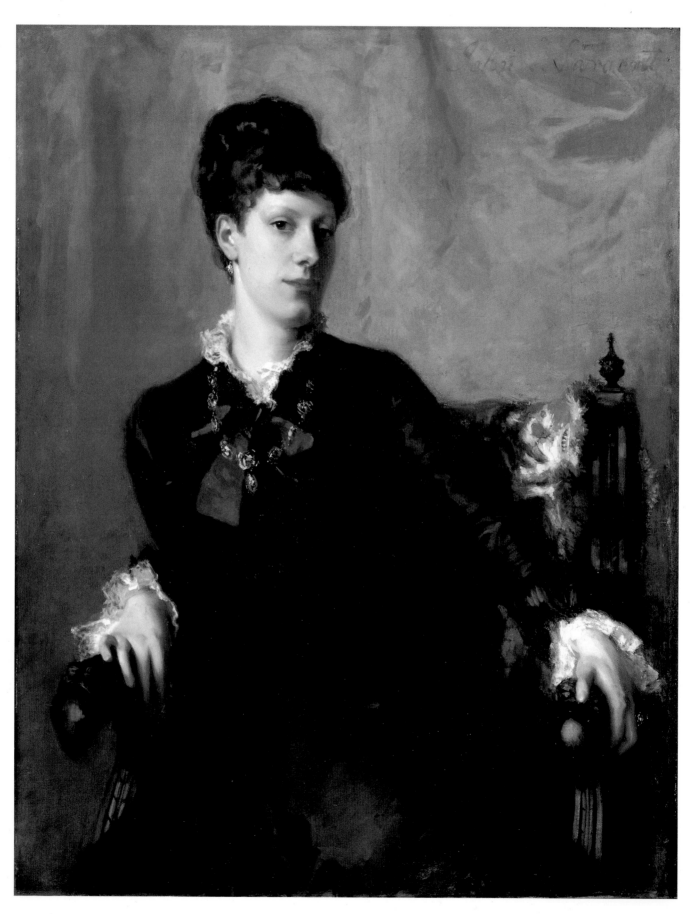

Miss Frances Sherborne Ridley Watts

I. Beginnings: A Career in Paris

JOHN SINGER SARGENT WAS BORN IN FLORENCE on January 12, 1856, to an American couple from Philadelphia. They had journeyed to Europe in 1854 to recover from the death of their first child, a two-year-old daughter. His mother, née Mary Newbold Singer, was the only child of a prosperous leather merchant of French lineage. His father, Attending Surgeon at Wills Hospital, came from a large family in Gloucester, Massachusetts, directly descended from Puritan settlers. In 1857 Dr. Fitzwilliam Sargent resigned from the hospital, and the couple settled into a nomadic routine, shifting with the seasons between European cities, resorts, and spas. They had four more children after John, two of whom lived past childhood: Emily, born in 1857, and Violet in 1870. The lively and charming Mrs. Sargent encouraged her family to remain abroad, where they could experience history, culture, and leisure to a degree that was not possible in America. Her inheritance supported them, and her pregnancies and changeable health may have prevented their return. This was a stimulating environment for Victorian children, but in the mind of the Presbyterian Dr. Sargent, the advantages were counterbalanced by suffering and sacrifice: in letters to relatives he complained of financial limitations, citing the "delicate health" of the entire family as their excuse for staying in places "more expensive than we should think of going to if we were well enough to avoid them." While remaining close to their relatives, and strong in their allegiance to the United States, the Sargent family lived in Europe the rest of their lives, never establishing a permanent residence together.

Sargent's education was pieced together by his parents, tutors, and brief stints in schools, notably in Florence and Dresden. He had a strong general knowledge, and a facility for languages and music. He remained an avid reader and an ardent amateur musician throughout his life. His father hoped that he would pursue a career in the navy, but it was sketching, a hobby of his mother's, that began to emerge as his passion. When he was eleven his mother told a relative, "[He] has a remarkably quick and correct eye. If we could afford to give him really good lessons, he would soon be quite a little artist. Thus far he has never had any instruction, but artists say that his touch is remarkable."

Miss Frances Sherborne Ridley Watts

1877. Oil on canvas, 41⅝ x 32⅞"
The Philadelphia Museum of Art.
Mr. and Mrs. Wharton Sinkler Collection

The twenty-one-year-old artist made his public debut with this polished performance: it was accepted for exhibition by the jury of the Paris Salon of 1877. The subject was a childhood friend of Sargent's, another American who had grown up in Europe. The example of Leonardo da Vinci, Andrea del Sarto, and Jacopo Tintoretto may have informed the mannered gracefulness of the woman's pose, for Sargent had sketched details from their works as a student. His choice of costume and props reflects the revival of Renaissance styles that flourished in France in the second half of the nineteenth century.

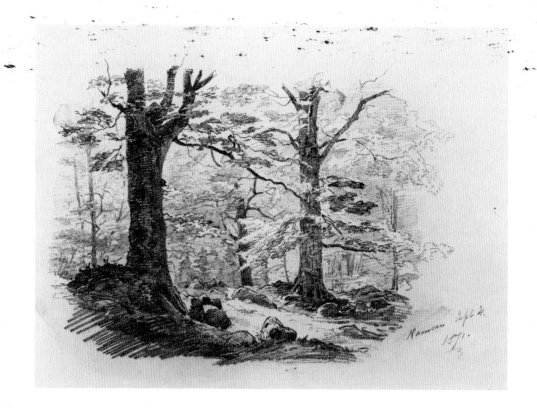

By 1871 the fifteen-year-old Sargent had begun an informal study of landscape drawing with artist friends of his parents. He made this sketch of woodland sunlight and shadow in Ramsau, a South German village in a border region near Salzburg. In both composition and technique it follows early-nineteenth-century conventions, and succeeds as a carefully worked, yet atmospheric vignette.

Mrs. Sargent was an enthusiastic tourist, eager to explore with her children the diversity of art, architecture, and landscape encountered on their travels. She always welcomed artists into her family circle. For example, in Rome in the winter of 1868–69 she and Dr. Sargent befriended the expatriated American sculptors Harriet Hosmer, Randolph Rogers, and William Wetmore Story. John developed a habit of sketching in art museums and churches. In the summer of 1870 he made dozens of landscape studies in both pencil and watercolor during a family tour of the Swiss Alps, and soon thereafter his parents "concluded to gratify him" in his "strong desire to be an Artist by profession." In 1871 Carl Welsch, a German-American artist befriended by the Sargents, took fifteen-year-old John on a sketching trip in the Tyrol.

Each autumn in 1869, 1870, and 1872 the Sargent family went to Florence for the winter. John's career as an artist became a topic of debate among acquaintances there. When the family returned to Florence in October 1873, he enrolled in the Accademia delle Belle Arti and joined a class that was learning to draw from plaster casts. However, the institution was undergoing internal reorganization, and young Sargent was dissatisfied. Family friends argued that it was time to give him the best art education to be had. While a few proposed London, Paris was the favorite. The family told relatives that "the French artists, undoubtedly the best nowadays, are willing to take pupils in their studios." Underestimating his own accomplishments, Sargent assumed it

would be necessary to spend another year at the academy in Florence, regardless of what they found out in Paris.

In May 1874, the Sargent family made an exploratory trip to the French capital, where the Third Republic was entering its period of bourgeois prosperity. The city had recovered from the Prussian siege and the destruction wrought by the Commune (1870–71). William Launt Palmer, a young American acquaintance from Florence, had just enrolled as a private student of the French painter Carolus-Duran, and he encouraged Sargent to try to do the same. On a visit to the annual Salon exhibition Sargent admired the teacher's work. Accompanied by his father, he went to show his portfolio of drawings and watercolors to Carolus-Duran, who invited him to begin as a student when teaching resumed in October. The atelier was only two years old, with about twenty students, predominantly American and English men. Students shared the costs of their communal classroom and studio, and Carolus-Duran visited them twice a week to critique their work and to give demonstrations.

Sargent described his new teacher as "a young and rising artist whose reputation is constantly increasing. He is chiefly a portrait painter and has a very broad, powerful and realistic style." Carolus-Duran had won critical acclaim in the late 1860s as a virtuoso. Emulating the Spanish seventeenth-century painter, Diego Velázquez, he abandoned certain procedures of elaboration basic to academic French painting—preliminary drawing and underpainting. Carolus-Duran painted directly onto the canvas with a broad brush, capturing the form and modeling of a face by depicting its principal planes in their basic tonal values. The middle- or half-tones were laid in first, then the darker accents, and finally the highest lights. The emphasis on applying wet paint into wet paint required a severely analytical eye and a gifted hand. This approach also permitted summary effects and spontaneous flourishes intended to convey a passionate and living sense of reality. Sargent's American peer Julian Alden Weir had reservations about studying with Carolus-Duran: "He paints in the style I like, but I feel that one ought to be a good draughtsman before studying with him, as he makes his pupils paint from the beginning, and overlooks drawing for tone and color." Weir, like Thomas Eakins a few years earlier, chose to study with Jean-Léon Gérôme, who was more closely allied with the academic conventions of the day. Sargent, on the other hand, avoided Gérôme as a teacher because he disliked the "downy appearance" of his work. The smooth finish and the softened edges of Gérôme's forms reminded Sargent of images "printed on china." He also had the impression that Gérôme and Alexandre Cabanel (another academician) were not diligent teachers,

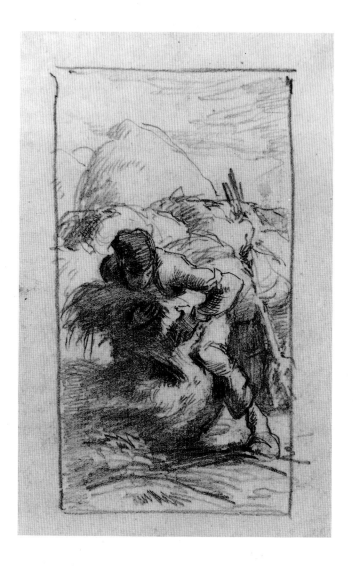

This small drawing is a copy of a work by the Barbizon artist Millet, who died in 1875. Sargent may have been inspired by the memorial exhibition of Millet's pastels in Paris that year. His expressively vigorous drawing captures the sculptural presence of Millet's figure and pays particular attention to the animated outlines of the laborer, who strenuously bundles the harvest. Millet's desire to instill monumental dignity and emblematic force in his representations of workers is preserved in Sargent's copy.

that their government-sponsored ateliers were noisy and crowded, and that their students were given to pranks and horseplay.

To complement his study of painting with Carolus-Duran Sargent undertook a rigorous study of academic drawing. He competed for one of the seventy places in the drawing class taught by Professor Adolphe Yvon at the Ecole des Beaux-Arts. All students in this class had to take the three-week qualifying exam *(concours)* twice a year. Sargent took the exam in the fall of 1874 and was admitted. He studied perspective, anatomy, and ornament drawing with Yvon during his first three years in Paris. In the spring of 1877 he won second prize against about three hundred competitors, and was awarded a silver medal. His father noted in a letter that it was "the first time that any American has passed so high." Study at the Ecole overlaid Sargent's longstanding desire to be an artist with a new sense of competitiveness, as is evident in a letter to his friend Fanny Watts: "The *concours* is now raging and tomorrow is the last and most anxious day. The question ought to be no longer merely to get in, but to get in high, which makes it more interesting."

Ballet Dancer ("d'après Degas")

c. 1877. Graphite, 6 x 3½"
Worcester Art Museum, Worcester, Massachusetts

Sargent's curiosity about progressive contemporary art during his student years in Paris is confirmed by this drawing—a copy of a pastel that Degas included in the third Impressionist exhibition in Paris in 1877. In its day the composition of this Degas was unconventional: the angle of vision juxtaposed cropped views of people standing in the wings, a dancer, and a surprising expanse of empty stage. The pictorial tension between the woman and her setting is less sustained than in the Degas. More significant is Sargent's eagerness to explore devices that give immediacy to a composition.

Sargent worked extremely hard during his student years in Paris. He lived with his parents for a year, but starting in the fall of 1875 he lodged alone. The only intermission in his study came in the summer of 1876, when he visited the United States for the first time. Traveling with his mother and sister Emily, he attended the Centennial Exhibition in Philadelphia, then moved on to Newport, West Point, and Montreal; he and a friend also made a quick trip to Chicago. In Paris the following spring he embarked upon the beginnings of his professional career. Carolus-Duran was proud of Sargent's rapid advance as a student, and chose him and a few others to help him on a commission for a ceiling decoration in the Musée du Luxembourg, the official museum of modern art in Paris. Sargent accompanied his teacher on a research trip in the south to gather visual images for the project. The allegorical subject, "The Triumph of Maria de Medici," inspired a trompe l'oeil work reminiscent of decorations by Paolo Veronese and his Baroque followers. Carolus-Duran and Sargent included portraits of each other as faces in the crowd welcoming Maria into the heavenly pantheon. The canvas

was exhibited at the Salon of 1878 before being installed at the Luxembourg.

As he began work on Carolus-Duran's decorative project, Sargent made his first submission to the fifteen male jurors appointed to select paintings for the 1877 Paris Salon. This enormous exhibition of paintings, drawings, prints, sculptures, and architectural projects, funded and organized by the French government, took place annually in May at the Palais des Champs-Elysées. The jury accepted Sargent's *Miss Frances Sherborne Ridley Watts*. It was exhibited with over two thousand other paintings. Typically, the pictures were hung densely, from floor to ceiling, and the jury always hung its favorite works in the most prominent positions. It is telling that Sargent chose to begin his Salon career with a portrait of a fashionable woman, for that was the source of Carolus-Duran's wealth and fame. *Miss Frances Sherborne Ridley Watts* was not done on commission, but as a lure for future orders, for the subject was an old family friend. It is a decorous and accomplished image of female charm, a work whose deliberate moderation was a good opening gambit for a newcomer to Salon politics. Although it did not draw significant commentary from art critics, it symbolized his entry into the arena of official French art.

Sargent spent the summer of 1877 on the coast of Brittany, combining a holiday and a professional working trip. He went there to make studies for his entry to the next Salon, planning to try a genre subject of a type that was more popular in those exhibitions than stylish portraits. The fisherfolk of northern France were part of the prevailing vocabulary of peasant imagery; at the Salon of 1874 (which Sargent attended) a medal was awarded to a painting by Augustin Feyen-Perrin that showed a grand procession of oyster-gatherers returning from their labors. Sargent went to the same village, Cançale, and made preparations for a work that would show a more informal line of women and children setting out with empty baskets. He encountered some difficulty in getting local women to model, but he returned to his Paris studio with enough oil sketches and pencil studies to elaborate a work for the Salon. He made two versions of the composition: the larger one was accepted for the Salon of 1878 and a smaller, more freely painted version was exhibited simultaneously in New York, at the first exhibition of the Society of American Artists. Both were warmly received by the critics. The prestigious art magazine, *Gazette des Beaux-Arts,* illustrated Sargent's Salon picture in a review that praised the bold modeling of the figures and the realistic effect of the luminous, sunny sky reflected on the watery beach. The smaller version, *Oyster Gatherers of Cançale,* was purchased from the New York exhibition by Samuel Colman, a landscape painter of the

Oyster Gatherers of Cançale

c. 1878. Oil on canvas, 16¼ x 23¾"
Courtesy the Museum of Fine Arts, Boston.
Gift of Mary Appleton

In the summer of 1877 Sargent spent ten weeks on the Brittany coast making drawings and oil sketches of the local fisherfolk. In his Paris studio he used them to invent this composition. In the spring of 1878 he sent this painting to the inaugural exhibition of the Society of American Artists in New York, and an example twice its size to the Paris Salon. These works attracted favorable comments on both sides of the Atlantic, and both were purchased by Americans.

Oyster Gatherers of Cançale

Hudson River School who was twenty-four years older than Sargent. He told a critic that he wanted to have it in his studio as a standard of excellence "to key myself up with." These auspicious remarks were quoted in G. W. Sheldon's book *American Painters* in 1878.

At the Salon of 1879 Sargent declared a dual interest in picturesque genre and portraiture by submitting a small painting of a native woman on the Mediterranean island of Capri and a dashing portrait of his teacher, Carolus-Duran. The Frenchman invited him to paint his portrait because he was so pleased with the one of him that Sargent had included in the ceiling decoration they completed in 1878. It was a clever move for both the stellar pupil and the celebrity artist. In the same exhibition Carolus-Duran won a Medal of Honor with his portrait of the Comtesse de Védal, therefore his pupil's flattering likeness added to the glory of the moment. Sargent showcased the public personality that Carolus-Duran had created for his professional and social advancement, showing his black-haired good looks and dandified costume. He hinted at the man's love of horsemanship, billiards, and fencing—his leisure pursuits noted in the popular press—by having him toy with his cane. The portrait was awarded an Honorable Mention by the Salon jury, and to Sargent's further advantage, it was used as a cover image by the mainstream magazine *L'Illustration.*

The Salon of 1879 also included a few Impressionist works that are now more broadly appreciated by the critics and the public—*Boating* and *The Conservatory* by Edouard Manet, and *Madame Charpentier and Her Children* by Pierre-Auguste Renoir. These artists were of the same generation as Sargent's teacher, and their work had been rejected by Salon juries on several previous occasions. In fact the Impressionists chose to organize their own series of private exhibitions in 1874 out of dissatisfaction with the conservative policies and admission standards of the Salon. The inclusion of works by Manet and Renoir in the 1879 Salon was an indication of a gradual recognition of the Impressionist movement. However, when awards were given to innovative work they went to promising young moderates like Sargent, and not to known "revolutionaries."

When Sargent sent *Carolus-Duran* to exhibitions in New York and Boston in 1880, it was received a little more coolly than in Paris. Critics welcomed the opportunity to see the much-discussed portrait for themselves, but a number of them were somewhat offended by the sitter, whom they described as foppish, effeminate, and vulgar. Despite these reservations, this portrait put Sargent on the threshold of fame in Europe and America. Dr. Sargent took especial pride in the fact that its good fortune at the Salon quickly brought his son six portrait commissions from the

Carolus-Duran

1879. Oil on canvas, 46 x 37¹³⁄₁₆"
Sterling and Francine Clark Art Institute,
Williamstown, Massachusetts

Charles-Emile-Auguste Durand was an innkeeper's son from Lille. He adopted the pseudonym Carolus-Duran after completing his training in Paris in the 1850s. By the late 1870s he was an acclaimed society portraitist and Sargent was one of his favorite pupils. This portrait won Sargent an Honorable Mention at the Paris Salon of 1879. Sargent captured his teacher's showiness—his dapper costume, handsome stare, and a red Legion of Honor award pinned to the lapel—but he tempered it with stylishly restrained brushwork and a subtle palette of blues, grays, and browns.

French. The first profile on Sargent was published in 1880, in the American magazine *The Art Amateur*. He was characterized as "an educated cosmopolitan" from an old, respectable, and wealthy Philadelphia family: "His social position is of the best." Sargent's portrait of Carolus-Duran was illustrated, and it was noted that their friendship was "of somewhat unusual intimacy" because the teacher "loves to have his American disciple in company." Sargent was clearly groomed for his career by the Frenchman. He was adept at the social formalities of the wealthy and the upper classes and he always wore a tie when he painted their portraits. As soon as he could afford it, his lifestyle followed that of his patrons: he had servants, and he received sitters in a grand studio decorated with paintings, fabrics, and bric-a-brac.

El Jaleo: Danse des Gitanes

II. Instinct for the Esoteric

I N ROME IN 1868–69, SARGENT FORMED A CLOSE teenage friendship with Violet Paget, who later wrote under the name of Vernon Lee. She recalled that their passion was anything "enormously picturesque and still unspoilt." They raved over "bits of antique marbles," pontifical masses attended by "black-veiled ladies," and "tinsel-hung churches, where tapers shone dim through the stale incense." That winter Lee saw for the first time Sargent's attraction to the outlandish and the bizarre. She connected it to his mother's exuberance and cheer, as opposed to his father's puritanical reserve. She said that the word "curious" summed up his "instinct for the esoteric, the more-meant-than-meets-the-eye, which plays so subtly through his audaciously realistic work." Similarly, his preferences "in music, literature, and, for many years, persons" were governed by an "exotic, far-fetched quality." This chapter focuses on Sargent's involvement with visual, musical, and sensual display through his early genre paintings. Professionally, he responded to a market for exotic picturesque imagery. Personally, he gratified his need for a release from the primness of his Anglo-Saxon Protestant cultural heritage through esoterically coded sensualism.

To understand both the art and the artist it is necessary to see how the different, sometimes opposing, aspects of Sargent's personality interacted. One lifelong duality involved the balance between commissioned portraits and independent works. His rise to fame in Paris depended on both, but portraiture became the core of his wealth. Once that business was underway, genre works (which also brought income) allowed travel away from the metropolitan studio, and a freer kind of professional pursuit. However, these periods of escape involved hard work, for Sargent was making studies that would be worked up into Salon paintings. This pattern was seen in the last chapter in the early instance of *Oyster Gatherers of Cançale*, although by 1878 Sargent was thinking of places more exotic than Brittany.

In May, 1878, Sargent wrote to Charles Deering, an American naval officer: "When I learned . . . you had two Japanese costumes for me, I was perfectly overwhelmed with delight. . . . Your descriptions of Japan made me wild to go there. There is no country I would rather see, and also

El Jaleo: Danse des Gitanes
1882. Oil on canvas, 93⅜ x 138½"
Isabella Stewart Gardner Museum, Boston

Completed in Paris early in 1882 in time for the Salon, this monumental work harked back to a trip to Spain taken three years earlier. It was Sargent's youthful tribute to the passion and fierceness of Gypsy music and dance in southern Spain. He focused his concerns as a realist on the strange theatricality of the event: the extravagant motions of the dancer, the singing, clapping, and strumming troupe lined against the wall, and the menacing shadows cast by crude footlights. The broad sweep of the canvas mimics the proportions of the performance space in a tavern, and the off-center placement of the dancer allows the viewer to imagine her noisy and riveting passage from one side to the other.

there is no country I am less likely to visit, especially for the present. I must stay in Paris; it is the only place." These words confirm Sargent's desire to experience unknown locales, even as his Parisian career was taking hold. Unable to see Japan in 1878, he made a short visit to Capri, where he was happy to have as his main model "an Ana Capri girl, a magnificent type, about seventeen years of age, her complexion a rich nut-brown, with a mass of blue-black hair, very beautiful, and of an Arab type." In Capri he expressed his personal attraction to the non-Caucasian otherness of dark-skinned people, who seemed outwardly to possess a bodily freedom and fervor that was alien to the genteel manners of his bourgeois upbringing. The progress of science and transportation made such "uncivilized" societies more accessible, and, unwittingly perhaps, Sargent contributed to the cultural enterprise that reduced such cultures to stereotypes of the primitive and the exotic. Such images, often subliminally coded to appeal to folkloric, sexual, and even colonialist fantasies, had a potent attraction for industrialized urban dwellers. On the island of Capri Sargent sketched handsome young local people with their brown skin viewed against white architecture. He painted a gentle, barechested man leaning against a wall, and a woman dancing freely on a rooftop as another woman sings and plays a tambourine. The works are paradoxical, for they evoke lyricism and passion, and yet they operate as quasi-ethnographic reports that fix their subjects according to the visions and desires of urbanites. This was a lifelong interest of Sargent's, for in 1922 he showed Martin Birnbaum, a young American, an "enormous scrap album, filled for the greater part with photographs and reproductions of aboriginal types the world over." *Dans les Oliviers à Capri*, the genre painting he exhibited at the Salon of 1879, shows a woman in a field at twilight; her arms casually hook over the snaking trunk of an olive tree, and the back of her dress is caught and lifted by its undergrowth to reveal her naked feet.

A five-month trip to Spain and North Africa in 1879–80 yielded two major Salon paintings for Sargent: *Fumée d'Ambre Gris*, which was exhibited in 1880, and *El Jaleo: Danse des Gitanes* shown in 1882. The artist's inscription on *Fumée d'Ambre Gris* indicates that its location is Tangier. The subject is a full-lipped Arab woman, holding up her robes in a canopy to catch the perfume of the ambergris smoldering in an ornate censer. She wears elaborate jewelry, her fingernails are painted red, and a line of warm brown cosmetic connects her eyebrows. Although she evidently belongs to a privileged class, Sargent did not intend her image to be read as a portrait; rather she is his unnamed souvenir of Tangier. The setting is the patio of a little house that Sargent and an unidentified male friend had rented. Sargent made preliminary drawings of the architec-

ture and the woman's hands. His desire for an impressive sense of authenticity may be inferred from the precision with which he ruled the outlines of the floor tiles into the wet paint. He may well have been inspired by Gérôme's studiously detailed paintings of Muslim life in Cairo, which were packaged in narrative compositions often derived from Dutch seventeenth-century genre pictures. Sargent's work differed in being executed on a larger scale, with a less overwhelming reliance on "ethnic" props and set decor. Most importantly, *Fumée de'Ambre Gris* had a self-conscious aesthetic and poetic goal—to paint a predominantly white sunlit figure in a white architectural setting. Strong color was confined to the carpets, the tiles, and a few details of the woman's costume. Sargent wrote Vernon Lee that color was "the only interest of the thing." In foregrounding the issue of colorism he reveals the second basic characteristic of his genre paintings: the Arab was not only an alluring embodiment of the exotic, she was an impersonal object in a formal exercise, a difficult motif to tackle.

El Jaleo: Danse des Gitanes was the largest and most controversial genre picture that Sargent ever painted for the Salon. It was created in the winter of 1881–82, although he first encountered the dance and the music that inspired it in Spain in 1879. That trip was a pilgrimage to study and copy the paintings of Velázquez in Madrid, and to experience the culture that had produced them. At the Prado he copied *Las Meninas*, the celebrated painting of the little Infanta Margarita, her retinue of attendants and dwarfs, and Velázquez himself. He also traveled in the south, making sketches in Madrid and in Granada's Moorish palace, the Alhambra. Sargent was thrilled by Andalusia, the southern region whose bullfights and flamenco were developing into touristic symbols of a regional culture that relishes life at extreme intensity. Sargent was most entranced by the music and dance of the local Gypsies. Throughout the world this nomadic race was suppressed because they seemed to lack ethical principles, and exalted superstition over orthodox religion. Their jewelry and brightly colored clothes easily identified them as "other." They were tolerated to a limited extent for their fortune-telling and their music. In Andalusia Sargent sought out the oldest musical expressions in which Spanish and Moorish traditions had mingled with the wild, morbid, restless, and mysterious elements of Gypsy culture.

El Jaleo: Danse des Gitanes expresses Sargent's thirst for the passion of flamenco dance, and couches it with his love for the art of two Spanish masters, Velázquez and Goya. The somber palette and sparse, orderly composition show affinities with Velázquez, while the contorted faces of the performers and the spooky lighting recall similarly weird passages in the prints and paintings of Goya. Although *El Jaleo* convincingly evokes

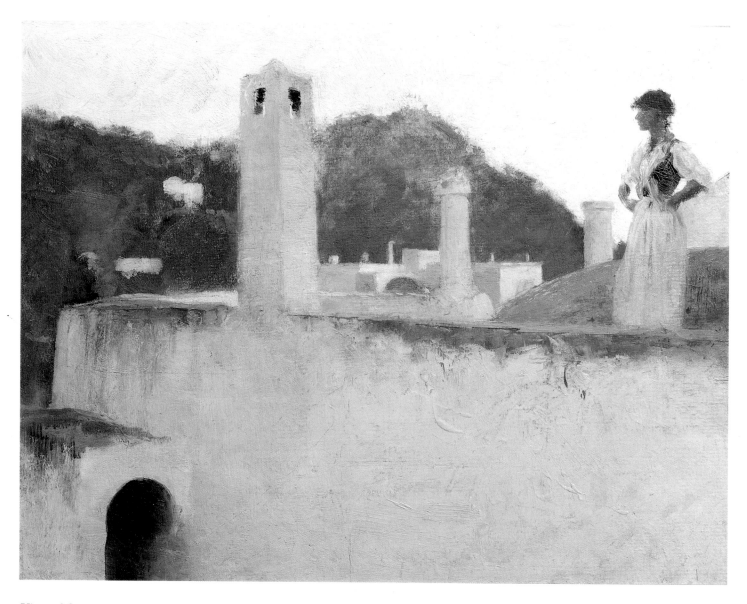

View of Capri

1878. Oil on academy board, 10 x 13¼"
Yale University Art Gallery,
New Haven, Connecticut.
Edwin Austin Abbey Memorial Collection

Writing from Capri in the summer of 1878 Sargent told a friend "Italy is all that one can dream for beauty and charm." Three elements that fired his imagination on Capri are combined in this small sketch—the delicately tinted twilight, the luminous white buildings, and the black-haired, brown-skinned inhabitants of Arab descent. The young woman observed on the rooftop stood proudly with hands on hips, visibly absorbed in the magical beauty of her island.

Fumée d'Ambre Gris

1880. Oil on canvas, 54¾ x 37"
Sterling and Francine Clark Art Institute,
Williamstown, Massachusetts

Sargent spent the first two months of 1880 in Tangier. He hired an Arab woman to pose in his rented house and made studies for a new work. He exhibited this painting at the Paris Salon a few months later. Writing in 1887, Henry James admitted ignorance of the "mysterious rite" undertaken by "this stately Mohammedan." From his aesthetic perspective it was sufficient that she was "beautiful and memorable." James' response typifies the appeal of exotic imagery to the Salon audience. In fact the woman's "rite" was mundane: she was perfuming herself with the ambergris burning in the censer.

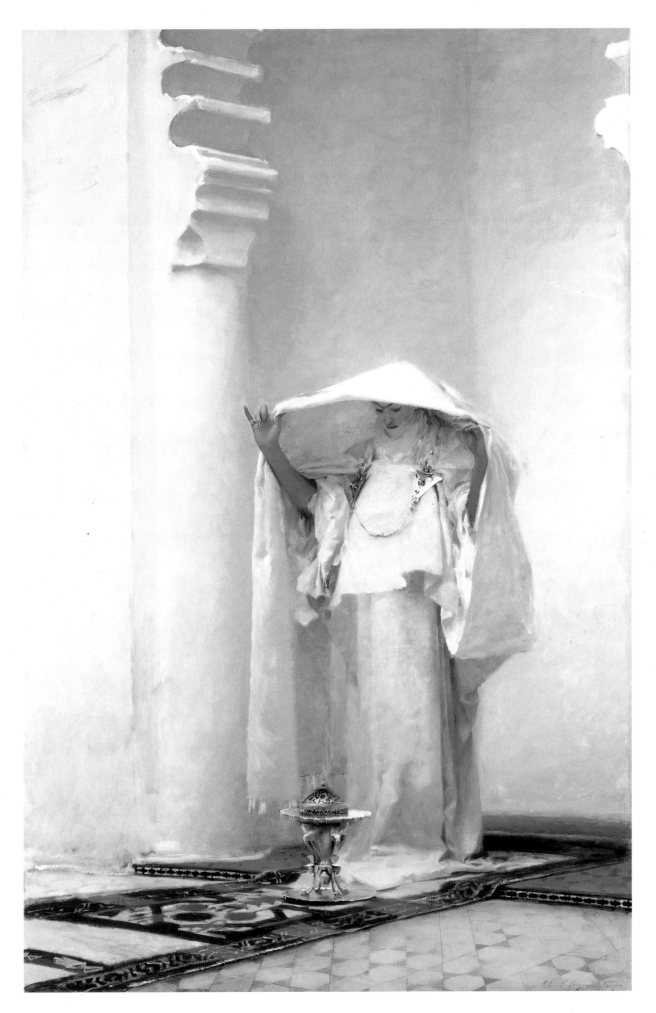

Fumée d'Ambre Gris

Study for "El Jaleo"

The dancer assumes the same pose as that of the finished version of El Jaleo. *The taut folds of her shawl and the wild swirling of its long fringe are more evident here than in the painting. For example, dark watercolor washes draw attention to the shawl's undulating movements. Conversely, the white dress, although exquisitely delineated in nervous outline, is less dominant here than in the painting. The artist mailed this drawing to his parents in Nice, possibly to give them a preview of the large Salon painting.*

a simple Spanish café with shabby walls and crude footlights, this large work was produced in Sargent's Paris studio with local models. The least authentic detail is the dancer's shiny white skirt, which a Gypsy would not have worn. Perhaps Sargent chose to play down Gypsy showiness to keep his palette closer to that of Velázquez. The word *jaleo* may be translated as "ruckus" and "hubbub": thus in his title Sargent invites the viewer to imagine the outbursts, cries, and clapping of the singers and musicians as they cheer on the dancer in her extravagant transit across the stage.

Spanish Dancer

c. 1879. Graphite, 14½ x 10"
The Metropolitan Museum of Art, New York.
Gift of Mrs. Francis Ormond, 1950

With heels touching and one arm raised in a curve, the dancer's pose draws attention to the tight, high-waisted pants and the short jacket that unify and attenuate his form. Sargent made other sketches of this man in similar dance positions. They may be records of his four-month tour of Spain in 1879, but this has not been confirmed by stylistic or documentary evidence; thus they may have been made outside Spain and perhaps as late as the turn of the century.

El Jaleo: Danse des Gitanes provoked lively discussions at the Salon. A closing report in *The Art Amateur* stated that painters had hailed it as "an extraordinary artistic tour de force" while the general public thought it "the ugliest picture in the whole exhibition." The polarization reflected the ongoing battle over a sketchlike, painterly finish versus the polished finish prescribed by official taste. The American critic in *The Art Amateur* stood firmly by "Academic rules" and accused Sargent of sacrificing "form" in his affected pursuit of "breezy dash and eccentric studies of light." In a basically enthusiastic essay on Sargent, published in 1887, Henry James made the same criticism: "It looks like life, but it looks also, to my view, rather like a perversion of life, and has the quality of an enormous 'note' or memorandum. . . . [It] sins in the direction of ugliness,

and, independently of the fact that the heroine is circling round incommoded by her petticoats, has a want of serenity." James informed his readers that the painting had found "a somewhat incongruous home in Boston," but did not identify its owner as blue-blooded Thomas Jefferson Coolidge.

With hindsight it is hard not to relate *El Jaleo: Danse des Gitanes* to Georges Bizet's *Carmen*, first performed at the Opera-Comique in Paris in 1875. Sargent surely knew the opera, for he was a musical fanatic, and a student in Paris at the time. He certainly felt its symbolism, for today it is easy to admire the powerful, voluptuous, and astonishing dancer in *El Jaleo: Danse des Gitanes* as a Carmen-like heroine. Inspired by Prosper Mérimée's novella of 1845, *Carmen* is the story of an Andalusian Gypsy who loves two men: an army officer and a toreador. This rebellious and sexy woman gives the opera its life, and yet she is dispatched violently in the closing moments. Carmen embodied the allure and the threat of both Gypsies and independent women: the double standards of the day made her demise a necessity. Bizet's opera scandalized the public and most critics, and was considered a failure. However, it was performed forty-eight times over eleven months, until low attendance closed the production. The affinity between *El Jaleo: Danse des Gitanes* and *Carmen* may have been suggested by the critic for the *New York Times*, who in 1882 noted that Sargent was "flattering the modern *culte* for Spain, and aiming at the well-known passion of Parisians for the stage."

In the early 1880s Sargent painted a group of Venetian genre pictures whose underlying themes are flirtation and the "allure" of Mediterranean working-class women. He spent a total of ten months in Venice in the winter of 1880–81 and the summer of 1882, hoping to find inspiration for a Salon painting. Two scenarios appealed to him: men and women interacting casually and suggestively in an alley, and women strolling leisurely or stringing beads in the hallway in an old palazzo. In an exploratory series of paintings he accentuated the spatial dynamic of the long narrow alley or hall, and the beautiful volumes of light and shadow encountered there. Working with models, he depicted young Venetians of his age-group, conducting their lives with flair. His pictures communicate his almost voyeuristic admiration for their ability to mix work and pleasure easily and openly, in a city that is both serene and dramatic.

While he exhibited two watercolor views of Venice in 1881, Sargent never painted a major Venetian piece for the Paris Salon. Critics had found the imagery of his Venetian paintings dark, gloomy, and degraded when they were shown in a group exhibition at a commercial gallery in Paris late in 1882. It dawned on him that they were painter's paint-

Street in Venice

1880–82. Oil on canvas, 27⁹/₁₆ x 20⅝"
Sterling and Francine Clark Art Institute,
Williamstown, Massachusetts

The sharply receding planes of a narrow alley dominate this composition. People who have explored Venice know that Sargent's observations were not exaggerated. Nonetheless, the sheer boldness of his pictorial space recalls a device used by Degas: an acute point of view that places the subject in an active visual context. Sargent painted a Venetian working-class woman and a more ambiguously coded young man into this dramatic perspective. The woman's position at the threshold of a tavern, and the man's orientation towards its interior hints at flirtation.

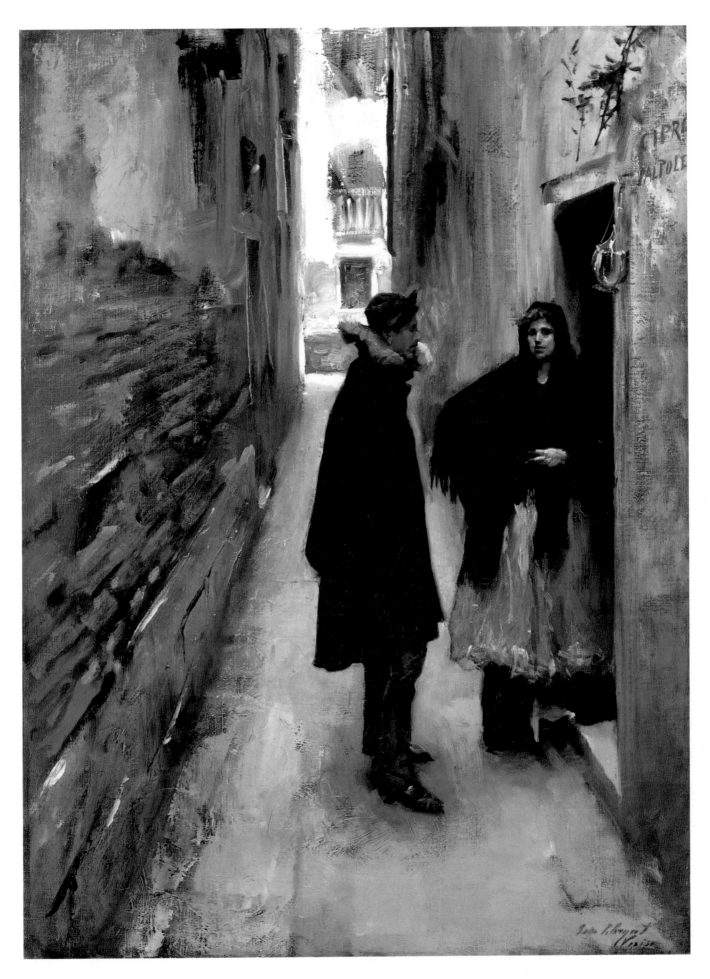

Street in Venice

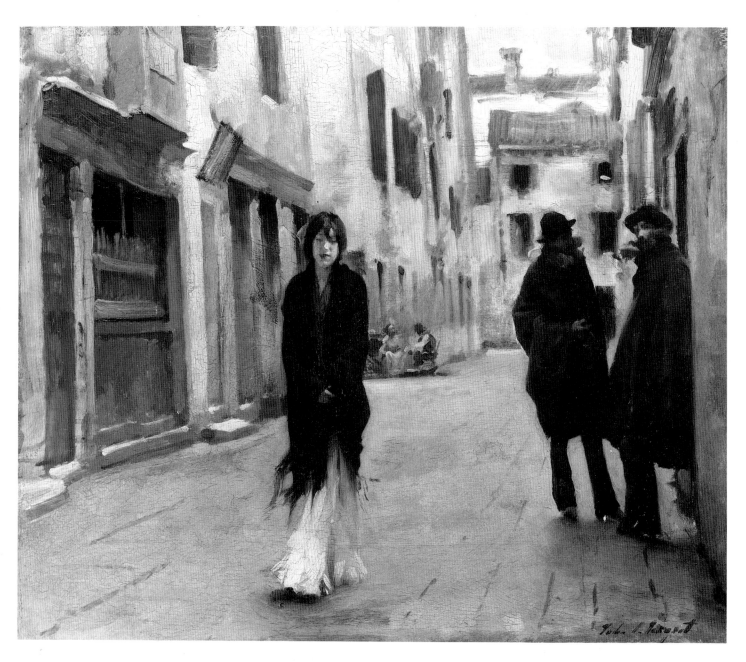

Street in Venice

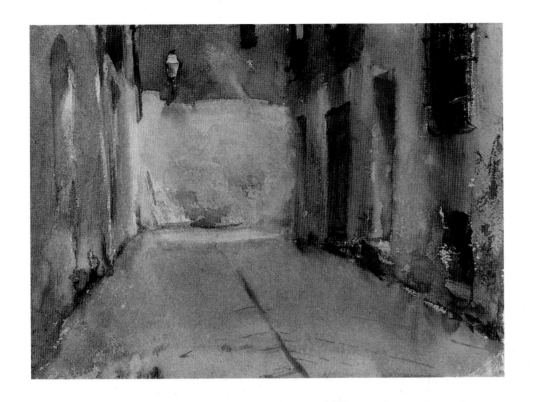

Venice

1880–82. Watercolor on paper, 9⅞ x 14"
The Metropolitan Museum of Art, New York.
Gift of Mrs. Francis Ormond, 1950

The box-like space underlying most of Sargent's early oil paintings of Venice is the focus of this watercolor study. As an empty setting it is inherently mysterious, but its sense of drama would not be diminished by the addition of human figures. In fact this street was probably sketched for later use: it might have been copied in oils as the background of a painting with figures. Sargent made drawings of models in different poses and used them for the characters in such paintings.

ings, and he realized that his personal romance with Venice as a brooding, mysterious shadow world was simply too unpopular. The subtleties of their dark palettes and their luminous tonalities were exciting only to painters and connoisseurs. The innuendos of gesture and body language, so suggestively articulated by his brushwork, held no interest for polite viewers, who saw only frank, unidealized images of workers and bohemians. Sargent gave these Venetian paintings as gifts to friends in the art world: to painters Carroll Beckwith, Jean Charles Cazin, and Henry Lerolle, to architect Stanford White, and to the Greek Minister to France, J. Nicolopoulu. Two others were traded with F. W. C. Bechstein for one of his company's upright pianos.

The poetic and painterly qualities of the Venetian paintings eventually appealed to a larger audience. In 1887 Henry James hailed one of them as "a pure gem." He appreciated the dual refinements of their execution and observations: "Wonderfully light and fine is the touch by which the painter evokes all the small familiar Venetian realities . . . and keeps the whole thing free from that element of humbug which has ever attended most attempts to reproduce the Italian picturesque." Although it might seem odd that James would praise the Venetian pictures while resisting *El Jaleo: Danse des Gitanes*, it should be borne in mind that the Italian works are much smaller, their city and culture were dear to him, and the women appear more passive. When two examples were shown at the National Academy of Design in 1888, a critic for *The Art Amateur*

Street in Venice

1880–82. Oil on wood, 17¾ x 21¼"
National Gallery of Art, Washington, D.C.
Gift of the Avalon Foundation, 1962

When Sargent included this painting in a group exhibition in Paris in 1882–83, his unconventional embrace of Venice disappointed one mainstream critic. The reviewer for the Gazette des Beaux Arts *read disease and danger into this painting: he described a dark, slum-like alley and an unkempt woman in a tattered black shawl, who seems to be shivering with fever. The bewildered Arthur Baignères bluntly stated his disappointment that Sargent had eschewed the Grand Canal, the Piazza San Marco, and women who rival the beauties painted by Titian.*

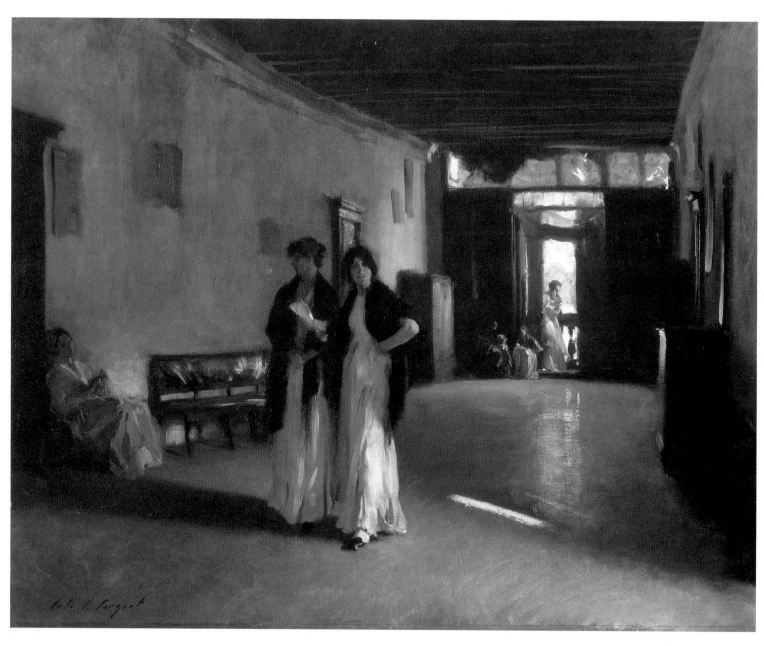

Venetian Interior

called them the best "painter's sketches" ever exhibited there. With an ironically witty turn of phrase, *The Studio* was in agreement: "Mr. Sargent, tiring of over-dressed beauties for the nonce, has picked up a few of the slouchiest specimens of woman-kind that Venice produces, but serves them up with such a skillful turn of the wrist, and such a dexterous toss of the pan, that with our eyes shut we should almost take them for duchesses."

Sargent's early genre paintings played an important role in his development as an artist drawn to the body and its expressive language of appearances. The imaginative and exotic emphasis of the genre works seems to have influenced his interest in capturing the striking mannerisms and curious fleeting gestures of the people whose portraits he painted. By applying his penchant for telling idiosyncratic details to portraiture, he aroused critical interest and debate, and strengthened his efforts to establish a signature style.

Venetian Interior

c. 1880–82. Oil on canvas, 26⅞ x 34⁹⁄₁₆"
Museum of Art, Carnegie Institute, Pittsburgh.
Purchase

Six women and a baby occupy the hall of a run-down palazzo. The seated figure at the left seems to be stringing beads, which is probably how all these women earned their livings. While paying tribute to the sensuous, relaxed spirit for which Venice is celebrated, Sargent avoids the contemporary tendency to stereotype the inhabitants as childlike, playful, or merely picturesque. The handling of paint helps to convey Sargent's lyrical response to the sunlight penetrating their long, shady space. The most remarkable instance is the bar of light in the foreground, denoted by a single stroke of thick paint.

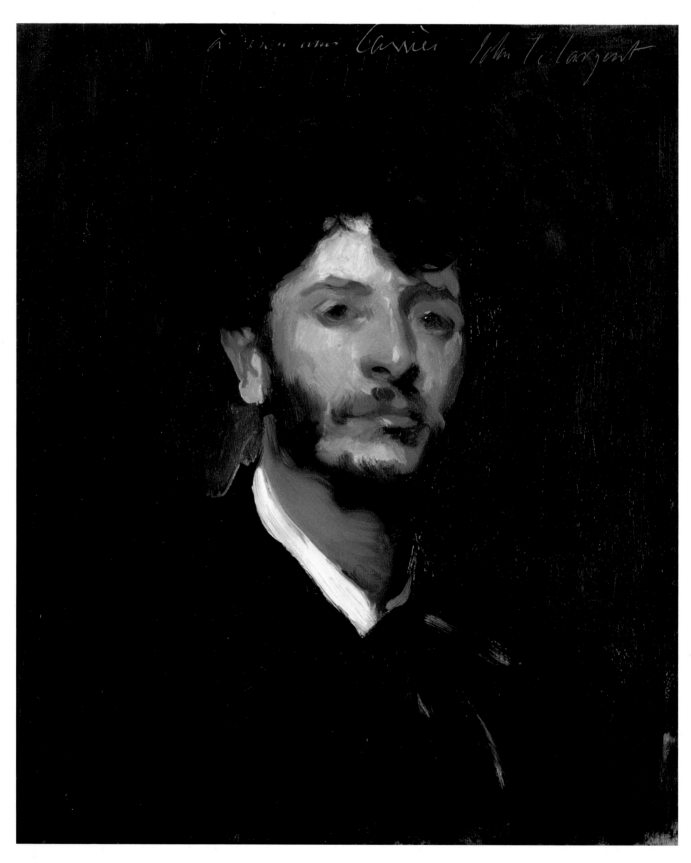

Jean-Joseph-Marie Carriès

III. Fame and Scandal as a Parisian Portraitist

THIS CHAPTER FOCUSES ON SEVEN WIDELY exhibited portraits of Parisian residents that secured Sargent's fame in the early 1880s. One of them, *Madame Pierre Gautreau,* provoked public outcry and mockery at the Salon of 1884. The portraits are eclectic in style and cosmopolitan in spirit, and in this foretell the increasingly international scope of his career. Before considering these key works and their critical reception, I want to stress their Parisian genesis, for regardless of American blood and an itinerant multinational upbringing, Sargent's ethos as a painter was thoroughly French. He studied oil painting for the first time when he moved to Paris as a student, and when the eager, gifted, and impressionable American became the protégé of Carolus-Duran, he totally assimilated his master's methods and credo as a painter and a portraitist. The realist philosophy that was the basis of his mentor's teaching is evident in an early portrait sketch by Sargent, *Jean-Joseph-Marie Carriès.* It indulges freely in expressive painterly effects since it was not a commissioned work, and yet it records exterior facts in the strict and economical manner he learned from Carolus-Duran.

Sargent's teacher decried overpainting and corrections, and argued that no stroke should be made that was not indispensable. He opposed the perfectly smooth and linear painting taught at the Ecole des Beaux-Arts, convinced that the legacies of Raphael and Ingres had been sterilized by academic rote. He taught Sargent to give life to his images with carefully emphatic inflections of the brush, practicing a painterly language that was both sensuous and precise. This position was neither new nor original: it profited from the radical positions taken by Gustave Courbet and Manet in the 1860s. In comparison, the art of Carolus-Duran was not controversial because its stylistic novelty was presented in terms of historical revivals and rediscoveries. He made a pastiche of Late Renaissance and Baroque bravura techniques taken from the work of Veronese, Tintoretto, Rubens, Hals, and above all Velázquez. Sargent accepted this philosophy, and his portraits therefore embody moderate or centrist art practices. They struck academically oriented French con-

Jean-Joseph-Marie Carriès

c. 1880. Oil on canvas, 22 x 18½"
Sheldon Memorial Art Gallery,
University of Nebraska, Lincoln.
NAA-Nelle Cochrane Woods Memorial
Collection, 1972

Carriès was a Parisian sculptor, one year older than Sargent, who exhibited portrait busts at the Salon in 1879 and 1881. This oil sketch of him, inscribed "à mon ami Carriès," is typical of a group of portraits made as gifts for friends and colleagues. Close acquaintance with a fellow artist dissolved the formality of a commissioned work. The intimate close-up of the head and the conspicuous brushstrokes confer spontaneity and vitality. Sargent's use of green to color the shadow beneath the mouth is an indication of his desire that an informal likeness should record all his observations of local and reflected light.

servatives as reckless because the ambitious young American liked to test, challenge, and flaunt his talent for bravura. More progressive critics saw promise in Sargent in the early 1880s. For example, Antonin Proust, one of the few contemporary champions of Manet's work, believed that Sargent was a remarkably talented artist "called to a great future."

The Honorable Mention won by Sargent's *Carolus-Duran* at the Salon of 1879 gave him exemption from the jury for one year. Free to take a risk, he showed *Fumée d'Ambre Gris* and *Madame Edouard Pailleron* in 1880. The Pailleron portrait surprised some critics, for "formal" portraits rarely had such a boldly casual outdoor setting. Posed beneath a tree, the subject is shown half-lit, in front of a bright lawn dotted with autumn crocuses and fallen leaves. The grass near the foreground is rendered with long strokes that create a blurred, windy effect. Behind the woman's head, at the top of the slope, a house and terrace are sketched in with bold impasto. Similarly, a variety of painterly effects was summoned to evoke the different textures and sheens of the subject's clothes and accessories. The impulsive reaction of the critic Margaret Wright to Sargent's display of style was to dismiss it as "Frenchy" and overly clever. Her chauvinism included the subject as well as Sargent's technique: "[She is] a modishly dressed and furiously red-headed woman, who looks as if her hair has not been touched for a week, and [her] dim eyes are half closed."

The members of the Pailleron family were perfect patrons for Sargent at the outset of his career: wealthy, intelligent, artistic, and socially connected, they indulged the enthusiasms of the young American. Madame Pailleron was the daughter of Edmond Buloz, the editor of the journal *Revue des Deux Mondes*. Her husband, also painted by Sargent in the summer of 1879, was a successful dramatist. In his portrait he stands holding a dog-eared book and gazes staunchly at the viewer; the wallpaper behind him is abstracted to a tonal fog with a few bold marks that suggest leaves and flowers. Sargent went on to paint a double portrait of their children which he exhibited at the Salon of 1881. *The Pailleron Children (Edouard and Marie-Louise)* has an aggressive impact on the viewer that directly results from Sargent's gift for "life-like" effects. Both children look high-strung, and almost menace the viewer with their stares. After seeing the portrait on exhibition at the Fine Art Society, London, in 1883, Oscar Wilde called Sargent's work vicious and meretricious (but within a year was more sympathetic and befriended the artist). Vernon Lee disagreed with Wilde. She wrote to her mother: "John's portrait of the Pailleron children is a splendid work, which, so completely healthy and wholesome, does one good to see after all this scrofulous English art." The Paris art establishment had already been as favorable in their

The Pailleron Children (Edouard and Marie-Louise)

1881. Oil on canvas, 60 x 69"
Des Moines Art Center, Iowa.
Edith M. Usry Bequest Fund in memory of her parents, Mr. and Mrs. George Franklin Usry, and additional funds from Dr. and Mrs. Peter T. Madsen and the Anna K. Meredith Endowment Fund, 1976

At the Paris Salon of 1881 Sargent exhibited this portrait and a full-length canvas of Madame Ramon Subercaseaux seated at the piano. These paintings won him a second-class medal, which made him exempt from the admissions jury at all future Salon exhibitions. The French critic J. Buisson complained that Sargent worked too much in the manner of his teacher Carolus-Duran in this portrait of two children: "He shows the [same] cleverness, dazzling effect, and rather ostentatious fluency, and similar qualities as a colorist."

FAME AND SCANDAL

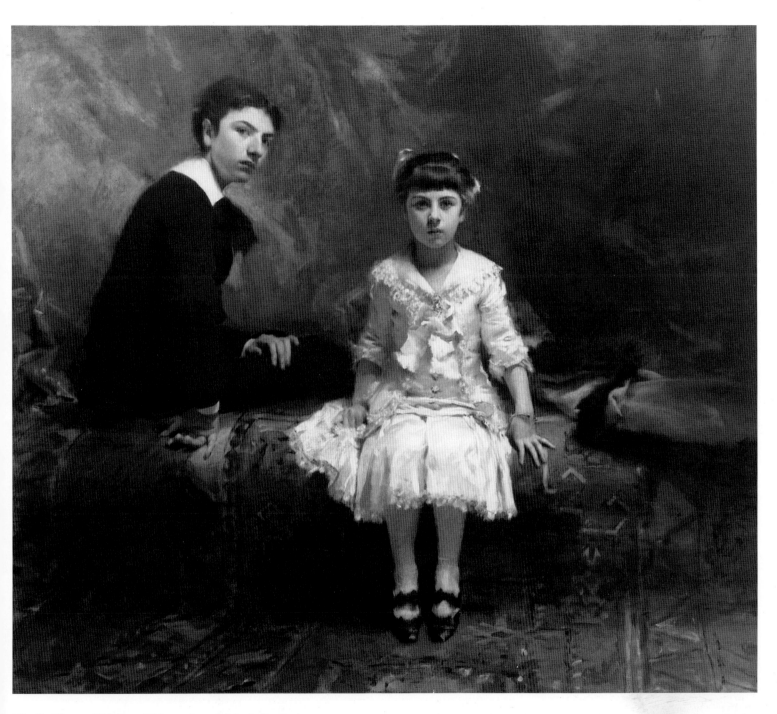

The Pailleron Children (Edouard and Marie-Louise)

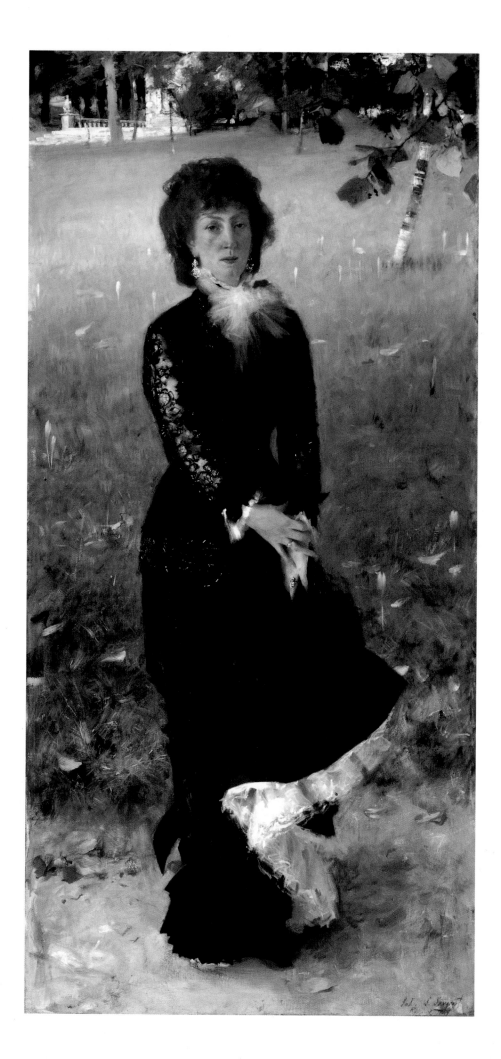

Madame Edouard Pailleron

1879. Oil on canvas, 82 x 39"
The Corcoran Gallery of Art, Washington, D.C.
Museum Purchase

Between 1879 and 1881 Sargent painted the portraits of Edouard Pailleron (a playwright and poet), his wife, his two children, and his mother-in-law, Madame François Buloz. Madame Pailleron posed outdoors at the country home of her parents in the south of France. The grounds of the estate compete with the woman's clothes for the attention of Sargent's brushwork. The incongruity between the showy, if withdrawn woman, and the loosely brushed landscape dotted with leaves and flowers, gives this portrait an unconventional appeal.

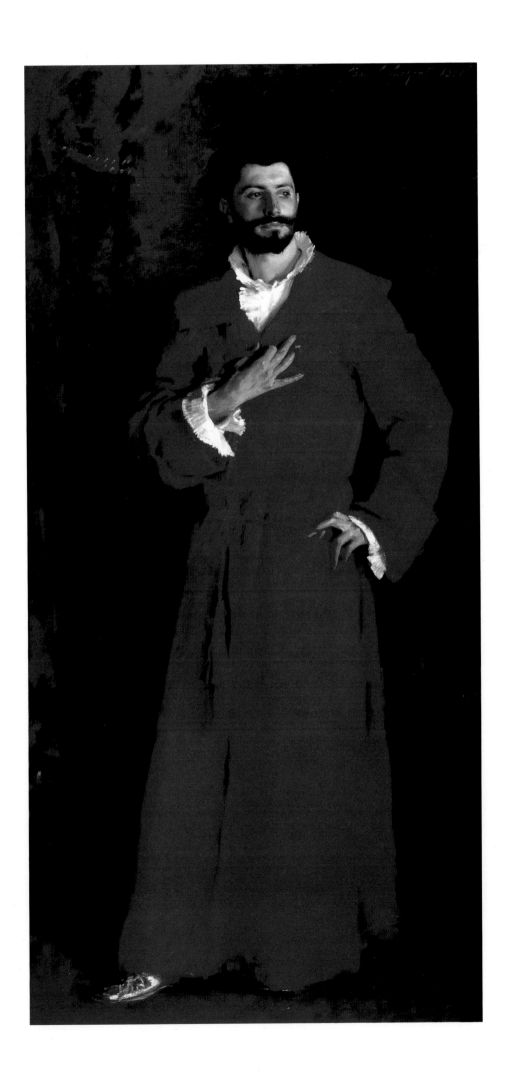

Dr. Samuel Jean Pozzi at Home

1881. Oil on canvas, 80½ x 43⅞"
The Armand Hammer Collection. The Armand
Hammer Museum of Art and Cultural Center,
Los Angeles

This portrait drew little comment from art critics at the annual exhibition of the Royal Academy in London in 1882. However, Sargent's friend Vernon Lee saw it there and wrote to her mother praising its "insolent kind of magnificence, more or less kicking other people's pictures into bits." The subject was a Parisian surgeon and gynecologist. Two patients reputed to be his lovers were Madame Pierre Gautreau and Sarah Bernhardt (who referred to him as "Docteur Dieu"). He struck a flamboyant pose for Sargent in a red dressing gown against a crimson carpet and drape. In 1885 Sargent described him to Henry James as "a very brilliant creature," a further indication of his admiration for Pozzi's ornate charisma.

assessment as Lee, for the children's portrait, along with the charming and conventional *Madame Ramon Subercaseaux,* won Sargent a second-class medal at the Salon. Manet was one of the other eight artists to receive the same medal in 1881. That year a reorganization of the Salon had given artists more control over the admission standards and the awards. There were now forty, rather than fifteen, artists on the painting jury. Carolus-Duran was a new juror, and he doubtless lobbied for a second-class medal to go to his protégé. This award made Sargent permanently free from the jury.

For his first life-sized, full-length male portrait, Sargent apparently wanted a pictorial effect as astonishing as the outdoor setting of *Madame Edouard Pailleron.* The subject, Samuel Jean Pozzi, was a Parisian gynecologist, but the viewer might assume from the portrait that he was a dramatic or musical "star" painted backstage. In fact, Sargent shows a boudoirlike setting in the doctor's home. The painting uses a red-on-red color scheme most common in portraits of popes and cardinals. Sargent plays the passionate red of the man's dressing gown against a crimson carpet and drape, and even uses red for his signature. He gives his sitter an alert and elegantly distinguished bearing that recalls the male portraits of Van Dyck, in particular the red-robed *Cardinal Bentivoglio.* In terms of a concerted formal play of reds and crimsons, the most famous precedent is Velázquez' *Innocent X.* These two celebrated seventeenth-century paintings were in museums in Florence and Rome, respectively, and Sargent is likely to have seen them in his youth. *Dr. Samuel Jean Pozzi at Home* was not shown at the Salon, but in 1882 it was exhibited at the Royal Academy in London, where it encountered chilly silence in the British press. It also represented him in Brussels in 1884, when he was invited to contribute to the first exhibition of the Belgian avant-garde group, Les XX. Most critics admired its execution, but as usual, the most cutting remarks betray concerns about Sargent's unrestrained bravura. For example, Emile Verhaeren wrote that the portrait embraced chic at the expense of a solid foundation—"like a champagne glass filled too quickly, it holds more froth than wine."

Of all the portraits discussed in this chapter, *The Lady with the Rose* was the most widely exhibited and the best loved in the 1880s. In twelve months (1882–83) it was shown in Paris, London, New York, and Boston. The subject was Charlotte Louise Burckhardt, a twenty-year-old Swiss-American whose older sister and father had already been painted by Sargent. She proved to be the only woman in Sargent's life around whom friends seriously speculated a romantic attachment. However, it is possible that the artist was the object of a pursuit by Miss Burckhardt and her mother. Sargent's family and their friends considered the young woman

The Lady with the Rose (Charlotte Louise Burckhardt)
1882. Oil on canvas, 84 x 44¾"
The Metropolitan Museum of Art, New York. Bequest of Mrs. Valerie B. Hadden, 1932

This portrait accompanied El Jaleo *at the Salon of 1882. Sargent intended to showcase the full extent of his interests and abilities by exhibiting two such different works together. Viewers deterred by the "reckless" qualities of the Spanish dance picture were delighted by the quaintness and charm of the portrait. The smiling subject was a Swiss-American resident of Paris. The restrained palette of black, white, and cream, and Sargent's broad application of paint reminded some critics of Velázquez—the precise historical association that the young artist hoped for as an endorsement of his gifts.*

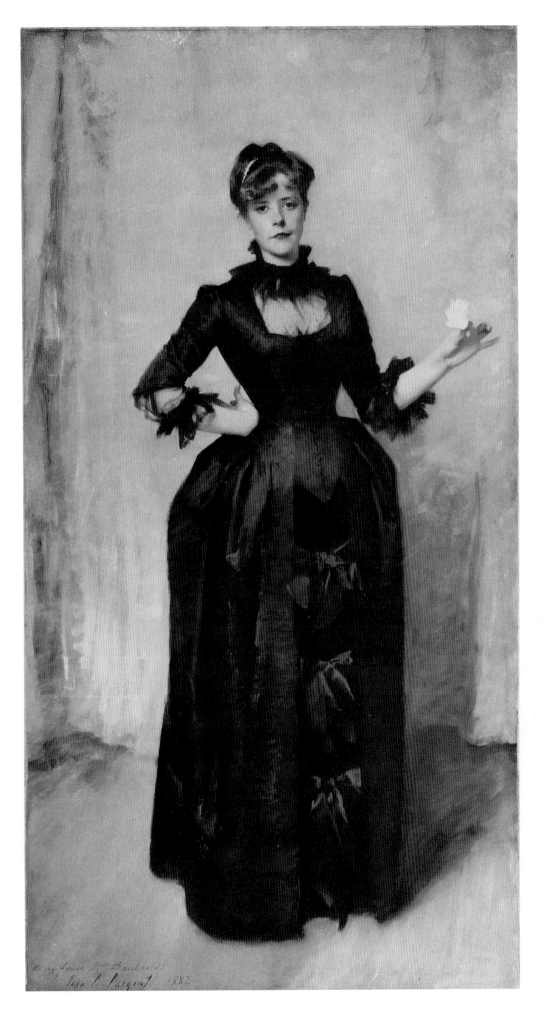

The Lady with the Rose (Charlotte Louise Burckhardt)

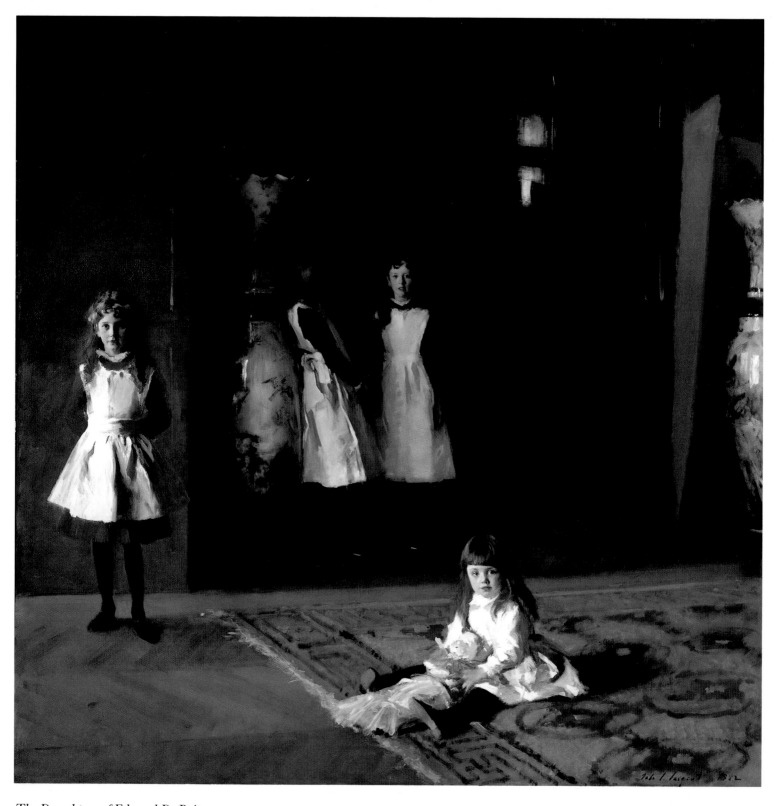

The Daughters of Edward D. Boit

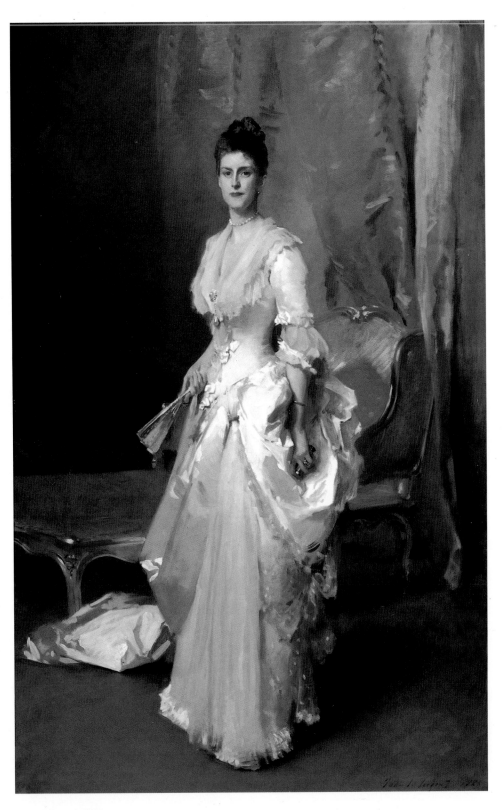

Mrs. Henry White

Mrs. Henry White

1883. Oil on canvas, 87 x 55"
The Corcoran Gallery of Art, Washington, D.C.
Gift of the Hon. John Campbell White

Sargent painted Mrs. White, the wife of an American diplomat, in his Paris studio. Within the year the portrait was hanging in the dining room of her new residence on Grosvenor Crescent in London, where Mr. White had been appointed First Secretary to the American Embassy. Much-needed support for Sargent's career as a portraitist was garnered in that dining room, for the first reactions of many English critics had faulted him for his "clever" and "Frenchified" handling of paint. When this portrait was exhibited at the Royal Academy, London, in 1884, the harshest reviewer described the execution as "hard" and "almost metallic," and found "no taste in the expression, air, or modelling."

The Daughters of Edward D. Boit

1882. Oil on canvas, 87 x 87"
Courtesy the Museum of Fine Arts, Boston.
Gift of Mary Louisa Boit, Florence D. Boit, Jane H. Boit, and Julia O. Boit, in memory of their father, Edward Darley Boit

The subjects of this large portrait were the children of rich New Englanders who traveled regularly between France, Italy, England, and America. Their ages are four, eight, twelve, and fourteen. The painting drew lively comments at the Salon of 1883, and was generally considered unconventional because the sisters seemed oddly separate within their cavernous Paris apartment. Henry James pointed out that the painting is a "comprehensive impression" of a place and a scene, within which the portraits of four individuals can be isolated by the viewer. The American critic William C. Brownell noted in 1883 that the staging of the figures and the dramatically lit space were inspired by Las Meninas, *the celebrated late work by Velázquez.*

uneducated, and her parents "extremely vulgar and designing." John and Louise did not become engaged, and he remained a bachelor.

The Lady with the Rose accompanied *El Jaleo: Danse des Gitanes* to the Salon of 1882—one the vehicle of sweet old-fashioned charm, the other a spectacle of public sensualism. In one the protagonist is a black-dressed belle coyly holding up a white rose of innocence, while the other presents a white-skirted Gypsy dancer lost in abandon. The pairing was a brilliant move on Sargent's part, because the statements countered each other: viewers had to deal with both sides of the artist, even if they could only admire one of them. Henry James was overwhelmed by *The Lady with the Rose,* and praised it royally in his 1887 essay on Sargent. He argued that this was not merely a portrait, but a picture; it was equally fine in color and composition, and showed a rare and brilliant ability to translate "the appearance of things into the language of painting." In short, it had "much in common with a Velázquez of the first order." In making his case for Sargent's great promise as an American portraitist James affirmed "There is no greater work of art than a great portrait."

Sargent exhibited *The Daughters of Edward D. Boit* twice in Paris in six months. It was one of the seven paintings he included in a group show at the Galerie Georges Petit late in 1882, and his only painting at the Salon of 1883. This large portrait—over seven feet square—was widely discussed, and often criticized as an open and unbalanced composition. This unconventional aspect was indebted to *Las Meninas* by Velázquez. Sargent knew well its ordered arrangement of figures, somber tonality, and its quiet, mysterious lighting, for he had painted a copy at the Prado in 1879. However, *The Daughters of Edward D. Boit* eclectically transcends its foundation in Velázquez. The influence of Hals' sketch-like painting technique is evident in such passages as the long, dragged strokes that model the pinafore of the girl on the left. The cult of Japanese art is literally present in the enormous modern blue and white vases standing like sentinels in the foyer of the Boits' Paris apartment, and the voids that dominate the asymmetrical composition mimic a Japanese aesthetic. Around 1920 Sargent observed: "[It is] merely an amateurish sort of arrangement that could find its rebuke in any good Japanese print." The detail that he liked in old age was the painting of the girl in the foreground, which he cited as an example of his desire to be faithful to observed reality.

The Daughters of Edward D. Boit marks a landmark in the emergence of psychological nuance in Sargent's work. His earlier portraits had been more studiously involved in creating a striking likeness in a painterly style, but in this large, more adventurous picture, commissioned by an artist friend, we see him intuitively exploring the combined moods of the

subjects and their setting. Just as the light shifts from bright foreground to dim interior, the daughters progress from the doll-clutching of childhood to the introspective moodiness of adolescence. There is a sense of ambiguity that derives in large part from the slightly anxious separateness of the four figures: they share a space but seem to hold back their feelings for each other. The portrait of the two Pailleron children, painted the previous year, reads like a stiff and artless studio photograph in comparison. Shadows and extensive yet closed-in spaces condition the psychological aura that hovers around the Boit children, and one precedent for these effects was Sargent's recent Venetian work—paintings with box-like compositions and occasionally ambiguous exchanges.

Sargent hits his stride as a painter of impressive and commanding society women in *Mrs. Henry White*. The Whites were American diplomats. They chose Sargent on the strength of *The Lady with the Rose*. Mrs. White's gesture with her fan might be compared to Miss Burckhardt's with her rose, but the similarity stops here. *Mrs. Henry White* captures a strong woman in a setting that is spare, yet eloquent and grand. Sargent casts his subject as a kindly but ceremonious patrician: her stance is erect, stately, and independent. The portrait was completed just when the Whites were moving to a post in London. They lent it to the Royal Academy exhibition in 1884. In contrast to their unresponsiveness to *Dr. Samuel Jean Pozzi at Home* two years before, the British critics now acknowledged Sargent, but treated him to a mixed reception. This was a bad year for Sargent, it was opined, referring to the two paintings shown in London that spring, but also alluding to the brouhaha surrounding the work he was showing concurrently at the Paris Salon—*Madame Pierre Gautreau*.

Sargent's great homage to Madame Gautreau, one of the most glamorous women of Parisian fashionable society, backfired at the Salon of 1884. He had grown naively confident about the Salon audience and the limits to which he could push his experiments with the conventions of portraiture. He hoped that the public would be awed and amazed by his interpretation, and instead they seized the chance to mock the woman and her type. She was born on Parlange Plantation in Louisiana in 1859, among the French aristocracy of New Orleans. Her father, a major in the Confederate army, was fatally wounded at the Battle of Shiloh. After the war her mother raised her in Paris, where she made an advantageous marriage to the banker Pierre Gautreau. As early as 1881 Sargent had been struck by the ostentatious presence she had at social gatherings, and a year later he asked, through a mutual acquaintance, to paint her portrait. He spent part of the summer of 1883 sketching her at the family estate in Brittany. The fact that Sargent made more studies of this

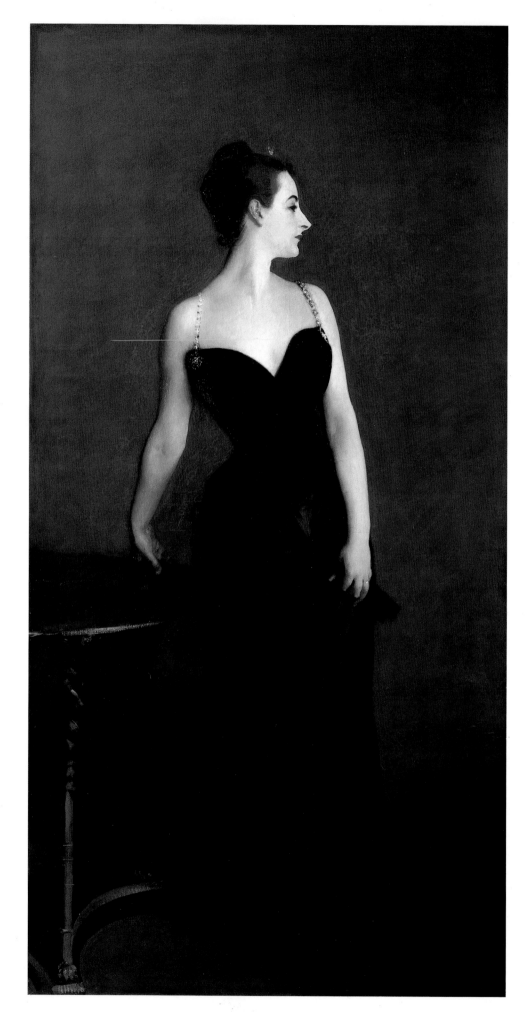

Madame Pierre Gautreau
(Madame X)

1884. Oil on canvas, 82½ x 43¼"
The Metropolitan Museum of Art, New York.
Arthur Hoppock Hearn Fund, 1916

Virginie Avegno was born in Louisiana and raised in France. She married Pierre Gautreau, a Parisian businessman with a country estate in Brittany. At fashionable occasions she affected a classical look by dressing her hair in a chignon, baring her shoulders, and making her skin white with cosmetic powder. Sargent asked to paint her, and told a mutual friend that he would create "the portrait of a great beauty." Most visitors to the Salon of 1884 dismissed it as an outlandishly defiant work that dwelled unnecessarily on the woman's vain desire to shock people with her artificially enhanced beauty. Her mother asked Sargent to withdraw the painting from the exhibition to stop the public mockery, but he refused, citing Salon regulations. When it entered a museum collection in 1916 Sargent suggested the title Madame X *out of deference to the subject.*

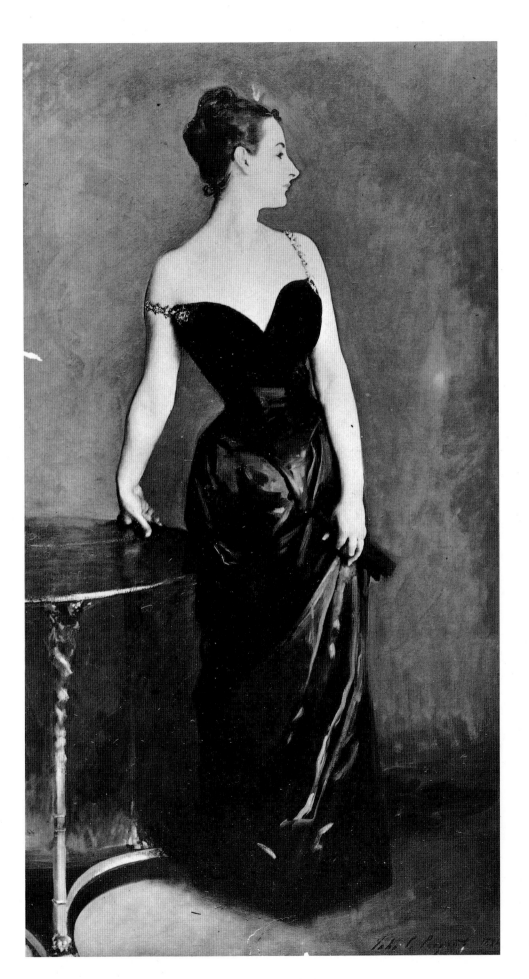

Original version of "Madame Pierre Gautreau"

Photograph, 1884.
The Metropolitan Museum of Art, New York.
Gift of Mrs. Francis Ormond, 1950.
Thomas J. Watson Library

The original version of the painting exhibited in Paris in 1884 was crucially different in that the dress was worn with one strap off the shoulder. This detail swayed Salon visitors to believe that the subject and the artist had both shown bad taste in their collaboration. A wry comment by the art critic for the newspaper Le Figaro *exemplifies the coarse and ignorant comments that greeted this portrait: "One more struggle and the lady will be free." After the exhibition closed Sargent painted out the fallen strap and added a new one in the "proper" position.*

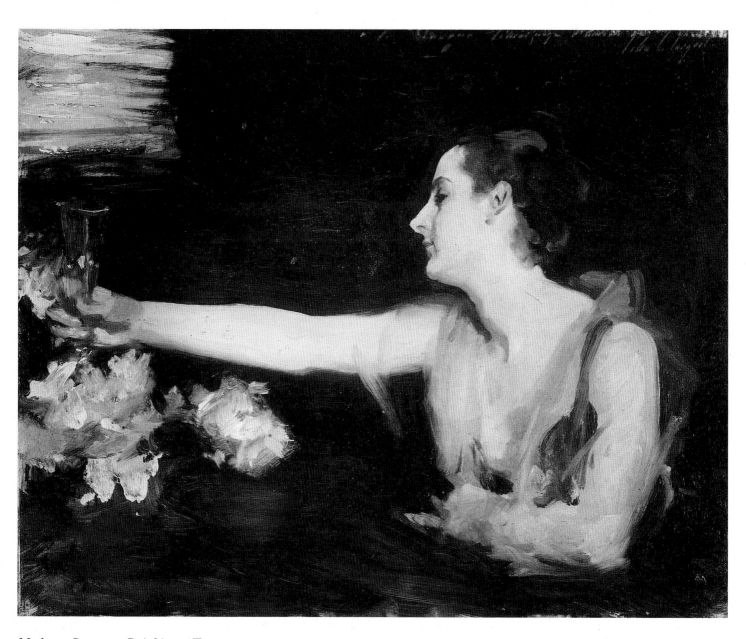

Madame Gautreau Drinking a Toast

Madame Pierre Gautreau

c. 1883. Pen and ink study, 9⅝ x 13"
Yale University Art Gallery,
New Haven, Connecticut.
Gift of Miss Emily Sargent and Mrs. Francis
Ormond (through Thomas A. Fox),
18 February 1931

The subject's cocked head obscures her coiffure in this drawing. She might be mistaken for a beautiful male youth. The shadowy, half-closed eye and the dark eyebrow add to the wistful mood of the image.

woman than of any other portrait client is an indication of his high expectations of the Salon work that they would create together.

Madame Gautreau had red-auburn hair and the transparent purplish tint of skin that can be an accompanying trait. Sargent compared her "lavender" coloration to blotting paper and potassium-chlorate tablets. He was also drawn to her "most beautiful lines." She wore tight-fitting gowns that exposed her shoulders and chest, and inspired admirers to compare her full, flawless lines to those of classical statues. He sketched her lounging, reading, and gazing out of a window; he also showed her drinking a toast. All his studies capture an indolent being. The painting that Sargent sent to the Salon had a different emphasis: the subject stands in a rather haughty pose, and her skin, with the exception of a purplish pink ear, is covered with white cosmetic powder. In this image she is an incredible idol with a compulsive need to display herself before an audience. The observations of Marie Bashkirtseff, a young painter, serve to introduce the scandalized reaction of the Parisian public: "It is a great success of curiosity; people find it atrocious. For me it is perfect painting, masterly, true. But he has done what he saw." By this she meant that Sargent had maintained his beliefs as a realist, striving for an accurate likeness that proved "horrible in daylight" because the woman's cosmetics were neither played down nor ignored. Bashkirtseff said that the chalky shoulders in the portrait had "the tone of a corpse."

Public complaint centered on the brazen manner in which the subject sported her décolleté gown. One detail in the original version of the portrait became the focus of attention: the diamond shoulder strap at the left was shown in a fallen position. The fallen strap was pulled in a taut horizontal position by the outstretched arm that steadied the willfully distracted woman. The effect was crucial on purely formal terms,

*Madame Gautreau Drinking
a Toast*

c. 1883. Oil on wood panel, 12½ x 16"
Isabella Stewart Gardner Museum, Boston

Madame Gautreau's profile shines against a darkened interior. Raising a glass in a toast, her arm stretches laxly over a sumptuous arrangement of pink flowers. The artist dedicated this painting to the sitter's mother, Madame Anatole Avegno. At a later date it was acquired by Dr. Pozzi, reputedly the sitter's lover. Mrs. Gardner purchased it at Pozzi's estate sale in 1919.

Madame Pierre Gautreau

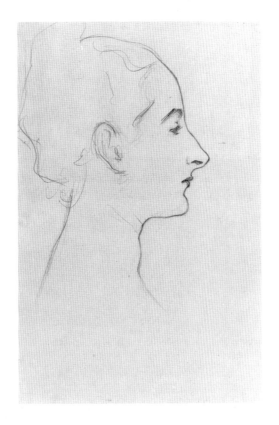

Study for "Madame Pierre Gautreau" (Madame X)

c. 1884. Graphite, 12⅝ x 8¼"
The Metropolitan Museum of Art, New York.
Gift of Mrs. Francis Ormond and
Miss Emily Sargent, 1931

One review of the Salon noted that the profiled head of Sargent's Madame Gautreau recalled the work of the fifteenth-century painter Piero della Francesca. The Renaissance aspect is stronger in this drawing than in the finished painting because the features are delineated with a delicate grace, and the face is not set so aggressively. This drawing also lacks the hair ornament, a small crescent moon of diamonds, that in the painting may be read as an attribute of Diana, the goddess of the hunt.

for its visual push towards the left counterbalanced the twist of the head and neck to the right. As crowds began to gather to mock the portrait the subject's mother begged Sargent to retire the painting from the exhibition, and he replied that Salon laws prevented this. Apparently Sargent petitioned the jury for permission to rework the painting, but was refused on the grounds that he should learn the consequences of painting such inflammatory portraits. Soon after the Salon closed he repainted the strap in an acceptable vertical position, creating the painting we know today.

When a French critic said that the fallen shoulder strap "betrayed the inviolability of the bodice" he was also hinting at the kind of challenge women like Madame Gautreau and artists like Sargent could pose to the status quo. For the ruling class this painting was a horrible vision of the sexual, financial, and political power of the burgeoning ranks of self-made people—*parvenus*—whose hastily acquired taste constituted a threat to cultural traditions. The brief, acrimonious scandal of *Madame Pierre Gautreau* came as a blow to the twenty-eight-year-old Sargent, who had never before been under attack for his moderate transgressions of conventional style and taste. He had wrongly assumed that critics would see in this work deliberate echoes of classical statues of Diana, Renaissance profile portraits, and Neoclassical cameos. He failed to anticipate their overwhelming reaction to the shock of recognizing a

Madame Pierre Gautreau

c. 1883. Watercolor and graphite on white paper,
14 x 9¾"
Courtesy of the Fogg Art Museum,
Harvard University Art Museums,
Cambridge, Massachusetts.
Bequest of Grenville L. Winthrop

During a visit to the subject's country home near Saint-Malo, Sargent wrote a friend that he was "struggling with the unpaintable beauty and hopeless laziness of Mme G." He shows her at leisure, gazing at the book in her lap. Observed against the sinuous lines of a sofa, she is an object of beauty, decorous and casual in the manner of the women painted by the French Rococo artists Watteau and Boucher. The seated pose gave Sargent the opportunity to sketch her in profile. In the final portrait her body language and profiled head convey a different message: she seems to turn away from the viewer deliberately, to flaunt her beauty.

modern phenomenon, which forced them to deal with "reality" rather than the goddesses and peerless beauties of artistic tradition. Only Louis de Fourcaud, writing in the *Gazette des Beaux-Arts,* defended the picture in terms of a serious and intellectually valuable program. He argued that Sargent's classicizing linear design had an interpretive function: it elicited a symbolic reading of the image, which he compared to a heraldic device. Sargent had created an emblem of a specific social type—"the professional beauty." The critic expressed disdain for this type, whose primary motivation was to mold her body with costumes and to alter her natural face with cosmetics in order to present herself as an idol for others. On the other hand, he defended Sargent's interest in the woman as a means of examining real life, and he insisted that the artist's achievement on purely formal grounds was both refined and significant.

Madame Pierre Gautreau was a watershed in Sargent's career. Its reception at the Salon put him in a position where he understood the power that a portrait could wield when perceived as a commentary on modern trends and values. Paul Arène predicted in *La Nouvelle Revue* that Sargent's *Madame Pierre Gautreau* would become for the Paris of 1884 what David's *Madame Récamier* was for 1800. But Sargent was not ready to take that chance. His repainting of the shoulder strap demonstrated an immediate and overwhelming desire to placate authority. He did not want to spoil his chances for continuing success and financial reward. Even so, his extraordinary trajectory since leaving the atelier of Carolus-Duran was interrupted. Portrait commissions from the French dwindled, and he entered a period of transition.

John Singer Sargent in his studio with portrait of Madame Gautreau

Photograph, c. 1883
Archives of American Art, Smithsonian Institution, Washington, D.C.
Photographs of Artists in their Paris Studios

Sargent repainted the problem shoulder strap in the unsold portrait of Madame Gautreau before being photographed with it. This alteration dissipated the sensualism of his initial statement, and symbolized his bid to put the Salon scandal behind him. The portrait remained in his possession and he did not exhibit it publicly for twenty years. The small canvas in front of Sargent is The Breakfast Room. *The large Chinese textile hanging behind him would later be used for the background of his London portrait* Lady Agnew.

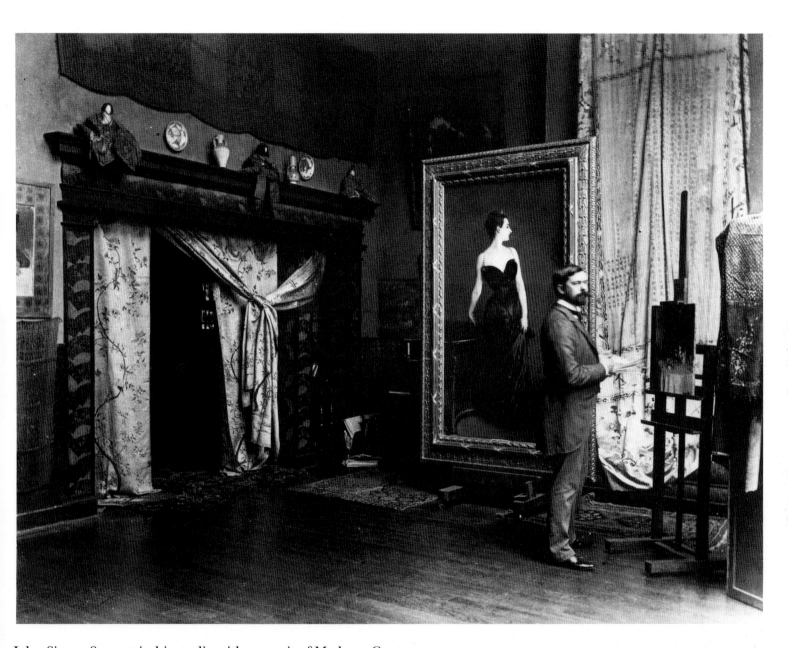

John Singer Sargent in his studio with portrait of Madame Gautreau

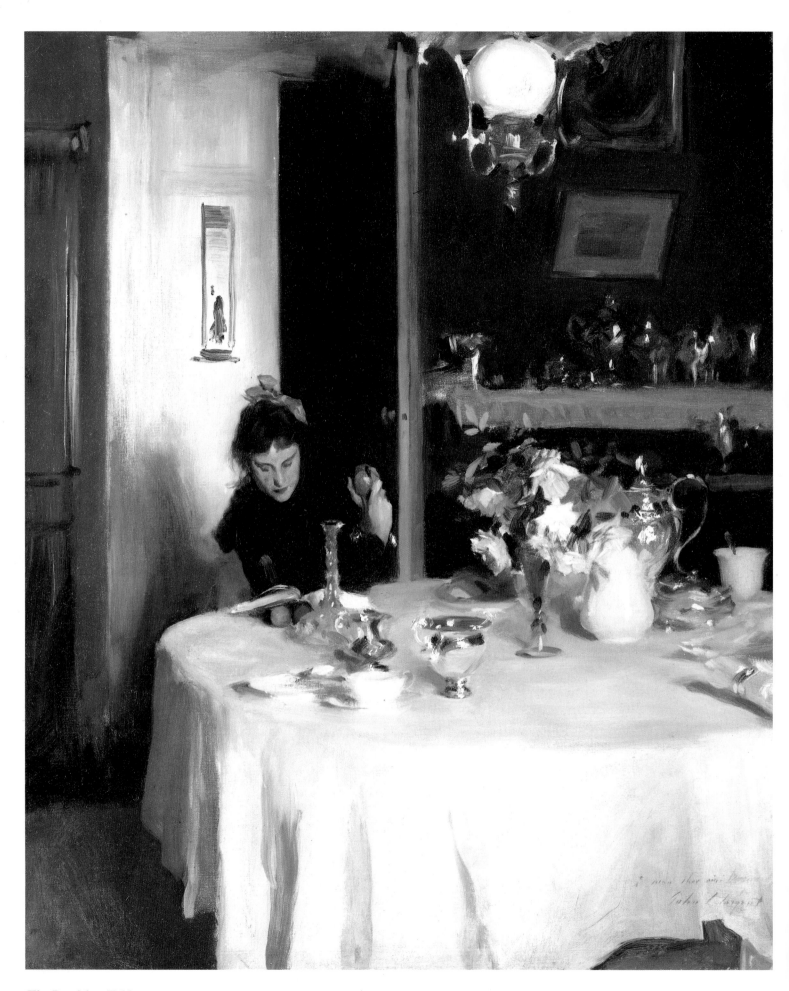

The Breakfast Table

IV. Decision and Indecision

THE PUBLIC DISAPPROVAL CAUSED BY THE *Madame Pierre Gautreau* episode stung Sargent. The extent of the personal disruption is suggested by Sargent's admission to Edmund Gosse in 1885 that he might abandon art in favor of business or music. Sargent had not clearly declared his colors to the cliquish and politicized Parisian art world. He now had to define himself and his position within the factionalized middle ground between the opposing academic and radical orthodoxies. He quit his studio in Paris in May 1886, and settled permanently in London, immediately opening a new chapter in his artistic career. The decision reflected his canny professional instinct for the best place to thrive through painting portraits for the upper classes. This chapter outlines his activities during the next five years, including his eager attempt to reinvent himself as an Impressionist, and the good fortune he enjoyed working as a portraitist in the United States.

Sargent had entered the most expansive and receptive phase of his career: he studied and experimented with a wide range of historical and contemporary art, and he strengthened the pattern of eclecticism that was the basis of his art and his formula for success. In the period 1882–84 Sargent was favorably compared to Renaissance portraitists, to the Baroque masters Velázquez, Goya, and Hals, to Japanese artists, and to his teacher Carolus-Duran. In 1883 he decorated his new living quarters on Boulevard Berthier in the English Aesthetic Style, using the wallpapers and accessories of Morris & Co. His studio decorations combined Japanese and Italian artifacts and textiles, and his own copies after Velázquez. In the 1880s his taste in music encompassed Italian and Spanish folk songs, the operas of Richard Wagner, and the chamber music of Gabriel Fauré. Sargent's art appealed to different factions of the art world for different reasons. Conservatives and academics wanted to tame the reckless streak that complicated his precocious talents, while some liberals wanted to see his "gift" develop in a direction compatible with their interests. Sargent's mixing of styles and forms exemplified the period's love of quoting and reworking diverse historical practices in the name of enlightened progress. The self-confident, optimistic credo of eclecticism and historicist imitation appealed to the civic and cultural

The Breakfast Table
1884. Oil on canvas, 21¾ x 18¼"
Courtesy of the Fogg Art Museum,
Harvard University Art Museums,
Cambridge, Massachusetts.
Bequest of Grenville L. Winthrop

This small painting of an interior is devoted to the charms and comforts of middle-class domesticity: silver, linen, and roses in an aura of tranquillity and privacy. A young woman sits alone at breakfast, apparently too engrossed in her reading to continue cutting the fruit she is holding. The subject was the artist's youngest sister Violet, and the room was probably in the house their parents rented in Nice.

leaders of the United States. Eclecticism shaped the work of the country's largest and most influential architectural office, McKim, Mead & White. In many respects, Sargent's services as an "American artist" echoed the work of these architects, who adapted the language of classicism, with its imperial and civilizing associations, to the needs of their modern national culture.

Sargent continued to exhibit at the Paris Salon after the fuss in 1884: he showed noncontroversial portraits of women there in 1885, 1886, and 1888. The Universal Exposition superseded the Salon in 1889, and Sargent served on the jury of American artists in Paris who helped a New York jury to select art for the American section of the international display of art. Six of Sargent's portraits of girls and women were included in the exhibition. *The Daughters of Edward D. Boit* and *Mrs. Henry White* were the earliest works in the group; the newest had been completed in America in 1888. Of the 189 American artists represented, only Sargent and Gari Melchers were awarded Grand Prizes by the international jury. On the occasion of the Universal Exposition the French government also gave Sargent a more prestigious national honor: he was named a Chevalier of the Legion of Honor along with four other Americans—William T. Dannat, Alexander Hamilton, Daniel Ridgway Knight, and James Abbott McNeill Whistler (who exhibited his paintings and etchings in the British section). Thus Sargent's reputation in Paris had not been destroyed by *Madame Pierre Gautreau*, nor by his move to London. After winning the French national honor the focus of his professional activities began to shift to the Anglo-American world.

When Sargent was photographed in his Paris studio with the retouched *Madame Pierre Gautreau* he chose to be working on a small, informal study of an interior, *The Breakfast Room*. This picture belonged to a new series in which he portrayed rooms and their bourgeois occupants. Typical of the group, *The Breakfast Table* depicts a woman in a setting whose ambience echoes her mood and pastime. About half of the picture is washed with pale sunlight, and the rest is in shadow. The woman engrossed in her reading and her privacy is Sargent's youngest sister Violet. She has propped up her book on a pair of oranges, and is peeling a third. Her body is viewed against an open door, whose frame opens onto a black void. To enhance the viewer's sense of privileged intrusion into the scene, the objects in the foreground plane—hanging lamp and table—are cropped by the edges of the picture. Although smaller in scale than many of Sargent's Salon works, this interior still relies on his seductive, painterly approach for its success: the quick responses of his brush vividly capture the light playing across the white tablecloth and glistening on the glass, porcelain, and silver.

The Dinner Table at Night, another example of this series, shows a well-appointed table in the lower right corner of the picture; the room is dimly lit; the head and body of a man are substantially cropped by the right side of the canvas. Painted in England in the summer of 1884, it depicts Mr. and Mrs. Albert Vickers enjoying a glass of port in their red dining room. This work and *The Breakfast Table* indicate Sargent's eagerness to approach the subject of bourgeois life in an informal manner. He surely attended most of the eight Impressionist exhibitions in Paris (1874–86), where he may have developed this new interest after seeing the interior scenes by Caillebotte, Cassatt, Degas, and Renoir. Sargent had a new desire to be associated with successful innovative artists. For example, in 1885, when he participated in a small group exhibition that also included the Impressionist Monet, he chose to exhibit *The Dinner Table at Night* and three portraits, including his painting of Rodin.

Fête Familiale: The Birthday Party combines two of Sargent's interests: the depiction of intimate domestic scenarios and the portrayal of friends and colleagues in the arts. It shows a child's birthday party in the home of Albert Besnard, another painter represented in the 1885 gallery exhibition that included Sargent and Monet. A comparison of *Fête Familiale: The Birthday Party* and *The Breakfast Table* indicates the growth of Sargent's concern for fluent handling, tightly cropped images, and faithfulness to the prevailing light. The different effects of the birthday candles, the table lamp, and the lamp in the corner of the room behind Besnard constituted a much greater challenge for Sargent than the earlier daylit scene of his sister at breakfast. At the same time, his palette has more light in it, and is less reliant on the browns and blacks that give cool restraint to *The Breakfast Table.*

The mood of relaxed diversion central to these paintings of interiors also affected Sargent's portraits of friends. He introduced cigarette smoking, still an unconventional activity in a portrait, into images of Paul Helleu, the French artist, and Robert Louis Stevenson, the Scottish writer. In *Paul Helleu* the subject dissolves in the lower left corner, and the walls and spaces behind him are sketched so summarily that they assume a lively presence as an abstract colored aura enveloping the face, hand, and cigarette. This sketch and the portrait of Stevenson both recall Edouard Manet's *Stéphane Mallarmé,* a small portrait that shows the writer casually seated with a cigar in his hand. Sargent and Manet both received second-class medals at the Salon of 1882, but it is unlikely that the senior "radical" artist of the day returned the interest of the American. Manet exhibited at the Salon once more before his death in 1883. Sargent saw *Stéphane Mallarmé* in the Manet memorial exhibition in Paris in January 1884. A month later he purchased one of Manet's oil studies for *Le*

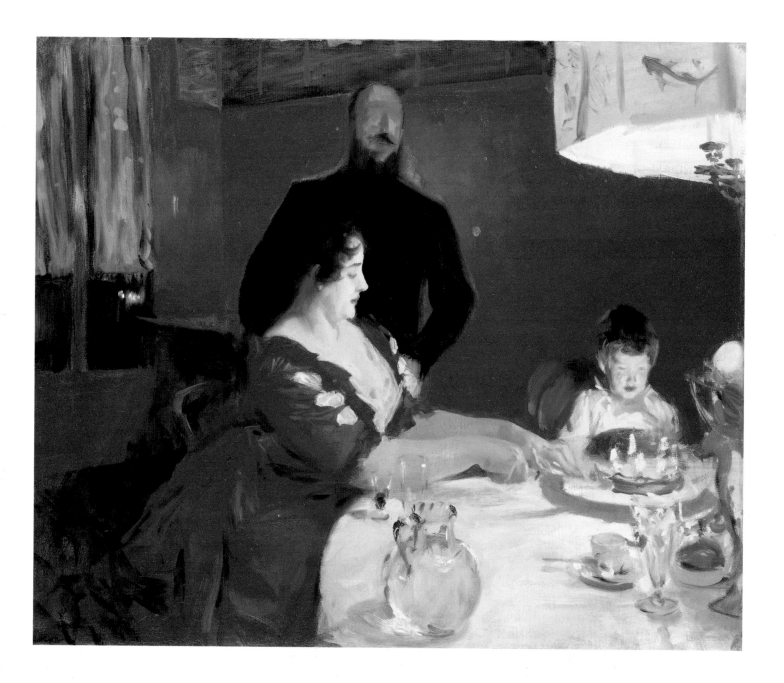

Fête Familiale: The Birthday Party

1887. Oil on canvas, 24 x 29"
The Minneapolis Institute of Arts.
The Ethel Morrison and John R.
Van Derlip Funds

The characters in this domestic nocturne are the French artist Albert Besnard, his wife, and their son, who is celebrating his birthday. Sargent's family portrait typifies his work in a relaxed and personal manner. It was too informal in finish and concept to exhibit at the Salon, where most jurors would find the father an eyeless form looming in the background. Clearly Sargent painted him as he saw him—out of focus and dimly lit. The mother's head and chest are more brilliantly lit by the overhead lamp than her arms and hands, creating an effect that is realistic, yet pictorially "unconventional."

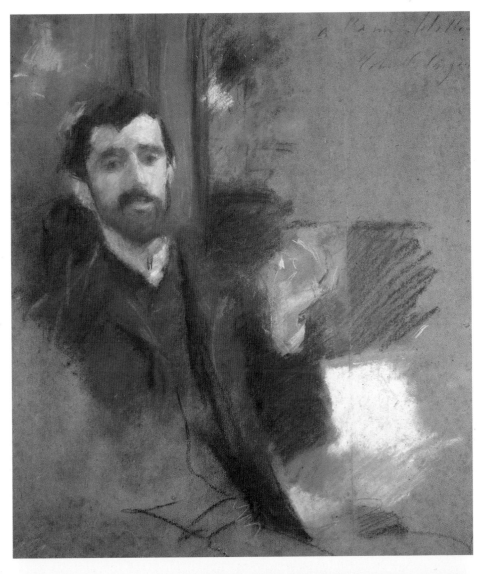

Paul Helleu

c. 1885. Pastel, 19½ x 17½"
Courtesy of the Fogg Art Museum,
Harvard University Art Museums,
Cambridge, Massachusetts.
Bequest of Mrs. Annie Swan Coburn

Helleu and Sargent met as art students in Paris in the mid-1870s. They became lifelong friends, and Sargent sketched Helleu many times. In this instance the dapper man pauses in the midst of conversation, with his mouth slightly open. The hand with the cigarette is caught in a gesture as momentary and suggestive as the quick, summary style in which the color is applied to the rough brown paper.

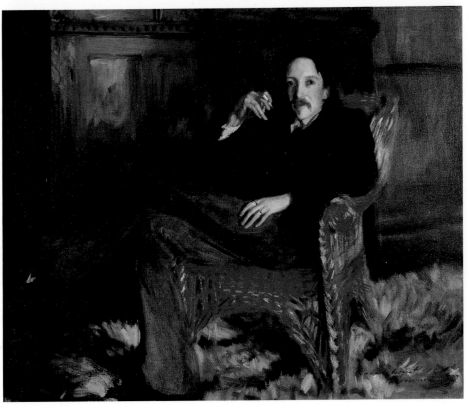

Robert Louis Stevenson

1887. Oil on canvas, 20¹/₁₆ x 24⁵/₁₆"
The Taft Museum, Cincinnati, Ohio.
Gift of Mr. and Mrs. Charles Phelps Taft

Mr. and Mrs. Charles Fairchild of Boston commissioned this portrait of the popular Scottish author. Sargent had painted Stevenson on two previous occasions, in 1884 and 1885, and he returned to Bournemouth a third time to paint him in his home. The frailness and attenuation of his subject's body were caused by consumption, which Stevenson bravely defied as a world traveler. Sunk into an orange-red wicker chair, he casts an amused, quizzical look at the viewer. His crossed legs shoot off to one side, showing the wide flair of his pants. Sargent turned Stevenson's fantastic hands into semi-autonomous creatures that reveal his eccentric persona and his non-stop smoking.

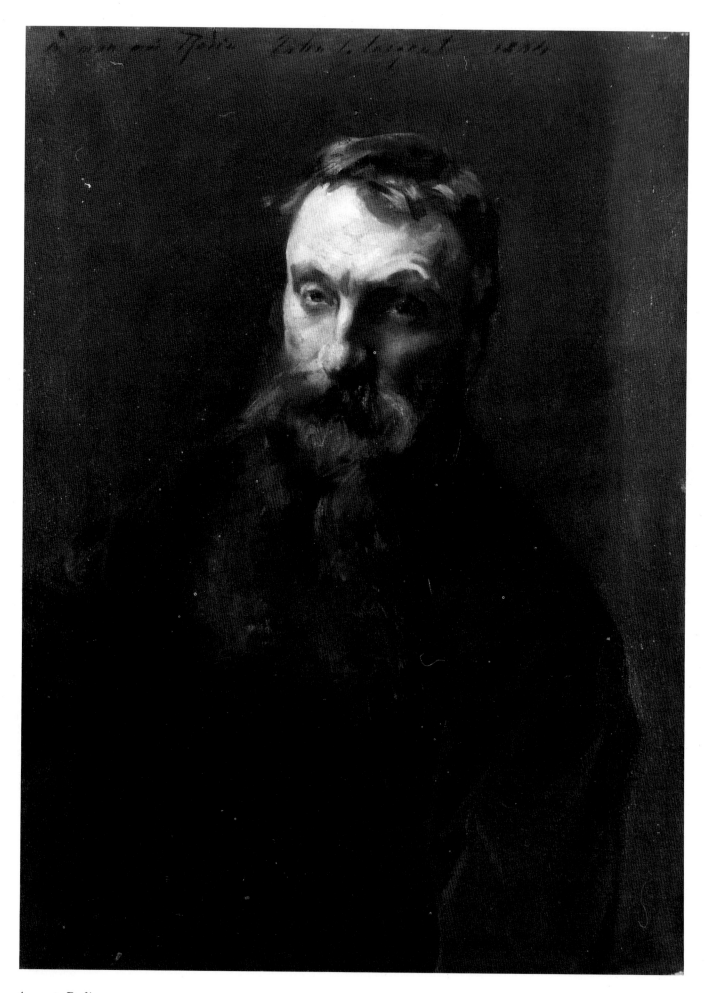

Auguste Rodin

Sargent painting outdoors

Photograph, c. 1885.
National Portrait Gallery, London.
Ormond Family Collection

*In addition to the business of portrai-
ture, Sargent maintained other artistic
interests in the 1880s, including exper-
imentation with Impressionist tech-
niques. In the second half of the decade
visits to Claude Monet at Giverny
inspired him to paint sunny outdoor set-
tings. The writer Edmund Gosse, who
observed Sargent during holidays in the
English countryside, described his activ-
ities as follows: "[He] started a new can-
vas every morning, painting for a
couple of hours at a time with the utmost
concentration. . . . He was accustomed
to emerge, carrying a large easel, to
advance a little way into the open, and
then suddenly to plant himself down
nowhere in particular, behind a barn,
opposite a wall, in the middle of a field."*

Balcon from the studio sale organized by the artist's widow. Soon after-
wards an American critic hypothesized that the "failure" of Sargent's
Madame Pierre Gautreau at the Salon was due in part to the influence of
Manet. These episodes are unrelated and yet they confirm that Sargent
had begun to explore the more unconventional subjects and techniques
associated with Manet and the Impressionists. Ironically, this conserva-
tive critic's mention of Manet was intended to give Sargent a friendly
warning not to join the "realistic cult" influenced by Manet's art.

Sargent sent his work to exhibitions in London for the first time in
1882, after becoming familiar with the city as an art center in the sum-
mer of 1881. On his second visit (March 1884) Sargent was shown
around by Henry James, who encouraged him to move there, as he had
done in 1876. They visited the studios of Edward Burne-Jones, a key fig-

Auguste Rodin

1884. Oil on canvas, 28¾ x 20⅞"
Musée Rodin, Paris

*Sargent and Rodin were invited foreign
contributors to the inaugural exhibition
of the Société des XX in Brussels, in
February 1884, the year this portrait
was painted. This event may have
brought them together, if they had not
already been introduced by their mutual
friend Paul Helleu. Sargent's portrait of
Rodin is a strong, workmanlike perfor-
mance. A reddish brown beard covers the
sculptor's mouth, neck, and chest and
flows over his black jacket. His gray eyes
and raised eyebrows convey a rather
stern detachment from the viewer.*

ure in the British Aesthetic movement, and Edwin Austin Abbey, the American artist who worked in England as an illustrator for *Harper's Magazine*. At the Royal Academy they attended an exhibition of works by the first president, Sir Joshua Reynolds, the master of late-eighteenth-century British portraiture in the grand manner. When Sargent returned to London in June 1884, it doubtless felt like an "escape" from the fiasco at the Salon, but he went to fulfill commissions received months before. He headed for Sheffield to paint three art students he had met the previous winter in Paris (*The Misses Vickers*); en route he stayed in Sussex where he painted the girls' aunt (*Mrs. Albert Vickers*). He also painted the small interior scene showing his hosts enjoying port after dinner (*The Dinner Table at Night*). And in an unexpected move he painted a large portrait of children posed informally outdoors.

Garden Study of the Vickers Children is an unfinished picture of English children watering splendid white lilies on a very healthy lawn. The entire background is a field of barely modulated green that signals Sargent's new interest in the effects of outdoor settings and light. The boy and girl are painted in essentially the same manner as the earlier Boit group, but the flattening effect of the green background and the vibrant silhouettes of the lilies strike a new note. Although this picture does not imitate the work of Monet, Sargent was beginning to turn a serious eye to the achievements of the Frenchman, whose startling plein air paintings were increasingly valued by dealers, collectors, and emerging artists. Sargent first met Monet in 1876 at the second Impressionist exhibition in Paris. In 1885 he visited Monet at Giverny as an enthusiastic fan, and sketched him as he worked on a painting of a haystack in a meadow. A friendship developed, and Sargent purchased two recent paintings from Monet in 1887, and two through dealers in 1889 and 1891.

During the summers of 1885 through 1889 Sargent stayed in various parts of the English countryside bordering the Thames and the Avon rivers, and experimented with plein air painting. He tried his own versions of Monet's flickering and broken brushstrokes, and applied his already keen perception of tonal values (learned from Carolus-Duran) to the more extreme and brilliant chromatic effects encountered outdoors. At this time Sargent told Edmund Gosse that "the artist ought to know nothing about the nature of the object before him, [and] should concentrate all his powers on the representation of its appearance." He argued that Impressionism was based on optical and retinal phenomena that anyone could learn to analyze. Thus Impressionism appealed to him as a refinement of the tonal method of painting he had learned in Paris; typically, he made no comment about the role of Impressionist technique in interpreting subject matter and content. In reality it was most useful

Garden Study of the Vickers Children

1884. Oil on canvas, 53½ x 35½"
Flint Institute of Art, Flint, Michigan.
Gift of the Viola E. Bray Charitable Trust

Soon after his "scandal" at the Paris Salon of 1884 Sargent visited England, where he had a commission to paint Mrs. Albert Vickers, the mother of these children. They lived in the countryside near Petworth, in Sussex. In her full-length portrait the mother holds a large water lily at her side. The floral motif continues in this large sketch showing her children watering potted lilies. The bold shapes of the flowers against the flat green background establish a decorative quality in keeping with the fashionable ideals of the Aesthetic Movement. The refined and wholesome children recall the type favored by the contemporary British illustrator Kate Greenaway.

DECISION AND INDECISION

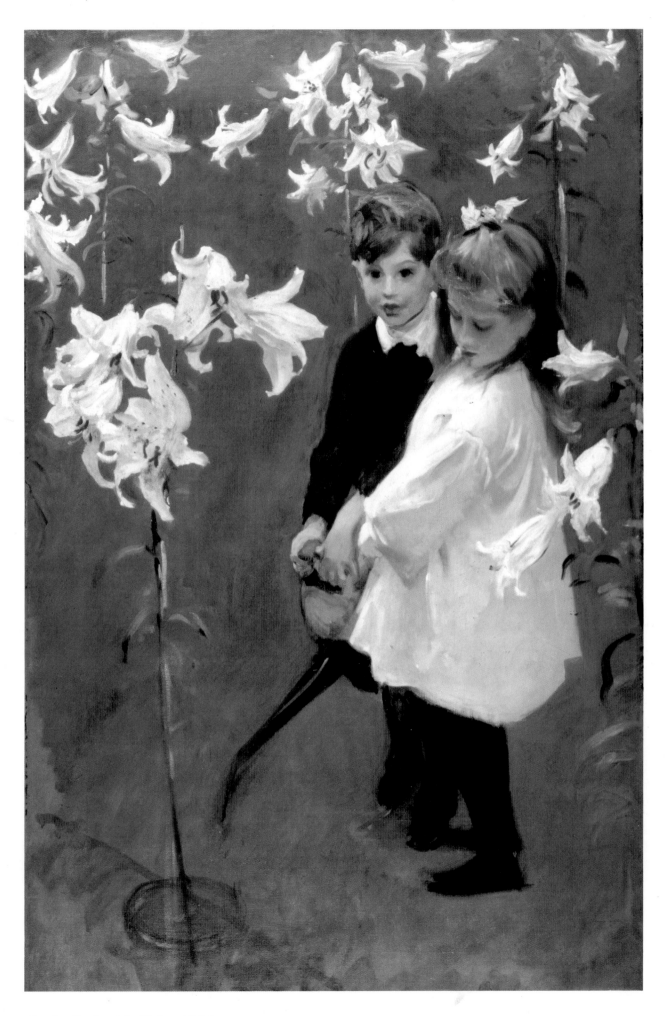

Garden Study of the Vickers Children

Study of Dorothy Barnard for "Carnation, Lily, Lily, Rose"

1885–86. Graphite, 9¾ x 8¼"
The Tate Gallery, London.
Bequest of Miss D. Barnard, 1949

The daughters of the British illustrator Frederick Barnard were the models for Sargent's large garden picture. This drawing and the painting were illustrated in the first extensive essay on Sargent in a British magazine (The Art Journal, March 1888).

Carnation, Lily, Lily, Rose

1885–86. Oil on canvas, 68½ x 60½"
The Tate Gallery, London

Sargent painted this large exhibition piece in the village of Broadway, in Worcestershire. He was part of an informal summer colony that included American artists Edwin Austin Abbey and Frank Millet, and American writers Lawrence Hutton and Henry James. He worked just after sunset recording an effect that lasted for about twenty minutes each evening. He wanted to show the warm glow of candlelight shining against the dim purplish light of summer twilight. Sargent wrote to Robert Louis Stevenson that he was trying to capture "a most paradisiac sight [that] makes one rave with pleasure." The title he chose is a line from a song by Joseph Mazzinghi that was popular in 1885.

to him as a license to extend his penchant for the "curious" into the realm of color; for example, he had an urge to paint Gosse when he saw that the blue sky reflected in his light brown hair created a "lovely lilac" effect.

Sargent's *Carnation, Lily, Lily, Rose* was a triumph at the Royal Academy in 1887. He began the picture in England in 1885 and worked on it there for two consecutive summers. In retrospect it is clear that his withdrawal from Paris in 1886, the year he completed this work, was propelled by the belief that he was creating the vehicle for a British success. In this large painting the artist evokes the chromatic subtleties of twilight, focusing on a brief magical period when yellow candlelight just outshines the flagging purplish daylight. This program would surely have interested Monet, but the finished painting makes a bold overture to British Aestheticism, and barely displays the maker's emergent infatuation with French Impressionism. It represents two pretty English girls in white smocks lighting paper lanterns that have been strung up between rose bushes; they are posed in a swirling sea of carnations in front of tall white Japanese lilies. The children have a bold presence antithetical to the luminous shimmering forms of the French Impressionists. Instead of the harmonious unity of surface generally found in Monet's work, Sargent indulges in literal effects that have a noisy illusionistic effect (consider, for example, the way different strokes are used to mimic differently shaped leaves). The painting is much larger than a typical Impressionist canvas of the day. Like the artist himself, *Carnation, Lily, Lily, Rose* is neither British nor French: it is a knowingly independent statement, and a stunning performance. Despite the cranky conservative who named Sargent "the arch-apostle of the dab and spot school," British critics were generally entranced by its poetic and sentimental beauty. The painting was purchased from the exhibition for the British national collection; the funds came from the Chantrey Bequest, and it was quickly pointed out in the press that this was "an exceptional honor for Burlington House to confer upon a foreigner."

After this success, it was not difficult for Sargent to win a reputation as a preeminent "British Impressionist." His works that come closest in scale, execution, and concept to those of Monet were painted in the summers of 1888 and 1889. He featured two examples at the fourth annual exhibition of the New English Art Club, in London in 1889. Formed in 1886 by artists interested in modern French work, this club was an alternative to the official Royal Academy exhibitions that controlled the mainstream of British art. Sargent showed two paintings of young women in white summer dresses in brilliant sunshine—a stereotypical Impressionist subject. Sargent and Wilson Steer were singled out as the

DECISION AND INDECISION

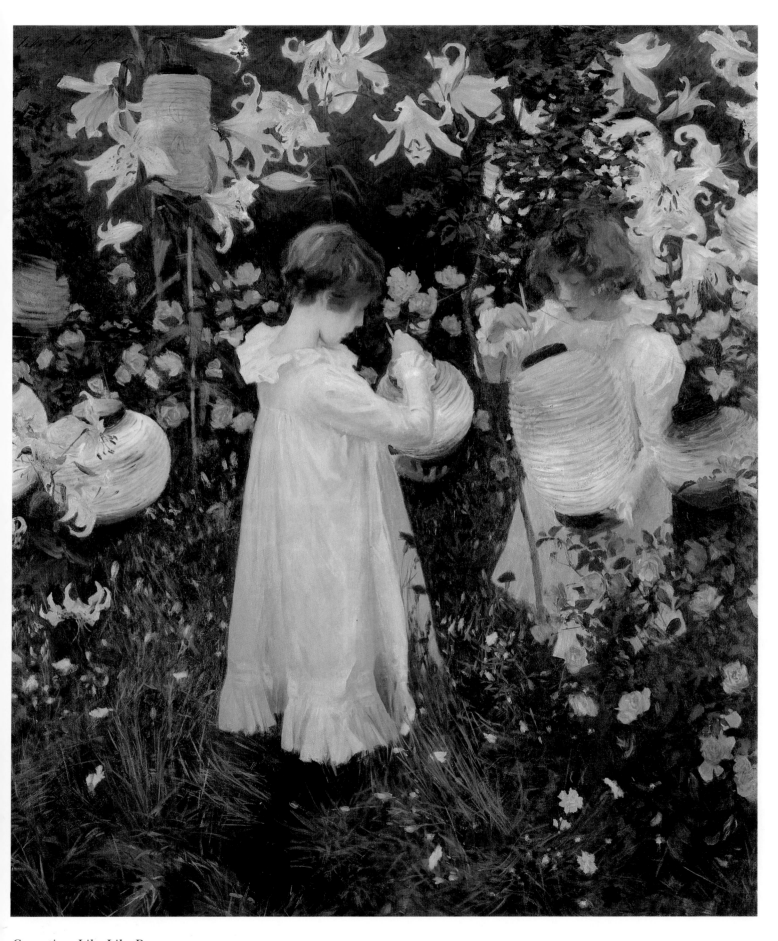

Carnation, Lily, Lily, Rose

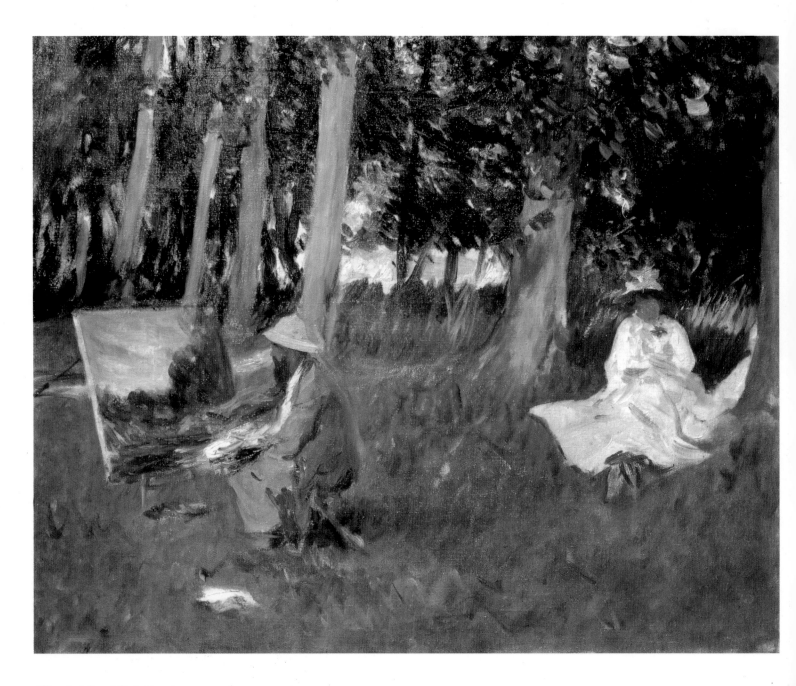

Claude Monet Painting in a
Meadow near Giverny

1885. Oil on canvas, 21¼ x 25½"
The Tate Gallery, London.
Presented by Miss Emily Sargent and
Mrs. Ormond through the National
Art-Collections Fund, 1925

By the mid-1880s Sargent was drawn to
the chromatic and painterly experiments
of Monet, who was his senior by sixteen
years. In 1885 he had the opportunity
to paint Monet at work, accompanied by
his new wife. The canvas that Monet
was working on during Sargent's visit

is recognizable as Meadow with Hay-
stacks near Giverny *(1885, Museum*
of Fine Arts, Boston). Sargent also
painted a small portrait of Monet's head
in profile; he presented it to the National
Academy of Design, New York, when he
was elected an Academician in 1897.

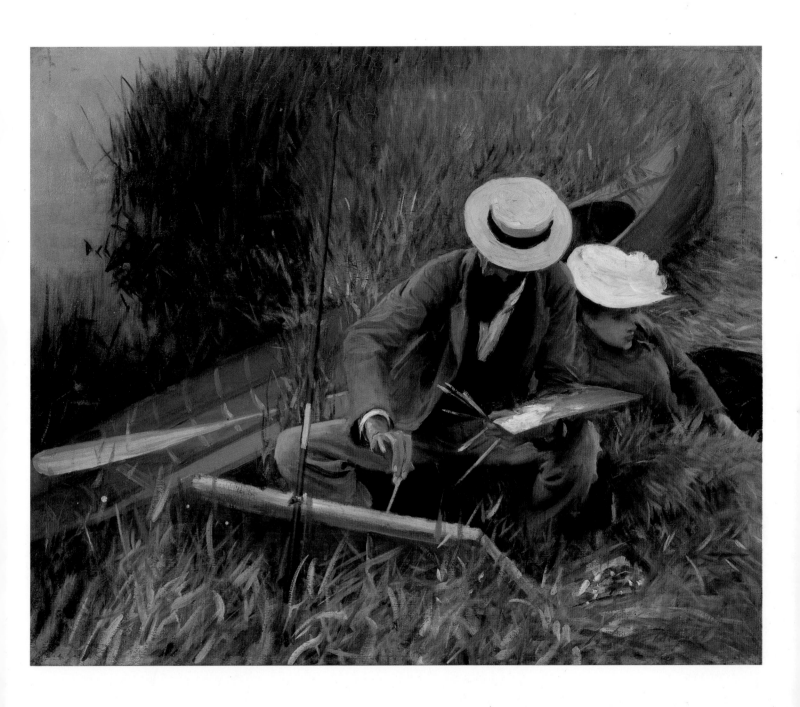

Paul Helleu Sketching with His Wife

1889. Oil on canvas, 26⅛ x 32⅛"
The Brooklyn Museum, New York.
Museum Collection Fund

Paul Helleu and his young wife visited Sargent in Fladbury. They posed for him beside the River Avon. The husband dominates the composition. Sargent showed his old friend at work on a canvas, with his wife seated behind him. In 1890 Sargent brought this painting and two other Impressionist-inspired works with him to America to present his most progressive work in certain exhibitions. This underscored his commitment to modern art and ensured that he was not (yet) pigeonholed as a conventional portrait painter.

most successful followers of Monet, but it was rightly noted in the press that they differed from him when they drew the figure. The weight of Sargent's academic education, and perhaps a personal bias, forced him to make the figure the solid focus of visual attention, as in *Carnation, Lily, Lily, Rose*. The integrity of the figure is readily apparent in the two 1889 Impressionist works, *A Boating Party* and *Paul Helleu Sketching with His Wife*.

Relocation to London conveniently postponed Sargent's dilemma concerning progressive practices, for British artists lagged behind the French with regard to the issues that interested Sargent. When Monet saw the two plein air paintings that Sargent exhibited in London in 1889 he called them imitations of his work. The belated acceptance of French Impressionist art by the British gave Sargent a modish local reputation as a disciple of Monet. A fundamental difference between Sargent and the French Impressionists was acknowledged by both Camille Pissarro and Monet. Pissarro wrote his son about Sargent in 1891: "As for his painting, that, of course, we can't approve of; he is not an enthusiast [of Impressionism] but rather an adroit performer." In 1926 Monet told Sargent's biographer Evan Charteris: "He was not an Impressionist in the sense that we use the word, he was too much under the influence of Carolus-Duran."

America was Sargent's symbolic homeland. For that reason his first working trip to the United States in 1887–88 was even more significant for Sargent's future than his timely embrace of Impressionism. Looking back on his first professional visit, Sargent later confessed that it was "a turning point in my fortunes." *Harper's Monthly* published an essay on Sargent by Henry James in October 1887, coinciding with the artist's arrival. James presented his friend as a brilliant professional, who at thirty-one had been a major talent for almost a decade. He characterized him as an Impressionist, but he was not referring to avant-garde French painting. In fact the American writer made no mention of Sargent's recent interests in Manet and Monet. For James an Impressionist was an artist of any period whose broad application of paint was a process of simplification that gave a fresh and intellectually stimulating visual impression. In his estimation, "Sargent simplifies with style, and his impression in most cases is magnificent." He argued that Sargent's fluent command of "the language of painting" went beyond the comprehension of the profane public audience; their "short-lived gibes" were inconsequential compared to the genuine service provided by Sargent's impressions of his sitters. Perhaps James' insistence on the highbrow qualities of Sargent's art helped him to become the darling of Boston's artistic elite in 1887–88. The artist's New England pedigree, his French experi-

A Boating Party

1889. Oil on canvas, 34 x 36"
Museum of Art, Rhode Island School
of Design, Providence.
Gift of Mrs. Houghton P. Metcalf in memory
of her husband Houghton P. Metcalf

In the summer of 1889 Sargent rented the rectory house in Fladbury, a village in the Cotswolds south of Stratford-on-Avon. The house and its terraced lawns can be seen in this painting behind the trees along the riverbank. Guests assemble in punts and canoes for a trip on the river. The boats and figures in the foreground have more substance than the landscape behind them, which is largely rendered through irregular dabs and strokes of the brush. Sargent never exhibited this painting.

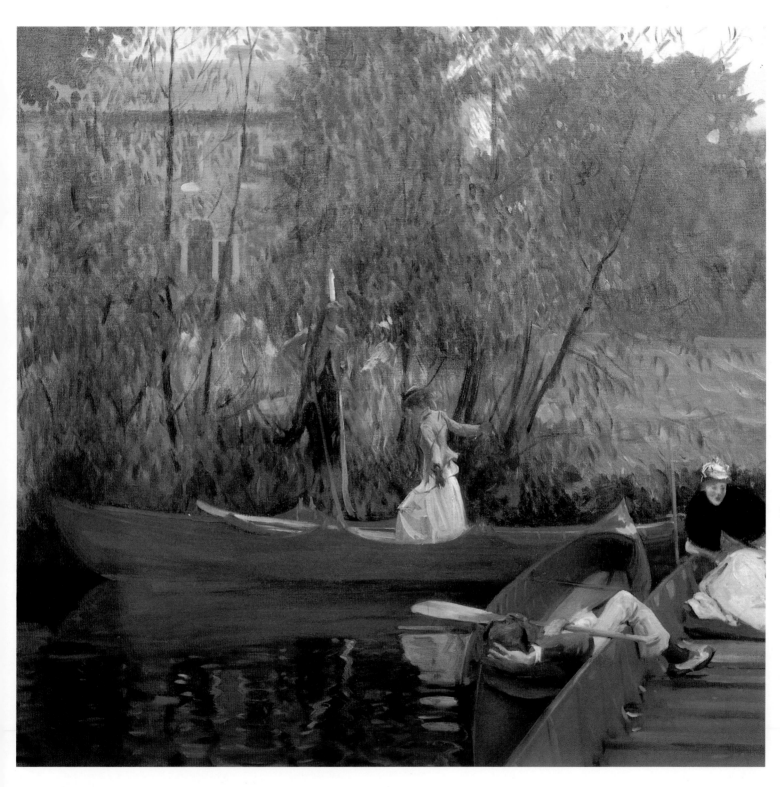

A Boating Party

Isabella Stewart Gardner

1888. Oil on canvas, 74¾ x 32"
Isabella Stewart Gardner Museum, Boston

Sargent's first visit to the United States as a professional portraitist (1887–88) was fueled in part by a commission to paint Mrs. John Lowell Gardner, a lively patron of the arts in Boston. He presented her as an idol, tightly clad in black, with the train of her dress carefully hidden behind her. Symmetrical and statuesque, she stands before an Italian fifteenth-century textile. In 1895 the French writer Paul Bourget described Mrs. Gardner as the ultimate American product, "a living work of art," and read in Sargent's image a symbolic expression of the American ideal: "Faith in the human Will, absolute, unique, systematic, and indomitable."

Mrs. Adrian Iselin

1888. Oil on canvas, 60½ x 36⅝"
National Gallery of Art, Washington, D.C.
Gift of Ernest Iselin

The subject, the wife of a Swiss-American businessman, posed for Sargent in New York. The only prop in her portrait is the small French neo-classical table used by the sixty-four-year-old lady to steady herself. The hand on the table became a telling detail in Sargent's portrayal: it illustrates her mature years, expresses her refinement, and hints at a resolute and tenacious character. Further clues to her personality come from her standing pose and somewhat nervous reserve. Sargent usually showed older women sitting at ease, with a smile of contentment and a more conventional air of vulnerability.

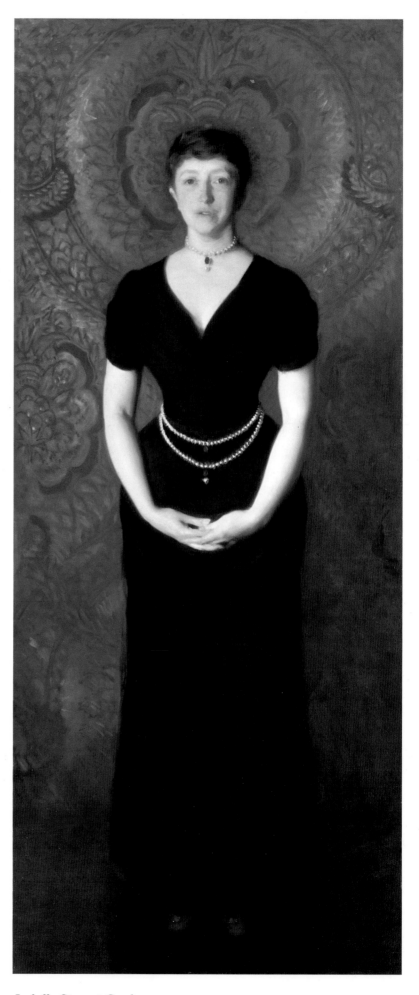

Isabella Stewart Gardner

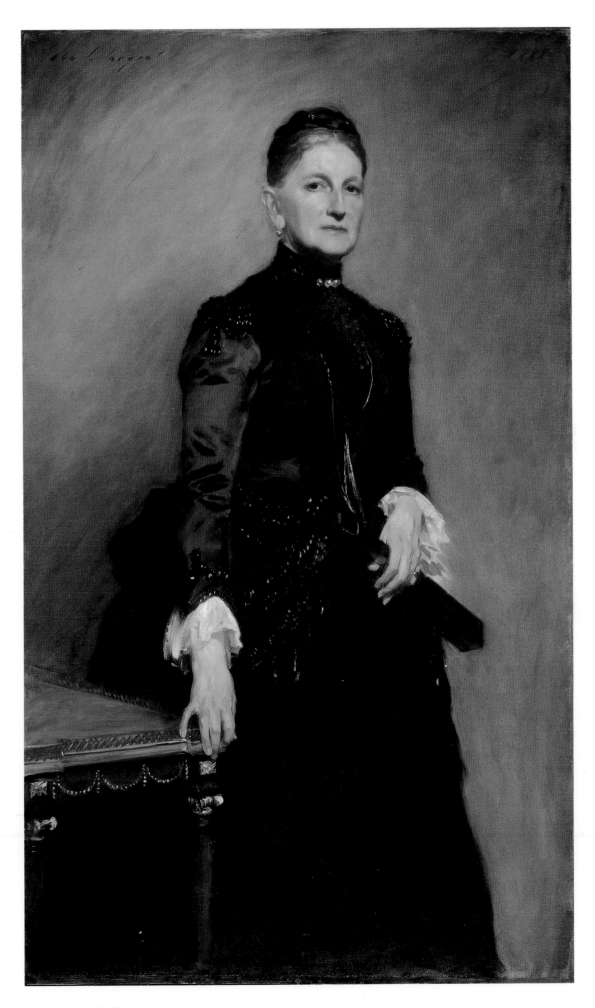

Mrs. Adrian Iselin

ence, and his home in London all conspired to make Sargent attractive to Boston's Wasp aristocracy. He painted members of the Fairchild, Forbes, Gardner, Inches, and Sears families, and the St. Botolph Club (a private social organization) honored him with his first solo exhibition at their clubhouse in the Back Bay. The twenty-two works on display included *El Jaleo: Danse des Gitanes, The Daughters of Edward D. Boit, Robert Louis Stevenson*, several of the portraits he had just completed, and three Venetian genre pictures. The Brahmin daily, the *Boston Transcript*, wrote that no one had ever displayed such a stylish collection of paintings in Boston before; nothing was commonplace or conventional, and the paintings had "the presence of real people whose appearance vouches for their excellent breeding and antecedents."

The most notorious work on display was the portrait of Mrs. John Lowell Gardner, Boston's maverick art collector who loved both the fine and the decorative arts, ancient and modern. Sargent pictured the forty-seven-year-old woman in a tight, décolleté black dress enshrined like an idol before a sumptuous fabric. Mr. Gardner was apparently less pleased about the portrait than his wife; it drew such mixed comments at its Boston debut that it was never lent again to public exhibitions, despite the artist's requests. Reviewing the Sargent exhibition, the local correspondent for *The Art Amateur* noted with amusement that "The first impression of many a well-bred Boston lady was that she had fallen into the brilliant but doubtful society one becomes familiar with in Paris and Rome." The "audacious, reckless, and unconventional" style and spirit of the artist and his exhibition were welcomed as a shock to Bostonian stuffiness and mediocrity. Already the historically important city of Boston had the reputation of a high-minded and narrow center, especially compared to New York's flashy cosmopolitanism.

Having painted portraits in Newport and Boston, Sargent moved on to New York, where his major patrons were the Vanderbilts. He painted the matriarch, Mrs. William H. Vanderbilt, for her youngest son George. He also painted George's sister, Mrs. Elliott Shepard. Sargent had planned to spend eight weeks in America, but he stayed for eight months and painted over twenty portraits, ten of them three-quarters and full-length pictures. Since he was paid three thousand dollars for the portrait of Mrs. Gardner, the trip was a grand financial success. Moreover, he had by no means exhausted American interest in his portraits: after only nineteen months in Europe, he would set sail again for America in December 1889.

Reapers Resting in a Wheatfield
c. 1888. Oil on canvas, 28 x 36"
The Metropolitan Museum of Art, New York.
Gift of Mrs. Francis Ormond, 1950

The reductive structure of this composition, in particular the "empty" foreground that accounts for half of the image, is a reflection of Sargent's interest in recent Impressionist landscapes. The palette, brushstrokes, and rural setting recall Monet's work of the early 1880s. This late summer English painting remained in Sargent's collection, and apparently he never included it in an exhibition.

DECISION AND INDECISION

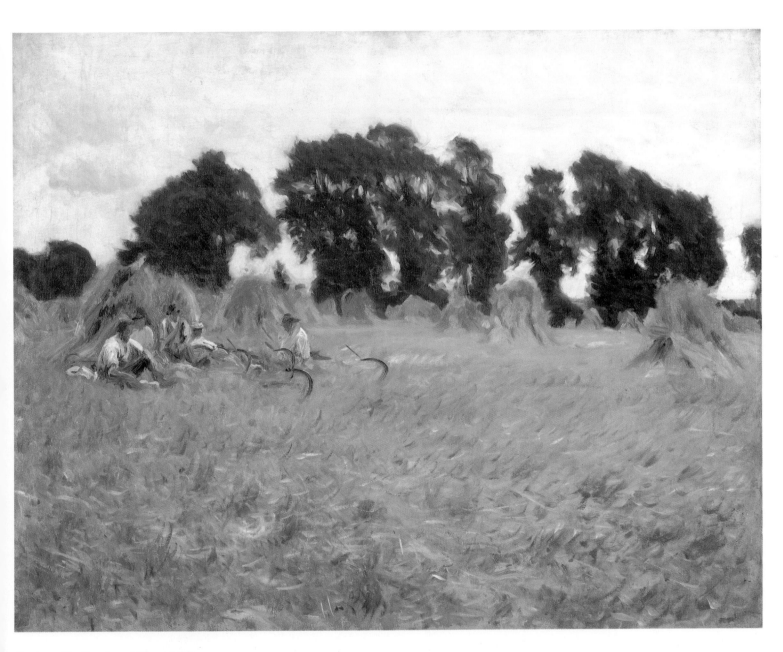

Reapers Resting in a Wheatfield

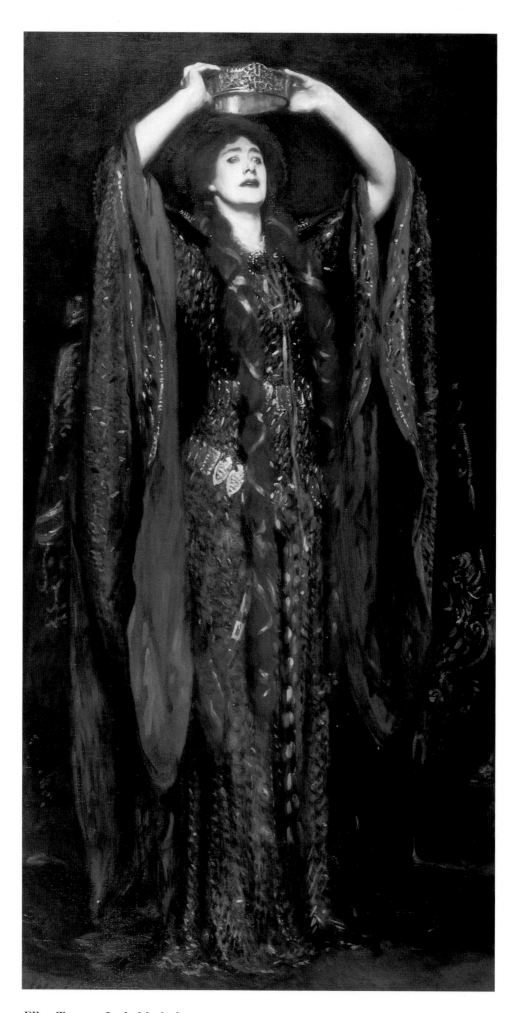

Ellen Terry as Lady Macbeth

V. International Success in the 1890s

THIS CHAPTER EXAMINES SARGENT'S FAME AT ITS APEX, and the manner in which it affected him. The discussion begins and ends with portraiture, his primary source of income, and turns midway to the first section of the mural decorations installed in the Boston Public Library in 1895. This commission was crucial in signaling that Sargent's abilities and aspirations were not devoted to, or limited by, the lucrative business of portraiture. In the course of the decade he was honored by two premier artists' institutions: both the Royal Academy, London, founded in 1768, and the National Academy of Design, New York, founded in 1825, elected him to associate and then full membership. Further recognition came through numerous articles about him and his work in art journals and popular magazines.

Viewers came to appreciate that Sargent sought to modernize portraiture by showing the most obvious, and hence most revealing, details of personal appearance. In 1899 a critic marveled that the faces in Sargent's portraits often seemed to "presage" the abundant "perplexities and anxieties [that] loom up before the contemporary man and woman." Sargent was even credited with the ability to make an individual's personal traits appear to be subtly emblematic of the moods, affectations, and traits prevailing in the culture at large. More conscious of his reputation for eccentricity in both technique and treatment of the sitter, he now moderated these qualities and tailored them to his advantage. A sense of Sargent's energy and new authority is suggested by the total of twenty-four portraits that he showed at the five Royal Academy exhibitions in just five years (1895–99).

People usually sat for Sargent at his Tite Street studio where he had a battery of props at his disposal—chairs, side tables, fabrics, folding screens, and a section of carved paneling from a Rococo interior. He reviewed the subject's own wardrobe, preferring people not to purchase something special for the portrait. He occasionally visited the residence to consider the room where the portrait would hang. He told men to plan for a minimum of eight sittings, and women ten. It was paramount for him to complete the foundation for the face in one sitting; when he was not satisfied he scraped everything away and started over. Once the

Ellen Terry as Lady Macbeth
1889. Oil on canvas, 87 x 45"
The Tate Gallery, London

Thrilled by her performance in Henry Irving's new production of Macbeth *at the Lyceum Theatre, Sargent decided to paint the leading lady crowning herself Queen. His picture skirts the tragic passions articulated by Shakespeare, and is ultimately a showcase for the actress and the costume designed by the artist's friend, Mrs. Comyns Carr. Bedecked with Celtic-style accessories, Terry's tightly sheathed body is enveloped by the folds of her flowing sleeves and massive cape. Celtic motifs also decorate the carved frame. Irving purchased the portrait to hang in the Lyceum Theatre.*

La Carmencita Dancing
1890. Graphite, 9¾ x 6⅞"
Private Collection

This rapid sketch shows a degree of abstraction that is extreme for Sargent. Here he captures what the New York press called the "torsal shivers and upheavals" of Carmencita's dancing. Her upper body is bent back as far as it can go, so that her head is almost upside down. Her dress is indicated by just four lines. In the lower left one foot protrudes from her skirt. The drawing was part of a sketchbook Sargent used in America in 1890.

painting was completed Sargent selected a frame, either adapting an antique one or giving a precise description for a new one. Doubling his prices of the previous decade, by the late 1890s he charged one thousand guineas or five thousand dollars for a full-length portrait (a value of about eighty-six thousand dollars in 1993). Many Americans traveled to London to sit for Sargent, incurring travel expenses and paying import duty when their portrait was shipped home; however, they did not have to risk the wait or disappointment of finding the artist overbooked on his infrequent and hectic visits to the United States. As the demand for Sargent's portraits skyrocketed, he learned the pressures of both the business and the clients, and as early as 1896 he made his first unsuccessful threat to paint "no more portraits" once existing orders had been fulfilled.

Sargent's first big successes of the decade were non-commissioned portraits of women: full-blown costume pieces inspired by the stage performances of the British actress Ellen Terry, and the Spanish dancer Carmencita. One played the murderous villain Lady Macbeth, the other danced the sensual flamenco. Sargent made of both an inseparable combination of magnificence and danger, the dual association that often structured his images of powerful women. The performances he depicted were lavish examples of the modern urge to recreate the historically remote and the ethnically exotic as entertaining diversions for urban audiences. Such spectacles were often represented in art exhibitions and magazines, and they were featured as "live" performances in theaters, music halls, and world's fairs. A new production of *Macbeth* in London inspired *Ellen Terry as Lady Macbeth*, but Terry's pose was not one that she used in her stage performance. Sargent probably suggested the self-coronation device. The theatricality of an almighty woman with raised arms and swathed in yards of fabric recalls his genre piece *Fumée d'Ambre Gris*. The conjunction of female power and sumptuous ritual also recalls his recent *Isabella Stewart Gardner*. Sargent raved about Terry's magnificence on stage, and, as he wrote Mrs. Gardner, he was determined to exploit the pictorial potential of the costume's "magenta hair." Sargent's palette played up the notion of "barbaric" splendor—peacock blue, purple, ruby, green, gold, and the deep orange-red of the knee-length braids. His flickering brushwork suggested the dazzle of the elaborately embroidered costume. After the portrait's debut in London in 1889, it was shown in the Paris Salon of 1890, and at the Chicago World's Fair in 1893. The American critic William Walton praised Sargent's courage in exploring the effects of the make-up and the staged attitude of fierceness and pride: "It is a portrait and a drama, both at once."

Walton's words apply equally to *La Carmencita*, which Sargent painted

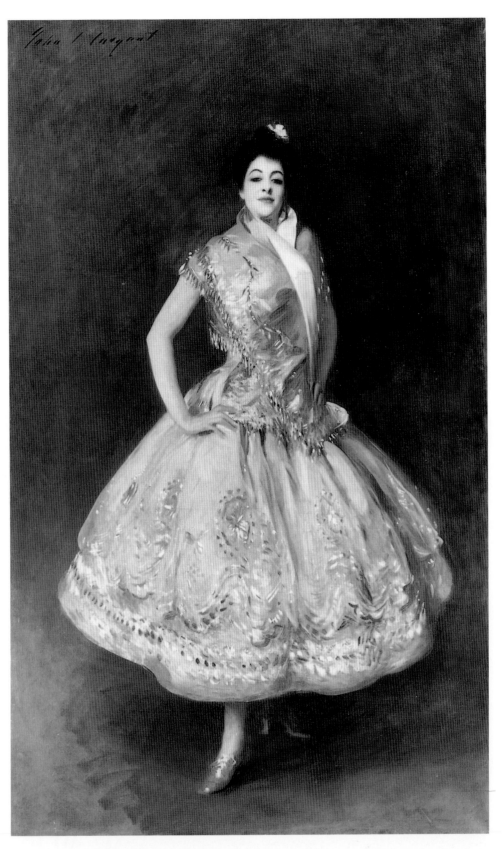

La Carmencita

1890. Oil on canvas, 90 x 54¼"
Musée d'Orsay, Paris

Carmencita was a popular Spanish dancer who toured internationally in the 1880s. When Sargent was in America in 1890, on his second portrait-painting tour, she was in New York giving highly successful public and private performances. The painting was hung in the place of honor at the annual exhibition of the Society of American Artists in the spring of 1890. New York critics found La Carmencita *"amazingly clever," but they had reservations about the drawing, the proportions, and the "high key" of Sargent's palette. In 1892 it was purchased by the French government for the Musée du Luxembourg, the modern art collection of Paris.*

and exhibited in New York in 1890: it is a portrait of the dancer in costume, who, with her head tossed back, may be assuming a pose to begin a performance. This latest pastiche of Velázquez echoed the Spaniard's use of a bold figure towering against a dark ambiguous background, and

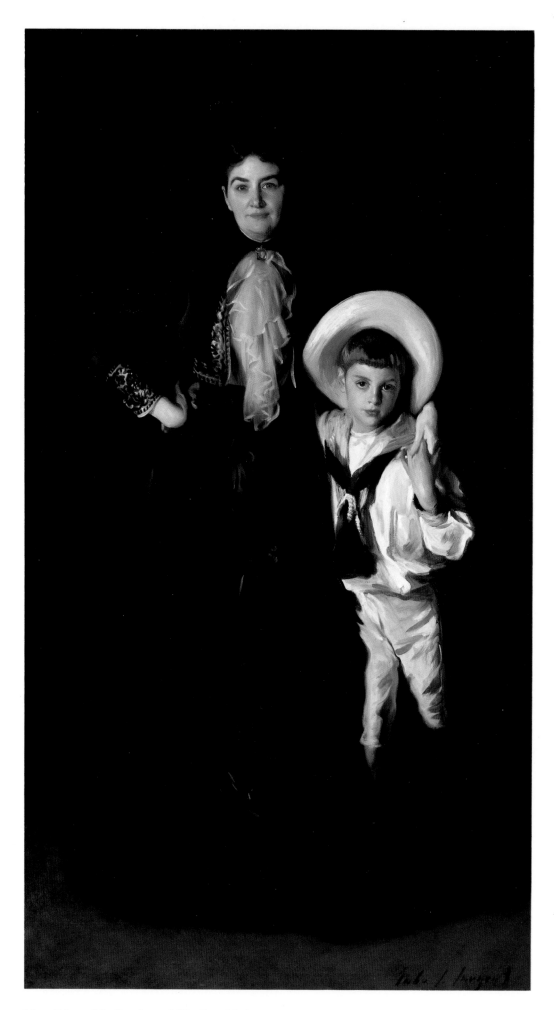

Mrs. Edward L. Davis and Her Son Livingston

a dashing overlay of flecked and spotted impasto to render the surface of an opulent fabric. After its debut in New York the picture was exhibited in Chicago, London, and Paris. Generally critics were divided along now familiar lines: many found it to be modern and intensely realistic ("a certain fiery essence of truth and vitality"), while others complained of a "barbarous" lack of finish ("God help those young painters who regard this painter as a sort of modern Velázquez"). At the close of the Salon of 1892 it was acquired by the Musée du Luxembourg, the national museum of modern art in Paris. Three years earlier Sargent had contributed funds to a subscription organized by Monet to purchase Manet's *Olympia*, a controversial representation of a naked prostitute, for the same museum. In 1891 the Luxembourg chose to represent the American artist Whistler by purchasing his *Arrangement in Grey and Black: Portrait of the Painter's Mother*. It is one of the ironies of their very different careers that Whistler was officially represented in Paris relatively late in life by a highly acclaimed painting from 1871, while Sargent was honored in his mid-thirties with the purchase of a new work. Sargent eventually regretted the sale, for he considered *La Carmencita* "little more than a sketch."

The non-commissioned portraits of Ellen Terry and Carmencita were made as showpieces for Sargent's credo as a modern portraitist—a summary fixing of all that was striking, a momentary impression of an exterior, the illusion of an active, "speaking" likeness using a rapid, animated technique. It is telling that he used an actress and a dancer for these signature works—people who move and pose professionally. To secure a handsome living he had to accommodate these still-controversial concerns into paintings that would please wealthy clients. Two unqualified victories that turned the tide of public opinion were *Mrs. Edward L. Davis and Her Son Livingston*, completed in Worcester, Massachusetts, in 1890, and *Lady Agnew of Lochnaw*, painted in London in 1892–93. Both infuse fundamentally popular imagery—a mother with an adorable child, and an enchanting, rich young woman—with calm and tenderness. They are compelling, almost life-size images of modern people, fashionably dressed, and behaving as one might imagine them in their homes. Lacking any detail or effect that critics could deride as odd, impolite, brazen, or slapdash, these pictures were total successes in exhibitions. When *Mrs. Edward L. Davis and Her Son Livingston* appeared at the Chicago World's Fair the American artist and critic William A. Coffin wrote in *The Nation*, "I doubt whether [Sargent] has done anything better than this. No other living painter has painted a portrait any finer, in a technical sense, and none has excelled it in general quality of style and that grand air that so distinguishes the work of the masters." Concurrently, the British editor of *The Magazine of Art* selected *Lady*

Mrs. Edward L. Davis and Her Son Livingston

1890. Oil on canvas, 86 x 48"
Los Angeles County Museum of Art.
Frances and Armand Hammer Purchase Fund

In June 1890 Sargent traveled to Worcester, Massachusetts, to paint the wife and son of Edward L. Davis, a former mayor. The subjects posed on the threshold of the family carriage house, where they were illuminated by strong sunlight and yet viewed against a very dark background. The boy commands attention with his white summer clothes and an alert face circled by a wide-brimmed straw hat. His brown suntanned hand stands out against his mother's pale skin. The painting was widely exhibited in the 1890s and praised for its gentle characterizations, its dignified composition, and its technical finesse.

Mrs. Hugh Hammersley

1892–93. Oil on canvas, 81 x 45½"
The Brooklyn Museum, New York.
Loaned by Mr. and Mrs. Douglass Campbell

The subject was a fashionable London hostess. The jauntiness conveyed by her lively glance is amplified by Sargent's rather agitated composition. With props that allude to courtly life in eighteenth-century France, he presents a case for Mrs. Hammersley as a modern Pompadour or Du Barry. The portrait won great acclaim at the New Gallery's spring exhibition in 1893. George Moore was one of the few London critics to withhold complete approval: he called it "the apotheosis of fashionable painting" and predicted that it would not achieve lasting fame because it was uncritically caught up with "the joy of the passing hour, the delirium of the sensual present."

Elizabeth Winthrop Chanler (Mrs. John Jay Chapman)

1893. Oil on canvas, 49⅜ x 40½"
The National Museum of American Art,
Smithsonian Institution, Washington, D.C.
Gift of Chanler A. Chapman

Miss Chanler, a twenty-six-year-old New Yorker, sat for her portrait in London. Her setting relies completely on Sargent's props and his personal possessions. Apparently he sought to balance the woman's external appearance as a "beauty" with her strong, serious, and kindly personality. He used the sofa that appears in Mrs. Hugh Hammersley, *but arranged it for a different visual effect. Aligning its rectangular back with the picture plane, he introduced order and calmness to the composition. He included two handsomely framed paintings in the background, perhaps to equate the subject with notions of preciousness and refinement. On the left is his own copy (made in Haarlem in 1880) of a detail from Frans Hals's group portrait,* Regentesses of the Old Men's Home; *on the right is an early Italian painting.*

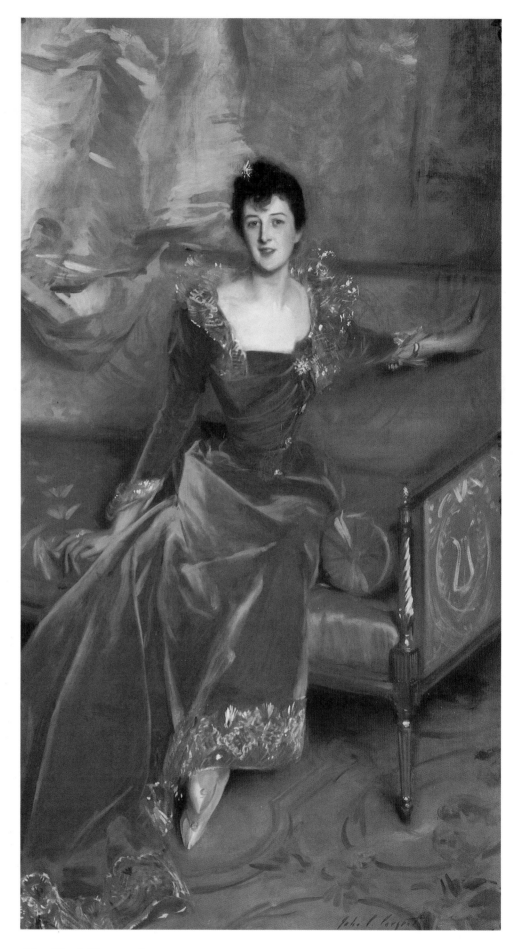

Mrs. Hugh Hammersley

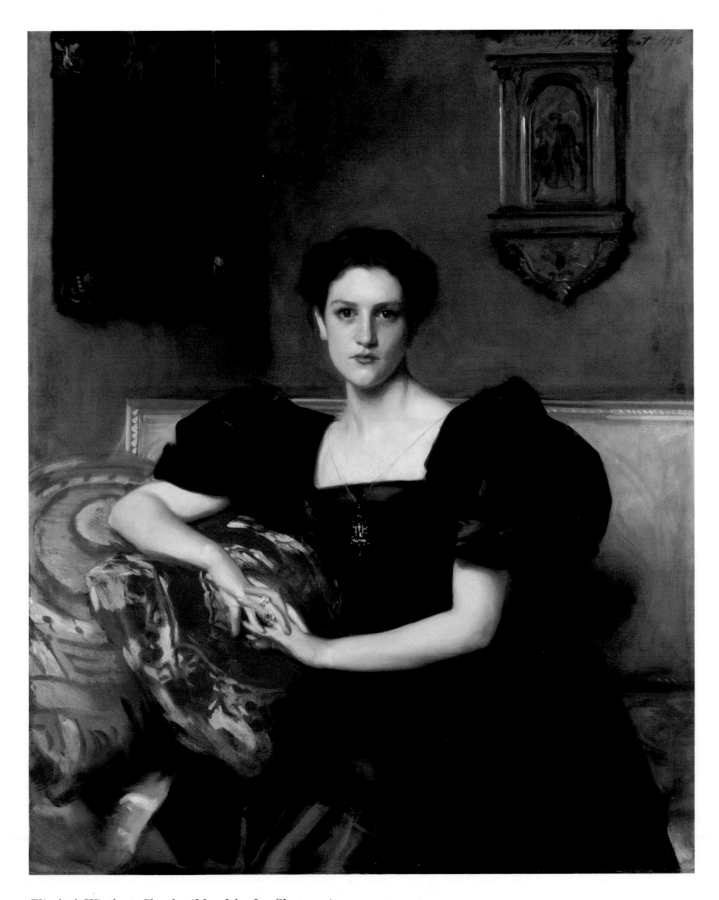

Elizabeth Winthrop Chanler (Mrs. John Jay Chapman)

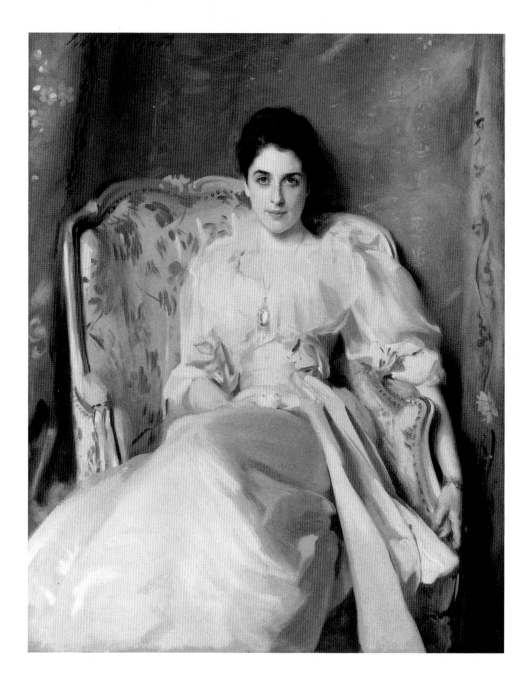

Lady Agnew of Lochnaw
1892–93. Oil on canvas, 49 x 39¼"
The National Galleries of Scotland, Edinburgh

Together with Mrs. Hugh Hammersley, *which was on display at the New Gallery at the same time, this portrait made Sargent "the man of the season" when exhibited at the Royal Academy in 1893. The critic for* The Times *declared it a masterpiece, writing: "[It is] not only a triumph of technique but the finest example of portraiture seen here for a long while." Sargent's execution in* Lady Agnew *has the same effortless grace and refinement as the subject herself: image and paint surface are equally seductive. She holds a white flower in her lap, and she is as relaxed and graceful as the flowing lines of the aristocratic French Rococo armchair. The palette and props strike an uncanny harmony with the beguiling mood of the woman.*

Agnew of Lochnaw as the most admirable portrait in the Royal Academy exhibition of 1893, using the following adjectives in an unctuous description: superb, subtle, refined, exquisite, dignified, individual, and masterful. And, in remarkable parallel with Coffin's opinion of *Mrs. Edward L. Davis and Her Son Livingston*, this London writer hailed *Lady Agnew of Lochnaw* as "the finest canvas ever put forth by Mr. Sargent, and one of the best portraits of the day."

Mrs. Hugh Hammersley and *W. Graham Robertson* are examples of portraits that were praised but not universally admired in the 1890s. The "faults" pinpointed by the critics became standard reservations about Sargent and his work. In the woman's portrait it was argued that the artist

had "enjoyed" the accessories as much as the sitter. Thus any sitter had to risk Sargent's urge to turn a commissioned portrait into a vehicle for his stylish bravura. In fact, Sargent painted Mrs. Hammersley's head sixteen times, from which it can be inferred that both he and the sitter worked hard to capture the vivacious characterization. One criticism leveled against *W. Graham Robertson* concerned Sargent's exclusive focus on an external or "superficial" likeness. It was argued that the portrait gave a living sense of the man, but the exaggeration of his "willowy form" and the neglect of more subtle qualities resulted in a caricature. This argument had been made a decade earlier in the case of *Madame Pierre Gautreau.* A special characteristic of Sargent's best portraits is their ability to function as almost orthodox images of social types as well as likenesses. Judgments were and are often based primarily on the social phenomenon symbolized by the subject. Madame Gautreau is thus a pathological "peacock woman," and Mr. Robertson is an effete, dandified aesthete.

It is tempting to read homosexuality as the subject of *W. Graham Robertson* and to speculate that homoeroticism fed Sargent's ability to create this lucid image, for the subtle visual codings of effeteness and boyish beauty are in place. It must be remembered that homosexuality had been a crime under British law since 1885. I propose that Sargent's portrait made the bravest public statement possible about the existence of homosexuals and their contributions to the style, manners, and thinking of the day. Whenever he was said to have revealed a sitter's "moral qualities," Sargent apparently insisted on the objectivity of his procedure: "I do not judge, I only chronicle." Despite his disregard for psychological notions of association and subjective preferences, a lasting value of Sargent's portraits is their capacity to teach us how to read the surfaces that people present to the world through the visual language of their clothes and gestures. His activity as a fashionable portraitist involved the kind of awareness that Jack Babuscio described in 1977 as an important aspect of homosexual sensibility within a homophobic society: "The experience of passing [for straight] can lead to a heightened awareness and appreciation for disguise, impersonation, the projection of personality, and the distinctions to be made between instinctive and theatrical behaviour."

During Sargent's visit to the United States in 1890, his friend Charles McKim asked him to consider a decorative commission for a long upper hall on the top floor of the proposed new Boston Public Library. Edwin Austin Abbey, the only other American artist invited to prepare mural paintings, vouched for his friend Sargent in a letter to McKim: "He can do *anything.* . . . He is latent with all manner of possibilities, and the

W. Graham Robertson

1894. Oil on canvas, 90¾ x 46¾"
The Tate Gallery, London.
Gift of W. Graham Robertson, 1940

Sargent asked to paint this slender, twenty-eight-year-old artist wearing this particular coat and accompanied by Mouton, his elderly poodle. Robertson recalled posing during a hot summer, wearing little beneath the long overcoat: "I became thinner and thinner, much to the satisfaction of the artist, who used to pull and drag the unfortunate coat more and more closely round me until it might have been draping a lamp-post." The few notes of color brightening the shadowy palette are as exquisitely poised as the dandy himself: gray eyes and trousers, white dog wearing a yellow ribbon, and cane with a jade and gold handle.

W. Graham Robertson

Head of an Arab

Sargent toured Egypt, Greece, and Turkey in 1890–91. This study of an Arab was probably made abroad, but it may have been painted from a model on his return to London. The subject is relevant to the artist's preparation for his recent mural commission from the Trustees of the Boston Public Library, for Sargent was planning a frieze of Old Testament prophets. The colors of this oil sketch demonstrate his assimilation of some Impressionist practices, particularly when this painting is compared to the portrait sketches made ten years earlier.

Boston people need not be afraid that he will be eccentric or impressionistic, or anything that is not perfectly serious or non-experimental when it comes to work of this kind." This denial confirms that Sargent's eccentricity was still a risk for any patron. It was to his advantage that he had once helped Carolus-Duran with a ceiling painting, and he knew the recent landmarks of decoration in Paris—the works by Charles Baudry at the Grand Opera (1874), by Puvis de Chavannes at the Panthéon (1878), and by Albert Besnard at the Ecole de Pharmacie (1887). Nonetheless, McKim took a risk when he selected Sargent. Since Puvis de Chavannes was to decorate the main staircase Sargent had the honor of

Study of Drapery for
"The Frieze of the Prophets"

c. 1892. Charcoal heightened with white chalk,
24⅜ x 18¹¹⁄₁₆"
The Corcoran Gallery of Art, Washington, D.C.
Gift of Violet Sargent Ormond and Emily Sargent

None of the figures in the finished frieze is as dramatic and bizarre as this. The absence of any visible body part in this drawing creates a weird effect. The dense black "void" and the white chalk highlights amplify the odd theatrical power of the hidden figure. Sargent's attraction to this manner of ambiguity may be inferred from the excitement of his execution. In the completed mural the prophet whose face is most buried in his robes was Joel.

making his first decoration in the same building as France's most celebrated muralist.

Sargent's first idea for the Boston project was Spanish literature, a natural response given the predilections expressed by *El Jaleo: Danse des Gitanes* and his very recent portrait of Carmencita. However, in a grand show of confidence and ambition, he soon changed his subject to a history of religion. He contracted to provide decorations for the two ends of an eighty-four-foot-long barrel-vaulted hall on the top floor of the library. The writings of Ernest Renan, a French historian of religion and language, inspired the themes that Sargent used to distinguish the two parts. One end would show the varieties of Paganism and the emergence of Judaism, and the other would celebrate the "triumph" of Christianity in the modern period. Just as the creators of the new Boston Public Library conceived it as an embodiment of American cultural progress, Sargent's modern notion of religion (via Renan) was ideologically structured as an evolutionary process leading to a more civilized and more rational future. Blinded by the rhetoric of progress, the artist and the library officials ignored or failed to see the negative implications of this statement for modern Jews.

Sargent's chosen theme indulged his love of exotic spectacle, and offered an opportunity to research the diverse ritualistic trappings and other visual manifestations of religious passion. Before working out the

Reclining Figure with Flying Draperies

c. 1892. Charcoal on pale blue paper, 24¼ x 19"
Courtesy of the Fogg Art Museum,
Harvard University Art Museums,
Cambridge, Massachusetts.
Gift of Mrs. Francis Ormond

To determine the poses and forms of the figures in his murals Sargent made hundreds of preliminary drawings from models. He favored a bold sketching style in charcoal. He hired professional models but also liked to draw his Italian valet, Nicola D'Inverno. This study recalls the figure of Adonis/Thammuz that appears in the ceiling decoration The Pagan Deities. *A symbol of summer and of warmth, the young god shoots arrows into the mouth of a snake that represents winter's darkness and cold. This was Sargent's visualization of the Syrian solar myth.*

visual framework, he wanted to immerse himself in original material and to experience the ancient world for himself. He left New York, went briefly to London, and was in Alexandria with his mother and sister Emily by December 1890. After touring Egypt for three months, they visited Athens and Constantinople. Sargent constantly sketched ruins, interiors, architectural details, decorative motifs, and the indigenous peoples. Over the next three years he planned and executed his Boston decorations in the large new studio his colleague Abbey had built in the English countryside. Sargent commuted between his London studio, where he continued to paint portraits, and the Abbey household at Morgan Hall, in Fairford, Gloucestershire. Using the sketches from his travels and hundreds of images and "old symbols" in photographs and prints, Sargent now worked strenuously to devise a coherent structure to contain them. He wrote to his Bostonian friends the Fairchilds: "It is getting on very slowly . . . and requires more brain work than is good for a would-be impressionist."

In 1894 Sargent exhibited two sections from his "Pagan End" at the Royal Academy: a lunette and the curved ceiling painting that abuts it. The lunette shows a group of nude Israelites huddling at the feet of their Egyptian and Assyrian persecutors, with the hands of Jehovah reaching down to halt the violence. The ceiling is a layered and interwoven pantheon of pagan deities and astrological devices; the Egyptian goddess

Astarte and Neith in
"The Pagan Deities"

*In 1895 the first sections of Sargent's
decorations for the Boston Public Li-
brary were brought from London to be
installed at one end of a long hall. His
theme was a history of religion, and the
ceiling illustrated here addressed poly-
theism. It shows the "false gods" wor-
shiped by the "oppressors of the children
of Israel." At the bottom of this photo-
graph is Astarte, a Phoenician fertility
idol. The library handbook of 1895
described her as "the goddess of sensual-
ity—beautiful, alluring, and heart-
less." Inverted above her is the colossal
head of Neith, the mother of the uni-
verse. Sargent had visited Egyptian tem-
ples in which Neith's outstretched body
spanned the entire ceiling, and he
adopted the idea for Boston.*

Neith fills its span, and superimposed over her are smaller figures of Isis, Osiris, Horus, Moloch, Thammuz, and Astarte and her priestesses. The London critics were astonished. For example, *The Art Journal* wrote that Sargent, the "master of realistic style," had turned his "mirror" to reflect a "mystic procession of archaic types and forgotten civilizations." When the new library opened in 1895 Sargent's contribution was only half complete, with nothing of the "Christian End" installed. The "Pagan End" was comprised of the ceiling and lunette exhibited in London plus a third element, a frieze of Old Testament prophets. Lined up beneath the lunette, the prophets were painted in a realistic manner. Their gestures and expressions range from despair to hope.

The new Boston Public Library was one of the great statements of modern academic classicism, demonstrating the municipal symbolism of this architectural style and inaugurating what is now called "The

First panel of "The Frieze of the Prophets"

1895. Oil on canvas: mural decoration
Courtesy of the Trustees of the Public Library
of the City of Boston

Below the ceiling devoted to pagan idols runs a frieze of nineteen Hebrew prophets: men who scorned polytheism and guided the Jews back to a single God. Moses stands at the center presenting the Tables of the Law. This detail shows three prophets of despair— Zephaniah, Joel, and Obadiah—and the young, hopeful, and handsome figure of Hosea. The emotive gestures of these figures recall those in Rodin's public monument The Burghers of Calais.

FACTVS·HOMO·FACTOR·HOMINIS · FACTIQVE·REDEMPTOR· · ·REDIMO·CORPOREVS·· ·CORPORA·CORDA·DEVS

The Frieze of the Angels

1903. Oil on canvas with relief ornamentation: mural decoration
Courtesy of the Trustees of the Public Library of the City of Boston

The second section of Sargent's decorative scheme at the Boston Public Library addressed the foundation of the Christian faith. It was installed in 1903 facing the earlier section devoted to Paganism and Judaism. Early Christian and Byzantine art inspired Sargent's rich, solemn, and splendid treatment of the Christian doctrine of redemption. In this frieze angels carry the instruments associated with the crucifixion: the pillar and the whip; the hammer and nails; the spear, reed, and sponge; the crown of thorns. In 1903 a critic praised the "dashing portrait painter" for inventing figures that were severe, deliberate, and hence architectural: "[They] are abstract and decorative in exactly the same way that the symbolic figures of a sixth-century mosaic would be."

American Renaissance." McKim, Mead & White relied on European traditions, and invited the leading French muralist to decorate the main staircase. Concomitantly, they gave commissions to American painters and sculptors (Abbey, Sargent, Augustus Saint-Gaudens, Daniel Chester French, and Frederick MacMonnies), and included Massachusetts granite and some American marble in the building materials. Looking to the Renaissance as the fount of modern civilization and a living European tradition, the architects argued that its forms and concepts should be adopted as the basis of the evolving needs of America. Ernest Fenollosa, Curator of Oriental Art at the Museum of Fine Arts, Boston, predicted that Sargent's hall, when completed, would become "a shrine for the pilgrimage of artists," comparable to the Brancacci Chapel in Florence, famous for its frescoes by Masaccio: "This wonderful experiment of Sargent's must penetrate American opinion like an irrigating flood, and stimulate directly and indirectly a long series of splendid native works."

When Sargent left Boston in 1895 he had a new contract: after decorating the "Christian End" of the hall he was to prepare a scheme to connect the two extremities. He would receive thirty thousand dollars from the Library Trustees for the entire project. The mural decorations took on enormous symbolic importance for Sargent: he thought that he was joining with McKim, Mead & White in making the United States the heir of the classical tradition. On a personal level the grandeur of his decorations would balance his worldly portraits, fulfilling his cultural and civic service as an American. Sadly, he allowed these decorations to become a burden, and a source of endlessly protracted toil. The "Christian End" was not delivered until 1903, and connecting elements were finally installed in 1916 and 1919, over twenty years after the library opened.

Crucifix

c. 1899. Bronze, 44 x 31 x 3½"
The Tate Gallery, London

This is a small version of the life-size, polychrome plaster sculpture that marks the center of Sargent's Christian wall in the Boston Public Library. To relate the suffering of humanity with that of Christ, he depicts Adam and Eve bound to Christ on the cross. The effect is both emotionally and decoratively strong. Adam and Eve hold out chalices to catch the blood that flows for the remission of their sins. At the foot of the cross Sargent presents a pelican piercing its breast to feed its young with blood; this motif was an early symbol of Christ's sacrifice to redeem mankind.

Back in London in 1895 Sargent was soon overwhelmed by portrait painting. Since Abbey had completed his mural decorations on schedule, Sargent now had to find a second studio in London where he could work on his Boston project. He was devoted equally to portraits and murals, but the decorations were easier to delay since Boston lay across the ocean. Sargent's originality as a portraitist continued to blossom. The English establishment now enjoyed the way he painted, but there were still occasional criticisms when he depicted certain patrons with his usual frankness and vitality. For example, at the Royal Academy of 1897 there was discussion about Jewish patronage when he exhibited *Mrs.*

Mr. and Mrs. Isaac Newton Phelps Stokes

1897. Oil on canvas, 84¼ x 39¾"
The Metropolitan Museum of Art, New York.
Bequest of Edith Minturn Phelps Stokes
(Mrs. I.N.), 1938

These New Yorkers lived in Paris while the husband was an architecture student. The original commission was a portrait of Mrs. Stokes alone. After reviewing her wardrobe Sargent chose to paint her in a blue satin evening gown. After a few sittings he abandoned this in favor of the "modern" clothes she wore for her walk to his Chelsea studio. He also decided to have her stand with one hand on the head of a Great Dane, which he proposed to borrow from a friend. Meanwhile, at Sargent's suggestion, the couple approached Whistler to do the husband's portrait. When Whistler's fee proved too high, Sargent was persuaded not to include the dog and to paint Mr. Stokes behind his jaunty wife.

Anthony van Dyck. *James Stuart (1612–1655), 4th Duke of Lennox and 1st Duke of Richmond*

1633. Oil on canvas, 85 x 50¼"
The Metropolitan Museum of Art, New York.
Gift of Henry G. Marquand, 1889.
Marquand Collection

Sargent's friend and patron, Henry Gurdon Marquand, donated this painting to the Metropolitan Museum in 1889. It may have been on Sargent's mind when he thought of including a dog in his portrait of Mrs. Stokes. It is easy to imagine a large dog beside Mrs. Stokes, its head appearing in the place of her straw hat, and its body masking the plainness of her skirt. The elegance, grandeur, and formal simplicity found in the aristocratic portraits of van Dyck and Reynolds were often echoed in Sargent's work after 1900, particularly when his portraits were to hang in ancestral homes. Two of his most ambitious group portraits for "country houses" can be seen in Blenheim, (Oxfordshire) and in Chatsworth (Derbyshire).

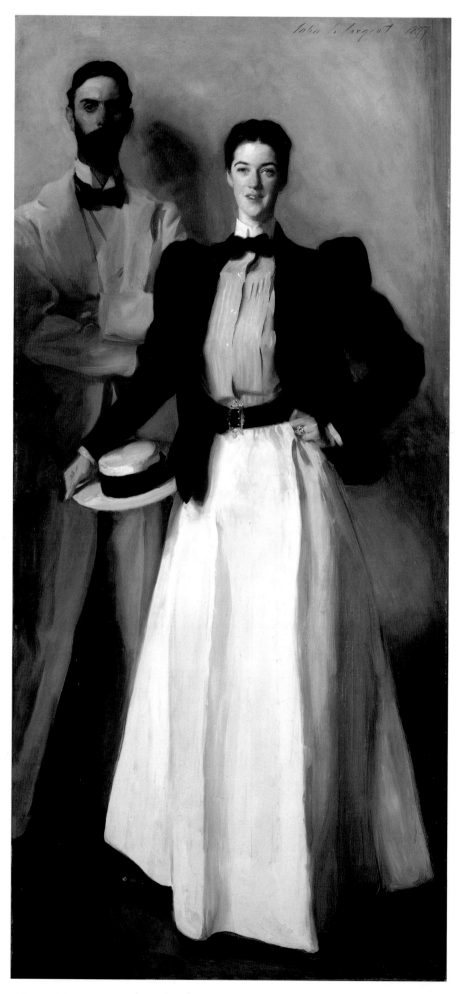

Mr. and Mrs. Isaac Newton Phelps Stokes

Anthony van Dyck. *James Stuart* (1612–1655),
4th Duke of Lennox and 1st Duke of Richmond

Carl Meyer and Her Children. In pose and composition it recalls *Mrs. Hugh Hammersley*: the vivacious subject is seated on a small Rococo sofa with her son and daughter behind it. Henry Adams was dismayed to find Mrs. Meyer—"a sprightly Jewess"—standing proudly with her portrait at a private viewing in 1896. Only three years before, Lady Agnew had become an instant celebrity because people were so enamored of her portrait by Sargent, and it is easy to understand the delight of anyone who had inspired a fine work by him. In a review of the exhibition Henry James said that the Meyer group showed a "knock-down insolence of talent." He described the children as follows: "Shy olive faces, Jewish to a quaint orientalism, faces quite to peep out of the lattice or the curtains of closed seraglio or palanquin."

Sargent's greatest patron in London at the turn of the century was the Jewish art dealer, Asher Wertheimer, whose portrait added more fuel to the debate about the artist's determination to paint his sitters objectively. Such disarmingly frank likenesses caused many viewers to assume that Sargent willfully allowed unflattering insights to enter his likenesses. Critics who held this point of view likened Sargent to a scientist or even a surgeon. His observations were said to be cruel or cutting, and his manner had a "cold-blooded insistency." Such "faults" were often cited when Sargent painted images that seemed to counter the values of the establishment, whether strong, exuberant characterizations of social minorities, or "unflattering" ones of the ruling class. On the other hand, the artist's sharpest insights were praised when they underscored the status quo. Thus American audiences loved the vibrantly healthy and confident emblem of the modern American woman in *Mr. and Mrs. Isaac Newton Phelps Stokes.* Moreover, British audiences responded warmly to the monumentally scaled portrait of the three daughters of the Hon. Percy Wyndham, which has the shadowy aura of an inner sanctum of intelligence, beauty, and privilege. Sargent was sometimes overwhelmed by his business as a portraitist, but it seems likely, as Vernon Lee hinted, that he would paint anyone who could pay his fee, whether aristocrat, plutocrat, or nouveau riche. Spirit in the sitter made the act of portrayal more exciting for him: in 1907 Sargent told an English diplomat that he preferred to paint Jews "as they have more life and movement than our English women."

In 1899 Henry James wrote to a mutual acquaintance, "Sargent grows in weight, honor and interest—to *my* view. He does one fine thing after another." James's inclusion of physique with professional standing and artistic merit is telling—even Sargent's body served as an indicator of his worldly success. As a young man Sargent stood over six feet tall; he was thin, with blue eyes, and a brown beard. By 1900 his girth betrayed an

Asher Wertheimer

1898. Oil on canvas, 58 x 38½"
The Tate Gallery, London

The unexpected detail in this portrait is the family poodle glimpsed in the corner; its lolling pink tongue is a witty foil for Wertheimer's restrained smile. Wertheimer, a prominent dealer in paintings and art objects, had a gallery on New Bond Street. Sargent recorded his Jewish ethnicity as a matter of fact. However, as visualized by Sargent, Wertheimer's shrewdness and aplomb contributed to a racial stereotype in the eyes of the covertly anti-Semitic Anglo-American elite. For example, the American Henry Adams wrote a friend: "As for me, I admire [Alfred] Dreyfus; but Sargent has just painted another Jew, Wertheimer, a worse crucifixion than history tells of." Alfred Dreyfus, an Alsatian Jew, and captain in the French army, had been exiled and imprisoned for treason; it was common to make pro- or anti-Jewish statements by referring to the humiliating treatment of Dreyfus, whom many believed innocent.

Asher Wertheimer

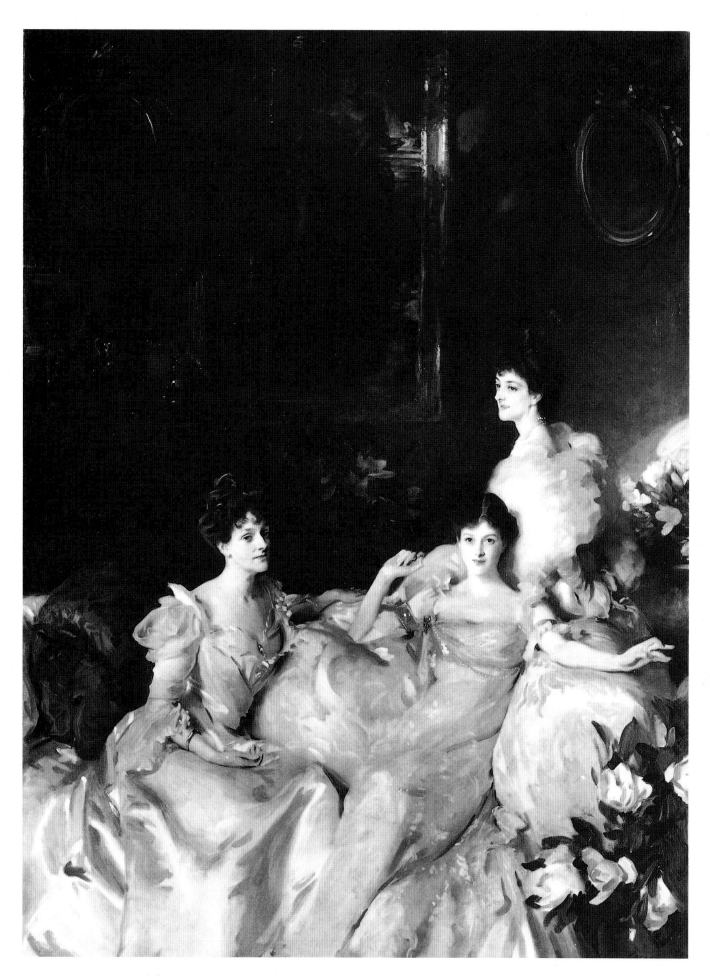

The Wyndham Sisters: Lady Elcho, Mrs. Adeane, and Mrs. Tennant

Max Beerbohm. *John S. Sargent*

c. 1900. Graphite, pen, and wash, 16 x 8½"
The Tate Gallery, London

Sargent attained a monumental status within the Anglo-American art world around 1900, the moment Max Beerbohm made this caricature. Towering like a crowing cock on firmly planted feet, he displays his gourmand's belly, bares his hairy throat and neck, and jiggles a cigarette between his lips. This image appeared in the Christmas supplement of the British magazine World *in 1900, the first of several caricatures by Beerbohm published in magazines and books during Sargent's life. Beerbohm's portrait of Sargent's success can be extended by Wilfred Scawen Blunt's 1899 description of him as a working professional. After meeting Sargent on the doorstep of the Wyndham family's London residence, Blunt wrote: "[He is] a rather good-looking fellow in a pot hat, whom at my first sight I took to be a superior mechanic."*

The Wyndham Sisters: Lady Elcho, Mrs. Adeane, and Mrs. Tennant

1899. Oil on canvas, 115 x 84⅛"
The Metropolitan Museum of Art, New York.
Wolfe Fund, Catherine Lorillard Wolfe
Collection, 1927

The daughters of the Hon. Percy Wyndham posed in their father's drawing room on Belgrave Square. George F. Watts painted the 1877 portrait of their mother that is seen in the background. When first exhibited at the Royal Academy in 1900 The Wyndham Sisters *drew praise from the critic Roger Fry: "[It] is the most marvelous tour de force he has yet accomplished. Since Sir Thomas Lawrence's time, no one has been able thus to seize the exact cachet of fashionable life, or to render it in paint with a smartness and piquancy which so exactly correspond to the social atmosphere itself. Such works must have an enduring interest to posterity simply as perfect records of the style and manners of a particular period."*

appetite that William Rothenstein described as "gargantuan," and his beard showed the traces of heavy smoking. These compulsions are fascinating in light of Sargent's almost gastronomic savoring of the process of painting, as well as his feverish behavior while he was executing a portrait. He constantly rushed back and forth for a long view of his canvas, making noisy exclamations over difficult strokes, and pausing for exuberant bursts of piano-playing. His creative passion was like the activity of a master chef, and his portraits have an ostentatious role that recalls turn-of-the-century *grande cuisine:* they were stunning and delicious showpieces, magnificently radiating affluence and assurance for an exclusive company. The analogy with opulent food does not belittle Sargent's portraits, rather it draws attention to their precise social task— to project a fastidious superiority by virtue of being ornate, exclusive, and prohibitively expensive.

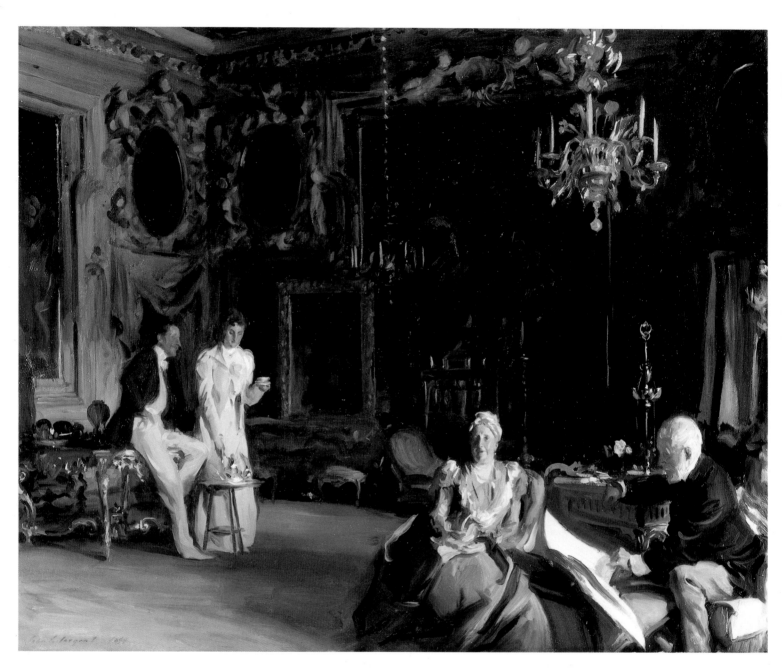

An Interior in Venice

VI. The Informal and the Personal

ALENT AND SUCCESS TOOK A TOLL ON SARGENT. The realization of his ambitions was complicated by his shyness and a personal reserve. He presented an astonishing public facade with works as distinctive and different as *Lady Agnew of Lochnaw* and *Asher Wertheimer*, but he could not comfortably handle all aspects of his own celebrity. Every new portrait made him at least one enemy, he remarked. He was easily rattled when sitters made comments and suggestions about their portraits, and he developed a pet expression—"just a little something not quite right about the mouth"—to characterize these negotiations between portraitist and client. With friends he was spirited and very witty, but he was quiet in public, and hopeless at making speeches. He valued privacy, and seems to have needed it as an antidote to his other endeavors. By 1900 Sargent was turning more frequently and meaningfully to informal and personal expression in his art. Now in his forties, he devoted more time to holiday trips, and took new pleasure in sketching in watercolor. These activities away from London became an integral part of his professional practice. Traveling allowed him to study historic works of art that were useful to his mural decorations. He often exhibited or sold the works that he made on his holidays, and on occasion he combined a holiday with a commission to paint a formal portrait.

An Interior in Venice will serve to introduce the themes of this chapter. It is a small oil painting representing the Daniel Sargent Curtis family, dear friends and distant cousins, at home in the Palazzo Barbaro. Sargent, their house guest, shows his hosts in their grand salon overlooking the Grand Canal. Following the precedent of *The Breakfast Room*, this picture describes the ambience of the place just as eagerly as the occupants. Ralph Curtis and his wife stand in the middle ground, and Ralph's parents occupy the foreground. The picture explores differences between generations and within couples that are worthy of a novelized treatment by Henry James. The senior Mrs. Curtis found Sargent's informal impression of her unflattering, and was annoyed that her son was immortalized in a slouching posture.

In 1899 Sargent exchanged this Venetian picture with the first painting he had given to the Royal Academy as his diploma work (an official

An Interior in Venice

1899. Oil on canvas, 25½ x 31¾"
The Royal Academy of Arts, London

During a stay at the Palazzo Barbaro in 1898 Sargent began this portrait of his hosts relaxing at tea. The man seated at the right is Daniel Curtis, an expatriate Bostonian who had lived in the palazzo since 1881. At the left is his eldest son Ralph, a painter friend of Sargent's since their student days in Paris. The matriarch, known to her family as La Dogaressa, refused this painting when Sargent presented it to her as a gift. She took objection to its unflattering disclosure of her age and to the improperly casual manner in which her son props himself against the gilt rococo table. Henry James was a good friend of the Curtis family and used some of his impressions of the Palazzo Barbaro in his 1902 novel The Wings of the Dove.

Ballroom of the Palazzo Barbaro, Venice

requirement of people elected to the senior position of Academician). It replaced his portrait of the violinist Johannes Wolff that he originally presented when elected in 1897. The substitution of an informal scene for a portrait is evidence of the artist's shifting priorities. *An Interior in Venice* was a resounding critical success when exhibited at the Royal Academy's annual exhibition in 1900. The critic of *The Saturday Review* praised its "nervous" and rapid execution: "What an honest infallible grasp of aspect. . . . Dark shapeless smudges reveal themselves at the right distance as cherubs and festoons in the decoration of the ceiling." On the other hand, James Abbott McNeill Whistler, an inveterate and brilliant nonconformist, criticized Sargent's new diploma picture in private conversations. The little interior made him long for the finish, delicacy, elegance, and repose that he valued in the Dutch masters Metsu and Ter Borch. Whistler reacted viscerally against Sargent's loose, buttery paint surface, and he dismissed *An Interior in Venice* in two words—"Smudge everywhere." Whistler was no more interested in the man than his work. He respected Sargent as a "good fellow," but saw him as "a sepulcher of dullness and propriety." Thus the self-absorbed and discerning Whistler decried the growing middle-brow cult of Sargent. He insisted that Sargent was no better than anyone else exhibiting at the Royal Academy in 1900, and that there was nothing there worthy of his praise. Whistler's criticisms of *An Interior in Venice* shed useful light on his own aesthetic canons, but failed to acknowledge Sargent's motivations. Sargent was publicly applauded for aesthetic achievements that Whistler had long battled for: painterly painting, the fleeting impression, and a modern spirit of vitality. Whistler also ignored Sargent's sentimental desire to capture the magic of places where the soul of beauty and contentment seemed to preside. The technical flourish and emotional verve of this Venetian oil painting became hallmarks of the watercolors that were a key part of Sargent's production in the latter half of his career.

Sargent loved to depict people at ease, relaxing, distracted by a pastime, lounging, or sleeping. *On His Holidays* is an important commissioned portrait in this regard, for it shows a British schoolboy reclining on a rock during a fishing trip to Norway. It is another of Sargent's turn-of-the-century statements that is not easily pigeonholed. The mood is intimate and private and yet the work is grand in scale. Moreover, the artist's attraction to the coolness and clarity of the landscape is not secondary to the likeness of the youth. After 1900 Sargent usually had a small group of traveling companions when he went on holiday, and he relied on them to help him create idyllic scenarios comparable to *On His Holidays*. He worked in oils or watercolors. Friends, sisters, nieces, and occasionally his Italian valet were shown reading or enjoying a siesta.

Ballroom of the Palazzo Barbaro, Venice
Photograph

This is the room where Sargent painted An Interior in Venice. *The Gothic palace dated from 1425, and this room, which could serve as a ballroom, was designed by Antonio Gaspari in the early eighteenth century. It is almost square, with four chandeliers that hang about eight feet above the floor. Cherubs, birds, and leafage modeled in stucco surround all the doors and paintings, which include large canvases by Sebastiano Ricci. The curtains near the ceiling conceal musicians' galleries. The wall off to the right contains balconies over the Grand Canal.*

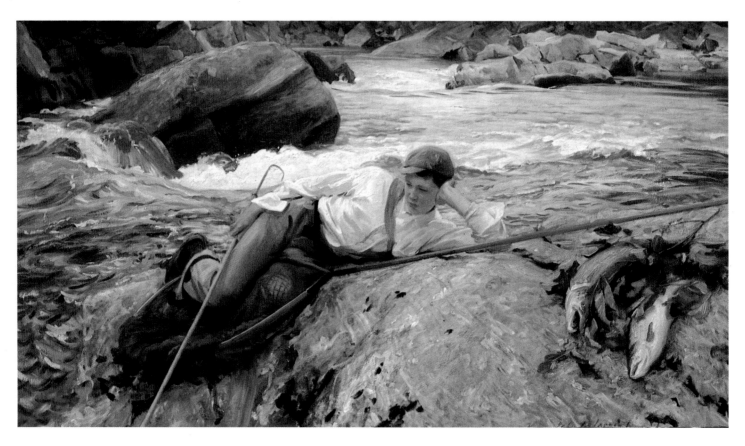

On His Holidays

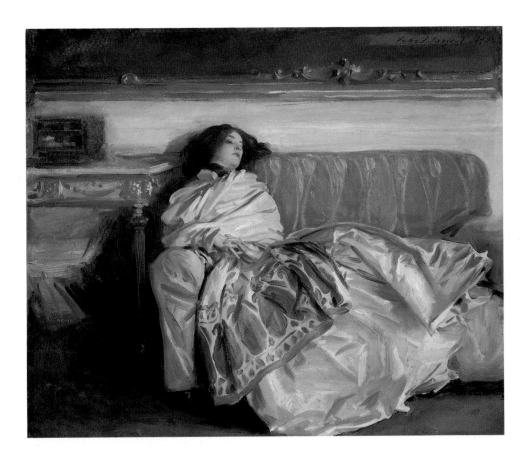

Sometimes he dressed them up in paisley shawls and old-fashioned bonnets, or Turkish costumes. He posed them by streams and brooks, in full sun or shaded by trees and parasols. An indoor version of this kind of imagery is the oil painting *Repose.* The sitter was Sargent's niece Rose-Marie Ormond, but she was not identified in the title since the picture looks on her as a symbol of beauty, serenity, and high culture, and not as an individual.

The theme of the fellow artist at work was intensified on these holidays. This interest dates back to the 1880s, when he painted three artists engaged in their own work: Ramon Subercaseaux in Venice, Monet in Giverny, and Helleu in Fladbury. In 1897 Sargent drew the young English artist William Rothenstein hard at work on a drawing. Rothenstein was making a series of portrait drawings of English celebrities, and had just made one of Sargent with a cigarette in his mouth. He wrote in his memoirs: "While I was drawing Sargent he couldn't bear to remain idle; he puffed and fumed, and directly I had done, he insisted on my sitting to him." The fact that Sargent had to be occupied all the time helps to explain the volume of work he completed when away from London. His many representations of other painters painting suggests that he favored like-minded individuals as traveling companions. *An Artist in His Studio* is especially amusing since it shows an artist giving fin-

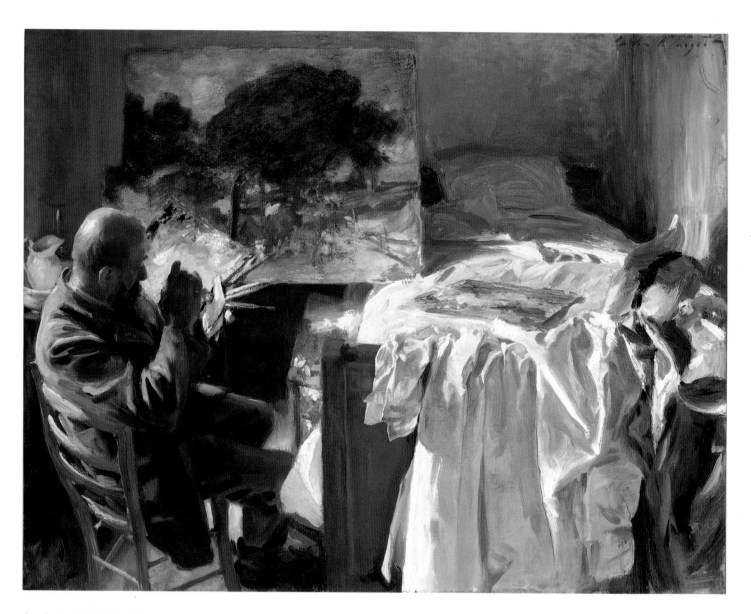

An Artist in his Studio

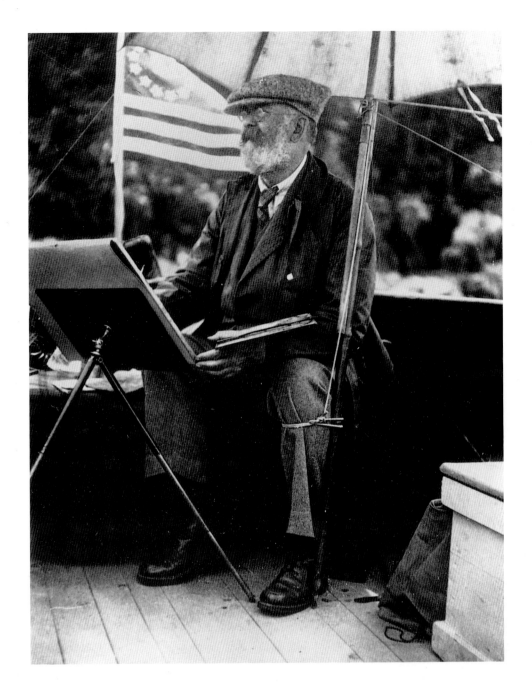

Sargent painting a
watercolor aboard Dwight
Blaney's Yacht "Norma,"
Ironbound Island, Maine

Photograph, 1921–22
Courtesy, The Blaney Family Archives

Sargent sketched in watercolors from the age of about twelve. This was a hobby of his mother's, and it became an increasingly important means of expression for him in later life. After the turn of the century he tried to make time for sketching holidays every year, and after 1903 exhibited watercolors in London almost annually. The photograph shows him working on a boat during a visit to the island owned by Dwight Blaney off Bar Harbor, Maine. His sharp gaze and alertly positioned right arm signal the rigorous looking that was the foundation of all his art, including his watercolors. As ever, his proper attire included a collar and tie.

An Artist in his Studio

1904. Oil on canvas, 21½ x 28¼"
Courtesy the Museum of Fine Arts, Boston.
Charles Henry Hayden Collection

A summer holiday in the Italian Alps with Ambrogio Raffele inspired this humorous picture. Sargent's companion is using a cramped hotel bedroom as a studio. The man and his landscape painting fill the left half of the composition, while the right shows his unmade bed, with a hat and shirt cast negligently upon it in the foreground. In 1904 the London Times wrote: "Surely never were tumbled white sheets so painted before!" Indeed, Sargent has boldly and tangibly delineated the principal folds and sunspots in brilliant white impasto.

ishing touches to a large landscape painting in his cramped hotel room. There is a double compulsion at work, for the viewer must remember that Sargent was crammed into the other end of this room, painting as feverishly as his subject. Other artists whom Sargent enjoyed as holiday guests were Wilfred and Jane De Glehn, and Adrian and Marianne Stokes. The artist's unmarried sister Emily was perhaps his closest holiday companion, especially after the death of their mother in 1906. Emily, like her mother and brother, sketched in watercolor. Sargent made several watercolors of her, and none shows her concentration better than *Miss Wedgwood and Miss Sargent Sketching*. Emily grips one brush between her

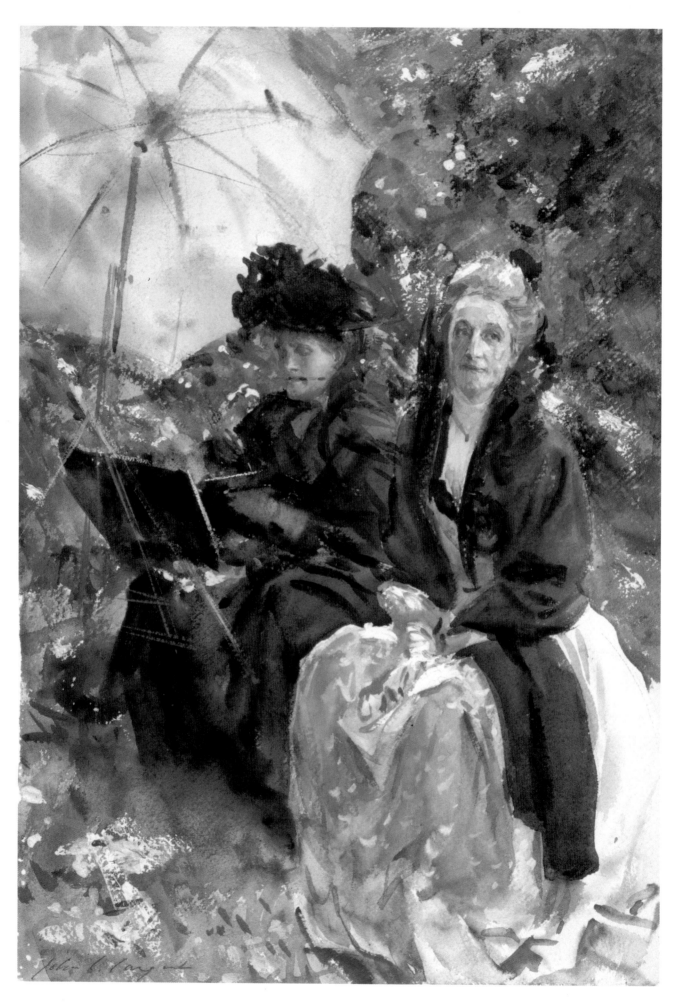

Miss Wedgwood and Miss Sargent Sketching

teeth while jabbing another into the box of paints she is holding. A large confection-like black hat trumpets her Victorian propriety, but in no way hinders her passionate pursuit of the sketch. Miss Wedgwood, a non-sketcher, sits at her side, charmingly at a loss. She has the role of companion, comparable to that of the woman in Sargent's *Paul Helleu Sketching with His Wife.*

Sargent said in jest that to make a watercolor was to "make the best of an emergency"—further evidence of his need to be busy making art no matter what. In fact the quality of his work in watercolor by 1900 was far greater than anything to be expected of any emergency. He turned to this medium seriously and diligently to engage those aspects of painting that were secondary to the portraits and mural decorations produced in his London studios. Contemporary critics had a point who claimed that the color in Sargent's portraits was "poor and thin" and was rarely a strong asset to his compositions. However, color and its effects were central concerns of his watercolors. In direct contrast to the conventions and routines accepted in his portraits, Sargent's watercolors emphasize the sparkle of outdoor light, the exuberance of color for its own sake, and forms and spaces that make composition an expressive element.

Sargent's watercolor technique was as eclectic and independent as the one he developed for his oil paintings, and yet identical in its total dependence on perceived reality. He was devoted to accuracy in both drawing and tonal relationships and in these principles his watercolors differ from his oil portraits only by degree—they look more dashing and spontaneous, and their sunlit palette is more brilliant. In traditional watercolor technique transparent washes of color are applied directly to white paper. Free from the opacity of oil paints, this medium allows a special quality of light to emerge from the white paper that is beneath and yet part of the image. However, Sargent was not a purist. His watercolors generally have a pencil drawing as a foundation; opaque pigment (gouache) is common, and on occasion is used for impastoed accents. He used translucent additives selectively to give body to those colors that need to be applied generously or with a boldly brushed effect. He made some highlights by scraping or scratching through to the white paper. Sargent was also adept at resist techniques: he used colorless wax or liquid blocking agents to cover selected areas of white paper or areas that he had already colored; he now painted over and around the area blocked out, then scraped away the masking agent to reveal the undercolor. As with his oil portraits, the watercolors rely on technical expertise and a gift for drawing. The viewer is confronted by a finished product whose marks, gestures, and sheer vitality belie the calculated manipulations and careful exertions of the artist. It was noted in the last chapter

Miss Wedgwood and Miss Sargent Sketching

1908. Watercolor and graphite, 19¼ x 14"
The Tate Gallery, London

Miss Eliza Wedgwood and the artist's sister Emily often joined him on summer holidays from 1906 through 1913. In 1908 they traveled to Avignon, Barcelona, and then crossed to Majorca to stay in Palma and Valldemosa. Like her brother and their late mother, Emily was an enthusiastic sketcher. Here Sargent shows her working away, her eyes looking down into her paint tray, her mouth holding one of her brushes. Very thin, wet washes serve to evoke dappled light on the painting umbrella in the top left; in contrast, thick deposits of unthinned paint are applied to model the sunlit folds of Miss Wedgwood's dress.

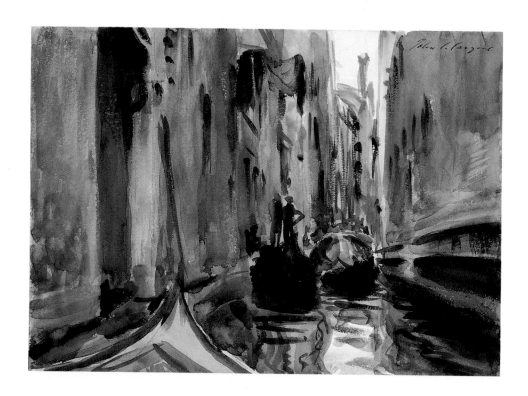

Rio di San Salvador, Venice

c. 1900–08. Watercolor and graphite, 10 x 13½"
Isabella Stewart Gardner Museum, Boston

The shadowy, sensuously textured aspect of Venice has long appealed to romantics. The prow of Sargent's gondola intrudes into the foreground of this composition. He has chosen to sketch in a dark side canal, where the dominant colors are the warm browns of the buildings and the blue-green water. This closed-in world of reflections and silhouettes brings to mind Henry James's précis of Venice: "The essential present character of the most melancholy of cities resides simply in its being the most beautiful of tombs."

From the Gondola

c. 1901–08. Watercolor and graphite,
10 x 13¹³/₁₆"
The Brooklyn Museum, New York.
Purchased by Special Subscription

In 1909 the Brooklyn Museum raised a special subscription of $20,000 to purchase eighty-three watercolors by Sargent. They had all been shown that year at Knoedler & Co., New York, in an exhibition of watercolors by Sargent and his friend Edward Darley Boit. This work, a view of the Libreria and the Doge's Palace, was part of that purchase. It is especially notable for its use of color applied to wet areas to create bleeding effects. The soft-focus impressions created by this technique make From the Gondola *one of Sargent's most entrancing images of Venice.*

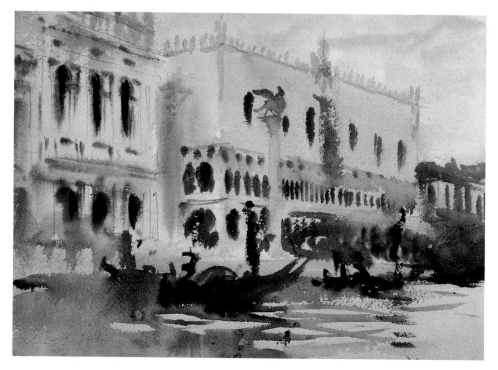

that Sargent scraped away the faces in his oil portraits until he achieved the immediacy of effect that he sought, but watercolor technique allows few alterations and no fresh starts once the paper has been stained. Given his facility Sargent relished the challenges and tactical procedures that the medium allowed, and he used it to express vibrant pictorial statements.

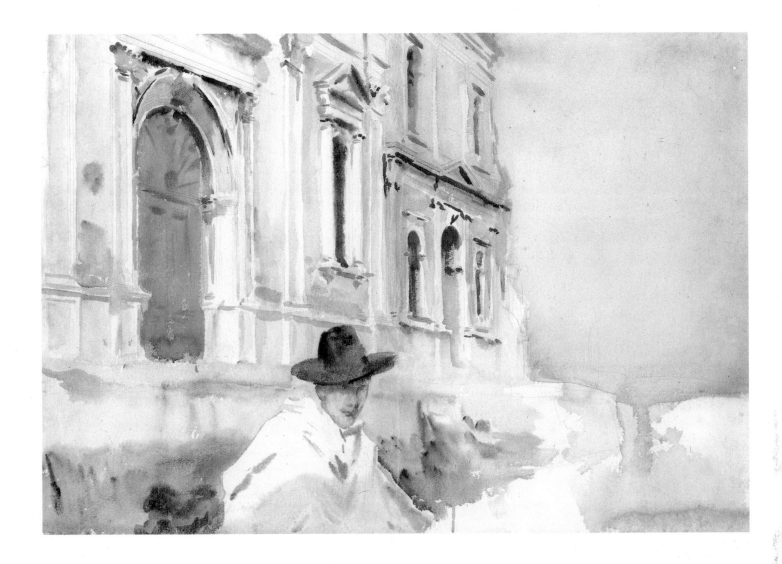

Man in a Gondola, Venice

c. 1900–08. Watercolor and graphite, 19½ x 21"
Ormond Family Collection

The young man confronting the viewer and the church rising grandly behind him have equal importance in this unusual composition. Both are cropped and neither is the primary focus of attention. Together with the luminous section of sky that is the third "element" in this composition, they form a poetic statement about the visual pleasures of the place, its people, and its light. The church is the Spirito Santo, located on the waterfront known as the Guidecca.

Venice was crucial in helping Sargent develop his strengths as a watercolorist. He worked there in this medium more than anywhere else from 1898 to 1913. Because he liked to sketch in a gondola, his Venetian subjects were often viewed close-up and cropped. The "snapshot" aspect that is common in his watercolors was thus heightened in his Venetian works, which capture architectural monuments, side canals steeped with "local atmosphere," moored ships and fishing vessels, gondolas and handsome gondoliers, steps and doorways, florid statues atop fantastic buildings, and all manner of bridges. A given watercolor may combine items from this list. In *Rio di San Salvador, Venice* the prow of Sargent's gondola points the viewer into the composition, through the flickering light of a narrow canal. The walls of the buildings, the surface of the canal, and the silhouettes of the distant gondolas are indicated with irregular washes and veils of color. *Man in a Gondola* is almost twice the size of *Rio di San Salvador, Venice* and more deliberate in its construction. Sargent did not hide the fact that he had ruled in the lines of the pilasters of the

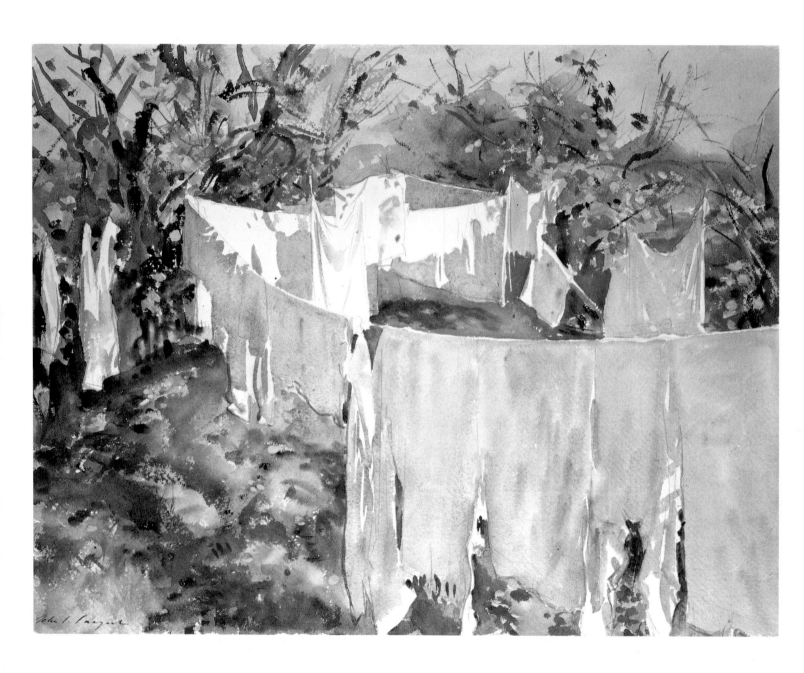

La Biancheria

1910. Watercolor and graphite, 16 x 20¾"
Courtesy the Museum of Fine Arts, Boston.
Charles Henry Hayden Collection

Freshly washed linen hung out to dry in a garden inspired this tour de force. The composition is organized around the washing line that enters dramatically from the right foreground and cuts boldly back and forth to recede into the middle distance. The linens take on pale blue shadows when not directly lit. Areas in which they gleam in sunlight derive their whiteness from the paper. Here Sargent created his brightest whites by not applying any watercolor washes.

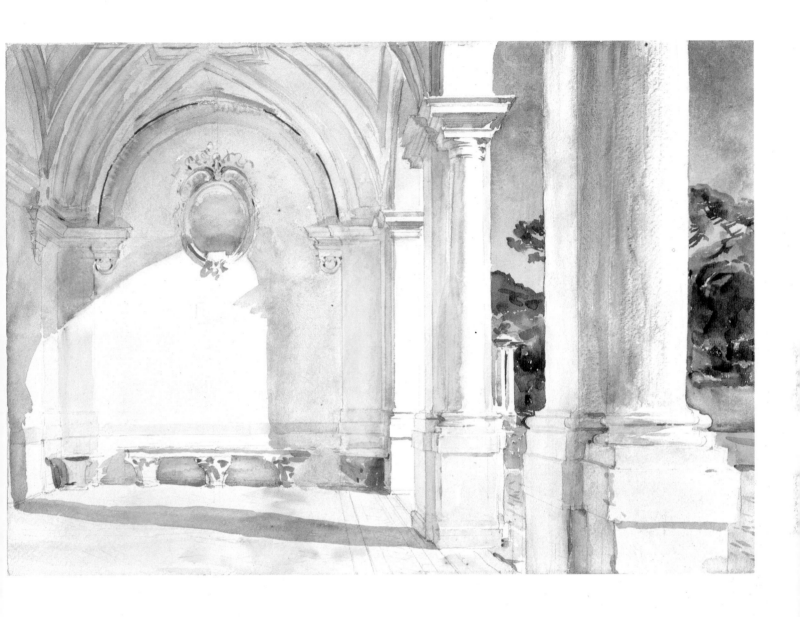

Villa Falconieri

c. 1910. Watercolor and graphite on paper,
14½ x 21"
Courtesy the Museum of Fine Arts, Boston.
Charles Henry Hayden Collection

The Villa Falconieri is in Frascati, outside Rome. The brilliant Italian sunshine contained and reflected within this Baroque architectural setting is the true subject of this work. A richly colored, more sketchy garden setting is glimpsed between the bold columns of this handsome lòggia, completed in 1649 after a design by Borromini. This watercolor exemplifies the love of classical strength and order that Sargent expressed in his later portraits and decorations.

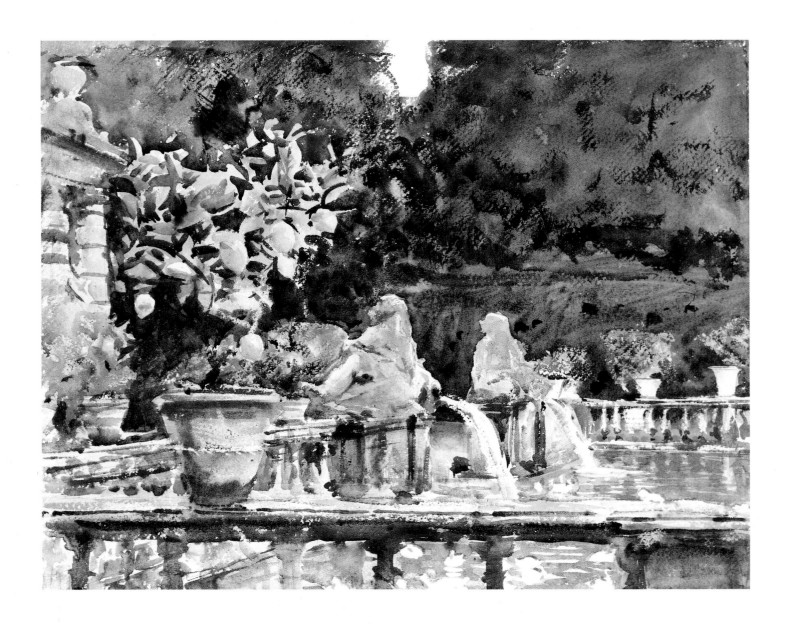

Villa di Marlia: A Fountain

1910. Watercolor and graphite, 16 x 20¾"
Courtesy the Museum of Fine Arts, Boston.
Charles Henry Hayden Collection

Sargent painted an oil portrait of the Marchese Farinola in Lucca in October 1910, after he enjoyed the use of the Marchese's Villa Torre Galli, near Florence. The formal gardens that Sargent visited during this Tuscan holiday inspired remarkable watercolors. This example shows the end of a long rectangular basin of water in a seventeenth-century walled garden outside Lucca. Positioning his stool close to the potted lemon trees placed at regular intervals all round the balustrade, Sargent had a diagonal view of the two statues of burly allegorical figures of Tuscan rivers.

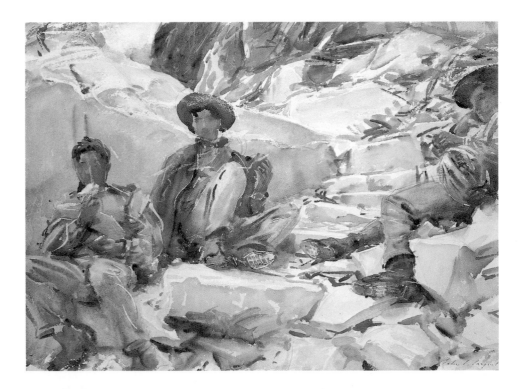

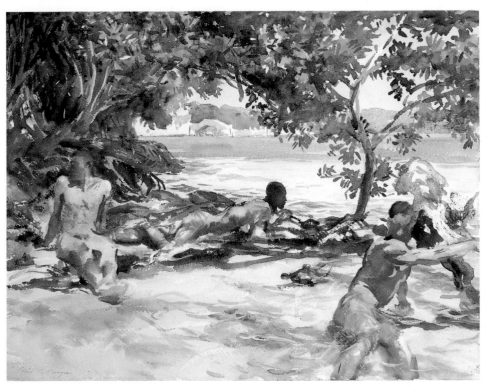

church on the left. However, this building is hardly the "subject" of his image, for the composition is a poetic grouping of observed fragments. The church, the young man, and the large clear sky are local things through which Sargent articulates a personal love of Venice.

Sargent's appreciation of Italian culture was profound. The attraction that he expressed through his watercolors differed from the documen-

tary and moralizing emphasis favored by the Ruskinian generation that preceded his. Sargent's sensibility focused on the nurturing spirit and sensual mood of Italy. True to his academic training, he never failed to record the precise line of a building or the exact form of a baluster, but the ultimate concern of his watercolors was to achieve an emotionally resonant visual effect. His eminent position gave him access to incredible villas and gardens, and he made certain watercolors in almost ritualistic homage to fountains, statues, and architectural sites; but he always showed such objects with the envelope of sensations contributed by their setting. He made a telling remark when Italian friends encouraged him to paint a scenic view (*una veduta*): "I can paint objects; I can't paint *vedute*."

Sargent was democratic in what he chose to see and paint, despite his privileged status as a visitor to Italy. It is not unusual to find an eminent Venetian monument sharing the space of the frame with a workaday presence, whether it is the head of his gondolier or a confusion of boats. Such conjunctions complicate the picture, visually and metaphorically, and establish a fractured or contingent modern point of view. Sargent was able to sketch in grand private settings denied to most people, but at the other extreme he also painted places and things that would fail to interest the average tourist. Consider, for example, *La Biancheria,* a water-color of washing hung out to dry in a garden, and an entire series made in 1911 at the work site of the marble quarries in Carrara. Formal con-cerns always contributed to Sargent's interest in any subject, but more importantly, Sargent did not avoid humble settings or working people, and his images of them are both objective and sincere. In Carrara he sketched laborers shaping and hauling huge blocks of marble, and in one instance showed three of them on a rest break. He showed the external dignity of working-class life. His images are tender or heroic, but they do not directly address the more difficult realities of hard lives and hard labor.

In Miami in 1917 Sargent sketched three African-Americans relaxing by the bay. The idyllic and enticing qualities of Sargent's treatment allowed viewers to forget the painful structuring of race and class in operation outside his picture. The artist translated natural beauty and pleasure into the artful beauty and pleasure of his paint surface. The shimmering reflections and shadows in the shallow water readily evoke a mood of freedom and openness. The context of creative excitement in which he made such watercolors was described in 1926 by his sketching companion Adrian Stokes. The text remains the most evocative and insightful summary of Sargent's passion when working on pictures that are both personal and informal: "His hand seemed to move with the

same agility as when playing over the keys of a piano. That is a minor matter; what was really marvelous was the rightness of every touch. . . . All was rendered, or suggested, with the utmost fidelity. Parts were loaded, parts were painted clear and smooth, every touch was individual and conveyed a quick unerring message from the brain. It was—if you will—a kind of shorthand, but it was magical! . . . Obviously he liked his work to be smartly done. He was acquainted with every device, but I am sure he *never* left a touch that looked clever unless it expressed what it was intended to convey."

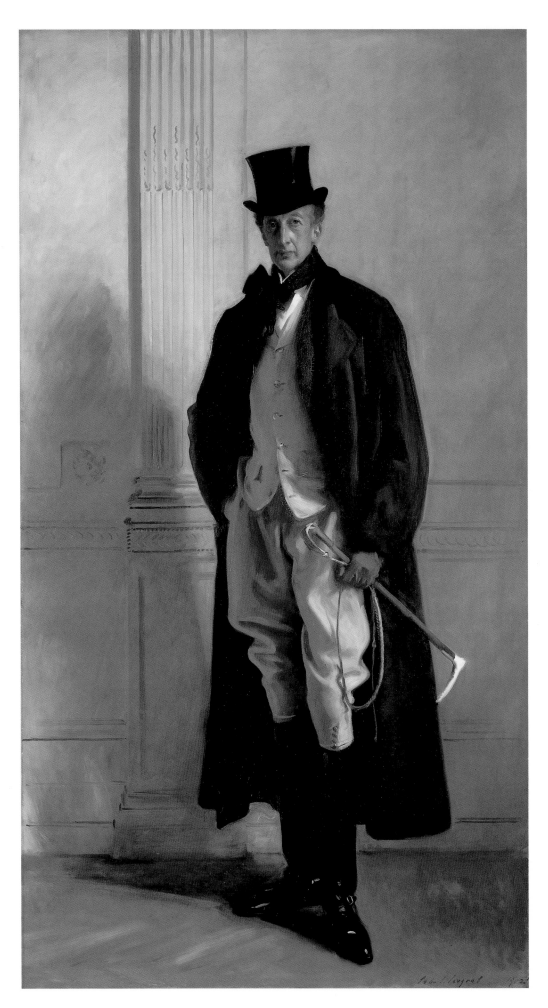

Lord Ribblesdale

VII. Canonized and Criticized

I N AN ESSAY PUBLISHED IN 1899, ARTIST John La Farge praised Sargent as "a standard bearer." According to the sixty-four-year-old New Yorker, Sargent enjoyed full recognition on both sides of the Atlantic just when Americans were beginning to appreciate the extent and significance of "American art." Without envy or complaint he observed that a "gracious fate" smiled on Sargent. In contrast to many American artists at home, he had not lost time trying to find an education that was right for him, and he did not have to "shoulder [his] way against the crowd" when he made his first mature works. La Farge contrasted Sargent with Whistler, who had actually influenced the course of European art, yet had to struggle to do so since he was a vanguard figure. Sargent had the triple approval of fashion, influential artists, and professional academies, and when many critics faulted his work they usually did so while admiring his inborn talents. La Farge quietly stated that Sargent was unequaled among modern painters in his knowledge of tonal painting and his "precise boldness" of touch; and he commended him for the innovative style and intelligence of his 1895 installation at the Boston Public Library.

Little published on Sargent in the first quarter of this century has the balance and restraint of La Farge's essay. The power invested in him as a prominent figure of the Edwardian establishment was usually met with hyperbolic praise. British and American art museums and mainstream art critics had embarked on a canonizing ritual to name him "the greatest" living portraitist or artist. However, the generation born a decade or more after Sargent was less universally accepting, and some began to give voice to a damaging attack that left no room for compromise. Sargent's art and the establishment that venerated it became one battlefield amid the larger struggle over modernist reform. Sargent made no conciliatory signs of curiosity, interest, or support for modernist art. He apparently deplored any questioning or reinterpretation of the fundamental values of traditional painting. By standing firm behind his prestige he became a target. This chapter is divided into three parts: an outline of Sargent's successes and achievements during this period; then a reconsideration of the same developments from the perspective of his oppo-

Lord Ribblesdale

1902. Oil on canvas, 101¾ x 56½"
National Portrait Gallery, London

The artist was so taken with Ribblesdale's appearance when he gave a speech at an Artists' Benevolent Fund Dinner that he approached him about a commission. A former Master of the Buckhounds (1892–95), the subject posed at the Tite Street studio in his hunting costume. His seemingly innate air of self-importance, his uniform, and the architectural classicism of his setting all signal status. The British tradition of portraying noblemen as athletic horsemen rose to a new level of swagger in Sargent's hands. Responding to the extraordinary forms and surfaces of Ribblesdale's costume, Sargent revealed the fetishistic allure of the top hat, gloved hand, riding whip, and shiny boots.

John Singer Sargent's studio, 31 Tite Street, London

Photograph, c. 1920
Ormond Family Collection

In 1900 Sargent took over the building next door to the studio and apartment that he had been renting since 1886. He maintained his old room, thereby greatly enlarging his establishment. His Tite Street house had been built in 1879 for the British portrait painter, Frank Dicey. Its studio had a large north window (seen here) with a view to the grounds of the Royal Chelsea Hospital. Sargent decorated his work space with tapestries, embroidered textiles, and old French and Italian furniture—items he often used as props in portraits. Examples of pilasters that recur throughout the room can be seen in the corner beyond the easel. One of them appears to great effect in the background of Sargent's Lord Ribblesdale.

President Theodore Roosevelt

1903. Oil on canvas, 58½ x 40½"
White House Historical Association,
Washington, D.C.

Sargent was approached to paint the official portrait of President Roosevelt in 1902. McKim, Mead, and White were remodeling the White House at the time, and they may have proposed their friend for the commission. The president posed on the new staircase in the entrance hall of the White House. He confronts the viewer from this plain, elevated setting. His robust and unyielding self-assurance is suggested by the brawny hand that grasps the newel post and by the set expression of his face. Henry Adams, one of the first to see this painting, wrote: "The portrait is good Sargent and not very bad Roosevelt. It is not Theodore, but a young intellectual idealist with a taste for athletics, which I take to be Theodore's idea of himself."

nents; and finally an attempt to interpret the artist's personal goals during his later years.

In London between 1900 and 1907 Sargent produced approximately fifteen to twenty-five oil portraits a year. He took his second installment of mural decorations to the Boston Public Library in 1903, and painted twenty portraits during an eighteen-week stay in America. A solo exhibition of studies and portrait sketches at the Carfax Gallery, London, in 1903 was the first opportunity he took to show his watercolors (five of them). The following year he joined the Royal Society of Painters in Water-Colours, and contributed regularly to their exhibitions for the rest of his life. After 1907 he became serious in his determination not to paint oil portraits. He was never able to stop, but he drastically reduced this drain on his time and patience. Portraiture remained central in his routine, however, for he had started to make charcoal drawings that could be completed in a single sitting of about two hours in length. He made over six hundred portrait drawings between 1900 and 1925, charging an average fee of four hundred dollars.

A motivating factor in these shifts was his unfinished hall at the library in Boston, which was soon joined by other decorative and "official" projects as his reason for declining portrait commissions. He remained in Europe for thirteen years before taking a third group of materials to Boston in 1916. He had produced a ceiling treatment and a series of lunettes for the long side walls that connect the parts installed

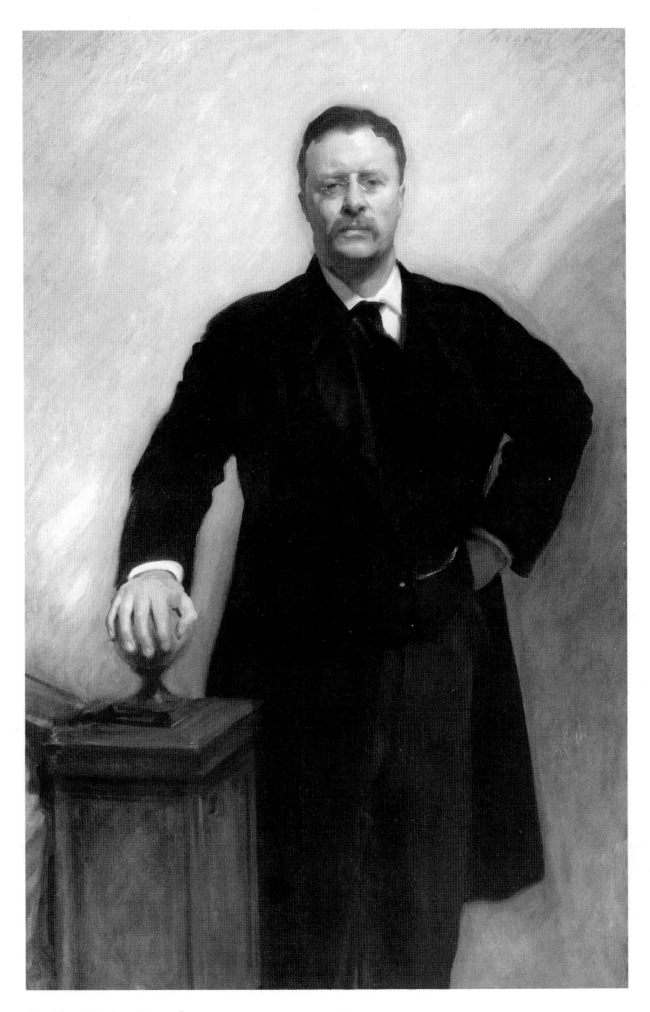

President Theodore Roosevelt

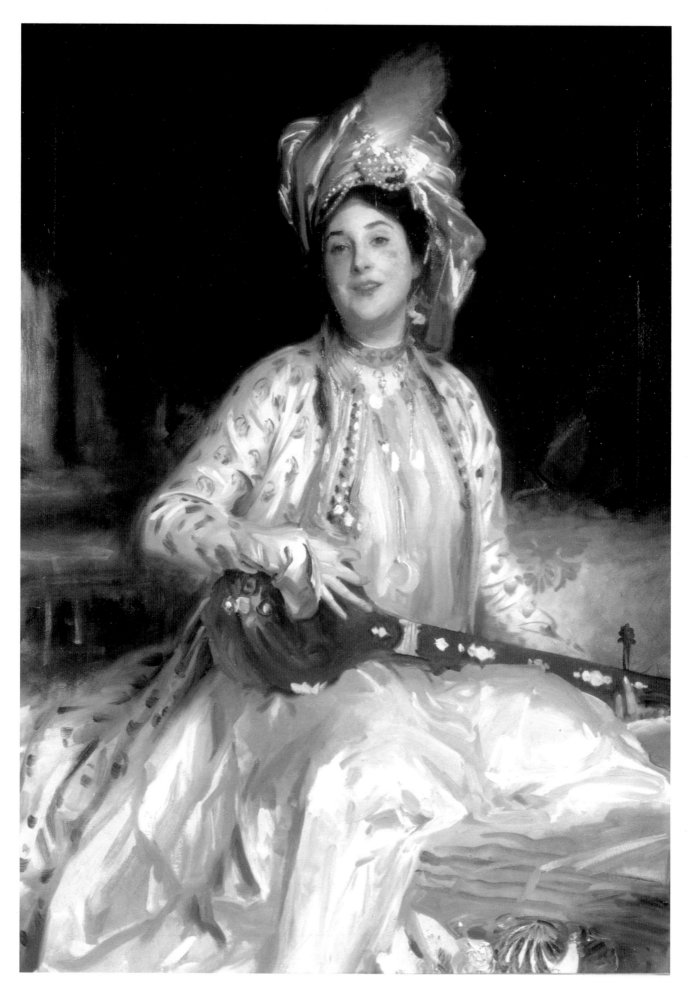

Almina, Daughter of Asher Wertheimer

in 1895 and 1903. During his stay in Boston in 1916 he received an invitation to make decorations for the rotunda of the Museum of Fine Arts, which had moved from its original 1876 building in Copley Square to an imposing, classically inspired granite structure on Huntington Avenue in 1909. He accepted, and happily developed plans more extensive than the museum trustees had intended. In the last year of World War I Sargent also agreed to work as a war artist for the British government. He painted two enormous canvases. He completed *Gassed*, a scene from military life, in 1921, and a year later he finished his group portrait of twenty-two uniformed generals standing in a row. In 1921 he was commissioned by Harvard University to create a memorial to "Harvard men who fought and died" in the Great War. He produced *Entering the War* and *Death and Victory*, two conventionally jingoistic paintings for the staircase of the Widener Library. When Sargent completed his Neoclassical decoration in the rotunda of the Museum of Fine Arts in 1921, his Bostonian patrons were eager for him to extend the scheme over the main staircase. This project occupied him until 1925, the year he died.

Sargent had to be a dynamo to take on this staggering schedule. Indeed, his stamina and powers of execution joined the list of qualities that made him seem extraordinary to his generation. Carroll Beckwith, Sargent's friend in the atelier of Carolus-Duran, wrote in his diary for 1895: "I can imagine no-one so brilliantly and justly endowed as Sargent. . . . I wonder if any painter ever stood so far above his contemporaries." "[Sargent] is the sharpest, the most precise instrument the century has forged," Marion Dixon wrote in an essay on Sargent published in 1899. His celebrated technical facility was often as lean and tight as it was elegant, giving his best paintings that exhibitionistic edge that Henry James had described as "insolent." A 1902 performance of this type, *Lord Ribblesdale,* achieves an almost sinister projection of power, demonstrating that Sargent was indeed a mirror and a propagandist for the Edwardian ruling class. When he painted President Theodore Roosevelt in Washington the following year it is not surprising that he aimed for a comparable expression of male authority. With hindsight the President's decisive grasp of the spherical finial seems to express his stance as an activist in foreign and domestic politics. Sargent's *President Theodore Roosevelt* is a middling performance, however. The head and hand are expressive, but the body and clothes seem to have been treated hastily. The stiffness that results may have been augmented by the President's insistence on holding meetings while the artist painted. *Lord Ribblesdale* is more complicated as a likeness, more telling as an emblem of a social type, and more rewarding as a formal and technical performance.

Almina, Daughter of Asher Wertheimer
1908. Oil on canvas, 52¾ x 39¾"
The Tate Gallery, London

After painting portraits of Mr. and Mrs. Asher Wertheimer in 1898 Sargent made ten more family pictures for them during the next decade. This painting of their twenty-year-old daughter Almina was the last in the series, and its only "costume piece." In her plumed turban and sparkling robes the subject continues the exotic personifications of the Orient that Europeans had promoted since the seventeenth century. The rich costume and props inspired some fine bravura passages: a wispy egret plume hovering like smoke above the turban; thickly painted highlights on the coins hanging over her breasts; in the foreground a shell-shaped silver dish holding melon slices.

Our Lady of Sorrows

1916. Oil on canvas with relief ornamentation:
wall decoration
Courtesy of the Trustees of the Public Library
of the City of Boston

After an absence of thirteen years, Sargent returned to America in 1916 to oversee the third and largest installation of his decorations for the Boston Public Library. Our Lady of Sorrows *was one of the new works. The artist adapted a seventeenth-century image in which the Virgin Mary is an object of veneration: she clutches the seven swords piercing her heart, each symbolic of an event that brought her sorrow. The theatricality and ritual aspects of this image, which is popular in Spanish churches, recall Sargent's attraction to flamboyant female protagonists in* El Jaleo *and* Madame Pierre Gautreau.

John D. Rockefeller, Sr.

1917. Oil on canvas, 70 x 60"
Collection of Senator and
Mrs. John D. Rockefeller IV

This portrait of one of the richest individuals in the world was commissioned by his only son, John D. Rockefeller, Jr. The billionaire's heir offered to pay Sargent one hundred thousand dollars for five oil portraits of members of the Rockefeller family. The artist could only be persuaded to make two: both of the legendary founder of the fortune. This, the second canvas, was painted at Kykuit, the Rockefeller estate near Tarrytown, New York. Sargent stayed there for almost three weeks while he worked on the painting. From 1917 to 1919 Rockefeller's son arranged for the portraits to be given special showings in museums in ten American cities.

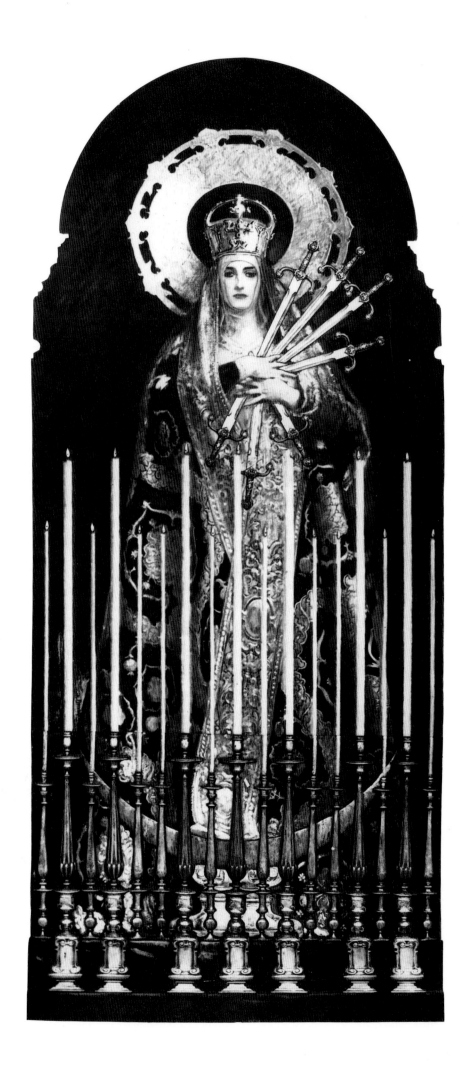

John D. Rockefeller, Sr.

Bernard Partridge.
Desirable Aliens

Cartoon for Punch, or London Charivari,
January 31, 1906

In 1906 it was commonplace to tout Sargent as a modern Velázquez. When the British national collection coincidentally but simultaneously acquired a famous work by each artist the satirical magazine Punch *responded quickly. The celebrated Jewish art dealer Joseph Duveen had purchased Sargent's* Ellen Terry as Lady Macbeth *for the nation, and he had also contributed funds towards the purchase of* Venus and Cupid *by Velázquez. Since neither artist was British it was accurate for* Punch *to describe them as desirable aliens, but in fact the title was a cruel play on the Aliens Act of 1905, which limited Jewish immigration. The racist implication was that Duveen had bought his way into the British establishment by helping Velázquez and Sargent to enter the National Gallery.*

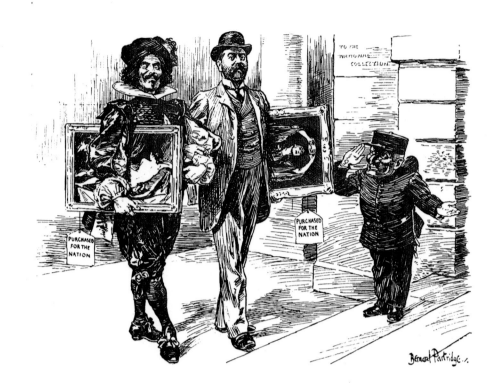

Self-Portrait

1907. Oil on canvas, 30 x 25"
Galleria degli Uffizi, Florence

Sargent's last self-portrait in oils was made at the time he began to decline commissioned portraits. However, the Uffizi Gallery's request for a self-portrait was an honor, a recognition of his international reputation. The painting joined a celebrated collection of hundreds of artists' self-portraits, including works by David, Ingres, Michelangelo, Rembrandt, Reynolds, Titian, and Velázquez. The other contemporary artists already represented in this specialized collection were such established figures as Bonnat, Bouguereau, Fantin-Latour, and Zorn.

There can be no doubt that Sargent's celebrity was enhanced by that of his clients, from statesmen and executives to famous authors, performing artists, and society beauties. Eventually, the process became reciprocal. Henry Adams said that a portrait by Sargent was one step "essential to immortality." It is sometimes argued, with snobbish innuendo, that Sargent was most useful to people with new money or foreign blood who wanted to buy social recognition. In fact the established classes relied on his services to extend their heritage. He worked for venerable establishments, memorializing the presidents of Bryn Mawr and Harvard, the headmaster of Eton, and the Archbishop of Canterbury. He made over two hundred charcoal portraits in his last six years, and most of them were blue bloods, including Mrs. John Nicholas Brown, Lady Elizabeth Bowes-Lyon (the mother of Queen Elizabeth II), and Winston Churchill. In 1917 he succumbed to the badgering of John D. Rockefeller, Jr., who wanted a suite of family portraits. Sargent obliged with two oil paintings of the seventy-eight-year-old patriarch, Mr. Rockefeller, Sr. (at fifteen thousand dollars apiece), but declined other commissions. His subject's son wrote to Sargent telling him that he was going to have the portraits exhibited in American art museums: "[They] reveal at a glance . . . the greatness of soul of this splendid man. I want to have people throughout the length and breadth of this land to see [them], for I feel that through your great art Father will be revealed to the American people as he could not have been in any other way." With Sargent's approval Rockefeller commissioned reproductions of the orig-

Self-Portrait

Above:
*Vaslav Nijinsky in "Le Pavillon
d'Armide"*
1911. Charcoal, 24¼ x 18⅝"
Private Collection

Sargent drew Nijinsky for the Marchioness of Ripon, who brought Diaghilev's Ballets Russes to London to celebrate the coronation of King George V. He showed the young Russian in a costume that he first wore in Paris in 1909, when he played the favorite slave of a wizard's daughter. Sargent's dramatic division of the background into black and white areas emphasizes the dancer's extraordinary neck and its carriage. The drawing captures the sexual ambiguity with which Nijinsky defied conventional gender stereotypes.

Right:
Baroness de Meyer
c. 1907. Charcoal on paper, 34½ x 28"
Birmingham Museum and Art Gallery, England

Reputedly the natural child of Edward VII, Olga Caracciolo grew up in an Italian noble family. Her second husband, Adolphe de Meyer, was a portrait and fashion photographer, and they were prominent in fashionable society. In this drawing Sargent reflects his subject's aura of grand theatricality with a flurry of slashing lines. The slanting asymmetries of her hat, her smile, and her neck accompany a slightly wild-eyed stare and evoke a splendid eccentricity. The artist uses the tonal range of charcoal here to great effect.

inals in a variety of media: photographs, engravings, and five replicas of each composition painted by other artists. These images, donated to various educational and commercial institutions, extended the influence of the original provided by Sargent.

The modernist position against Sargent began to take shape in 1900 in a review by Roger Fry, a thirty-four-year-old artist and writer. After an undergraduate training at Cambridge University, Fry studied art in Paris in the 1890s; in 1910 he would coin the term Post-Impressionism, consolidating his role as a British modernist crusader. In contrast to those who criticized Sargent's bravura only when it seemed slapdash, Fry questioned its validity entirely. In his review of the group exhibition at the New Gallery in 1900 he acknowledged Sargent's *Major-General Ian Hamilton* as a brilliant example of his work, but pointed out that the artist was a "précis-writer of appearances," with "no desire to transcend the mood of ordinary life." Sargent missed "fundamental traits of character"

CANONIZED AND CRITICIZED

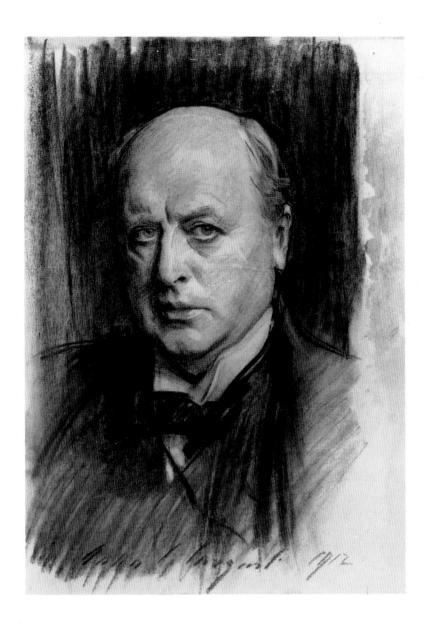

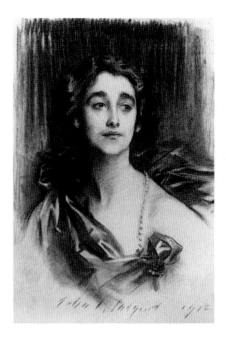

and "important emotions" because his summary technique was devoted to external appearance. Fry's punch line was "I cannot see the man for the likeness." In an unsigned review of Sargent's solo exhibition of sketches and watercolors (Carfax Gallery, 1903) Fry focused his argument: Sargent was "our best practitioner in paint," but he must be ranked with the "professionals" and not the "poets." He belittled the Venetian sketches by resorting to the pernicious language of class. Sargent had the reactions of "an ordinary tourist," his color would appeal to "the common man," and his paintings of gondoliers focused on a "vulgarly picturesque type." Fry insisted that facility was not an acceptable excuse for the poor quality of Sargent's imagination and his lack of "finer perceptions and instincts."

Sargent had largely withdrawn from the French art world by this time, and was probably surprised by the critique written in 1905 for the magazine *Les Arts de la Vie* by Comte Robert de Montesquiou (a sitter to

Stairway leading to Sargent's
decorations at the Museum of
Fine Arts, Boston

Installed in 1921. Photograph
Courtesy the Museum of Fine Arts, Boston

*In 1909 the Museum of Fine Arts
moved to a new location on Huntington
Avenue, and seven years later the
Trustees commissioned Sargent to deco-
rate the rotunda at the top of the grand
stairway. Sargent was the only artist
invited to make decorations, and his
work was to occupy the heart of the insti-
tution. His fee for the project was
$40,000. The rotunda has an elliptical
plan, with its major axis aligned to the
approach from the main staircase. The
visitor ascends towards an oval paint-
ing whose subject suggests the custodial
role of museums:* Architecture, Paint-
ing, Sculpture Protected by Athena
from the Ravages of Time.

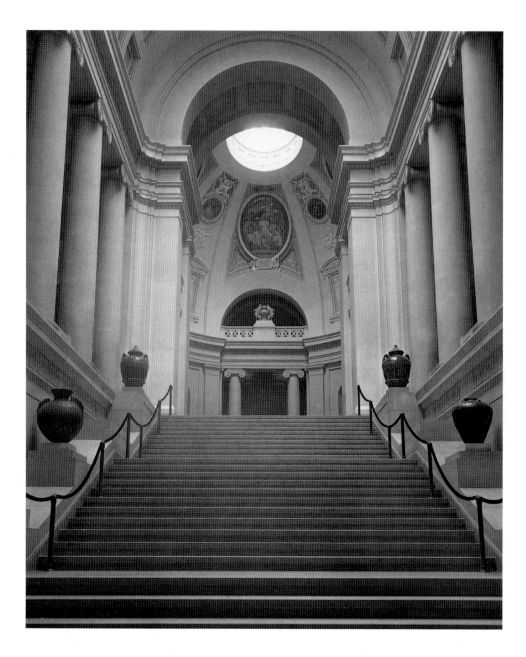

Sargent's decorations for the
ceiling of the rotunda, Museum
of Fine Arts, Boston

1921. Photograph
Courtesy the Museum of Fine Arts, Boston

*Although he had been asked to provide
large lunette paintings for the existing
dome, Sargent chose to redesign the
entire space. It was an opportunity to
unite painting, sculpture, and architec-
ture, following the grandest traditions
of European high art. The paintings do
not dominate his final statement, rather
they are elements in a comprehensive
scheme of ornamental frames and bas-
reliefs. The paintings have rich blue
grounds, and together they read as
medallions in the predominantly white,
pale yellow, and gold dome. This scheme
is the most complete statement of the
orderly and delicate Neoclassicism that
Sargent now embraced.*

Whistler and Giovanni Boldini, and a model for Proust's homosexual
character, M. de Charlus). The French aesthete reviewed *The Work of John
S. Sargent, R.A.,* a volume of photogravures published two years previ-
ously in London and New York, and his epigraphic title, "Le Pavé rouge,"
likened the massive book with red bindings to an extravagant paving
stone. The count had a distrust of the book's monumentalizing program
and saw a consistency between its less-than-refined characteristics and
the art it illustrated. He made an exception for *Madame Pierre Gautreau*—
a magnificent, graceful, magisterial, and unforgettable work—which
represented for him the culmination of Sargent's career at its beginning.
Sargent had not learned that virtuosity for its own sake was a sign of grave
inferiority, and he did not deserve his reputation. Montesquiou argued

CANONIZED AND CRITICIZED

Sargent's decorations for the ceiling of the rotunda, Museum of Fine Arts, Boston

A Wrecked Sugar Refinery

that Boldini practiced virtuosity with more intelligence than Sargent, using its expressive power to suggest the sitter's character, passion, and soul. The count's critique of Sargent differs from that of Fry in not being allied to a modernist agenda. But they share a growing distaste for the factitious and meritorious impulses of the art favored by the establishment. The British artist Walter Sickert addressed this issue in a 1910 essay for the weekly magazine *The New Age*: "I herewith convict almost the whole critical Press of this country for ten years either of elementary ignorance, or laziness and indifference, or of craven abjection to a social and commercial success." Sickert's title was "Sargentolatry."

These opinions were not shared by most artists and critics, and when Fry wrote on Sargent again in 1923 he confessed to feeling like "a solitary Devil's advocate." He reviewed the nine portraits that the Wertheimer family had donated to the National Gallery, and commented on the fact that Sargent was now "more fully represented than any living and almost any dead artist in our national collections." He spoke of pure art and applied art, and placed Sargent in the latter category, where he was "a brilliant ambassador between [his patrons] and posterity." He concluded that the "purely aesthetic point of view" was irrelevant in a discussion of Sargent, who practiced applied art. Sargent had no passion to discover visual truths: he was happy to take a technique invented by the pure artist Manet and apply it to a social end. Manet pursued "aesthetic significance" and Sargent put it to practical use.

The 1913 Armory Show, an international survey of modern art shown in New York, Chicago, and Boston, turned national attention to such new movements as Expressionism, Fauvism, Cubism, and Futurism. In its wake more Americans joined in the modernist critique of Sargent and his reputation. When Forbes Watson wrote an essay in 1917 on the

The British War Memorial Committee commissioned Sargent and several other artists to make works for a future Hall of Remembrance. Sargent observed life in the trenches at the front line in France. In his London studio he worked with models and re-imagined a scene outside a treatment center. Soldiers blinded by mustard gas are gathered together, and stumbling lines of men are led to a medical tent for new dressings. As much as his image illustrates suffering in a compassionate manner, Sargent chose a spectacle that would satisfy his pictorial needs. His image accords overriding respect to the traditional format of the classical frieze and plays down ugly details.

A Wrecked Sugar Refinery

Sargent spent over three months in France as a British war artist in the summer of 1918. He made a few watercolors such as this, recording damaged buildings. Their mood is always detached. Evidently he wanted to document the facts before him in a visual record that does not comment on or interpret the suffering and destruction occasioned by the war.

Boston Public Library decorations he began by lamenting "the curious extremes of blind praise and blind condemnation which Sargent's work now calls forth." Watson argued persuasively that Sargent, his champions, and his Bostonian patrons constituted an aging generation that was ignorant of the "vital art" that flourished in Paris in the 1890s and was "stirring the world almost everywhere." Inspired by Cézanne, Matisse, and Picasso "the modernist [artist] is trying to bring back to life ideas—fundamental ideas—which the Sargents of this world have clouded in veils of cleverness." When Watson viewed Sargent's murals he felt no "aesthetic thrill." Noticing that visitors gave most attention to the descriptive brochures provided by the library, he argued that the art lacked the power to "kindle the responsive imagination." Sargent's admittedly ingenious weaving of religious symbols struck him as "artificially antique, a cold and soulless eclecticism." In his estimation *Our Lady of Sorrows* was a low point: a display of "decadent ecclesiasticalism." In 1921 Paul Strand, a thirty-one-year-old American photographer in the circle of Alfred Stieglitz, relied on modernist orthodoxy for a harsh dismissal of Sargent's watercolors: "Mr. Sargent escapes the reality of American life, both physically and in spirit. He is one of our expatriates. He travels about the world to record with undoubted virtuosity the places in which he has not really lived, whose pulsating life he could neither feel nor understand. He gives us merely, but with greater ability, the average vision of the travel-book illustrator, a vision which is photographic in the worst sense of the word, unorganized and formless—a record of something that has been seen rather than life that has been felt." Strand's hero was John Marin, who painted quasi-abstract vital gestures in landscape formats. Strand saw in Marin's art a synthesis of admirable, but opposing, tendencies—Winslow Homer's "powerfully male vision" and Charles Demuth's "sensibility and whimsicality."

One assumes that Sargent was affected by this mounting reaction against his work, although he made no statements in his own defense. Again he was the antithesis of Whistler, a showman who turned to his advantage all opportunities to rebut his opponents. The modernist attacks may have seemed unimportant to Sargent compared to the massive support system that exalted him: the steady stream of exhibition projects, wildly enthusiastic responses in the mainstream press, and representation in the permanent collections of museums around the world. Sargent even declined the knighthood that Edward VII offered him in 1907, choosing to retain his American citizenship. He may have attributed some of the attacks to jealousy, for wealth, reputation, and independence made his position enviable. Roger Fry was the cause of the one occasion when Sargent took a public stand on a somewhat controversial

issue. Fry had asked Sargent's permission to list his name as a supporter of the exhibition "Manet and the Post-Impressionists" that he organized at the Grafton Galleries in 1910. Sargent declined. The exhibition, which included Cézanne, Denis, Derain, Gauguin, Maillol, Matisse, Picasso, Redon, Rouault, Seurat, Van Gogh, Vlaminck, and others, administered a shock to the London art world. Fry discussed his project in an essay in *The Nation,* listing Sargent as a supporter of the movement. Finally the artist struck back. He wrote to the editor with understandable annoyance, and in the anger of the moment revealed the extent of his conservatism: "I am absolutely sceptical as to [the paintings on exhibition] having any claim whatever to being works of art, with the exception of some of the pictures by Gauguin that strike me as admirable in color, and in color only." He also noted that the new term Post-Impressionist did not apply to Manet and to Cézanne. Sargent's letter was published, followed a week later by Fry's rejoinder, in which he stated that he had a letter from Sargent expressing an admiration for Cézanne. Some insight into the artist's stodgy behavior may be gained from Vernon Lee, who was "admonished" by Sargent in the late 1890s for writing about the relation of psychology and art. Their friendship lasted because she chose not to discuss these interests in his presence: "Sargent did not like opposition, nor I dogmatism."

The Post-Impressionist episode of 1910–11 forced Sargent to declare his colors. In 1914 he said to his old friend Helleu: "Ingres, Raphael and El Greco, these are now my admirations, these are what I like." He knew the violence and unrest of the modern world, but he refused to give it relevance or meaning in his view of the fine arts. Two incidents that must have disturbed him deserve mention. At the Royal Academy in 1914 an activist slashed Sargent's new painting of Henry James to draw attention to the struggle of women for the right to vote. In 1918 his niece Rose-Marie was killed in the German bombardment of Paris. When he went to the Western Front as a British war artist in 1918 modern warfare did not ruffle him. He was so immured in his civilized routine that he assumed that nobody did any fighting on Sundays. Mostly he was frustrated because he could not find an acceptable subject. He wrote his friend Mrs. Charles Hunter that his visits to the trenches had been a waste of time: "It is ugly, meager, and cramped, and one only sees one or two men." He perked up when he saw "roads crammed with troops on the march. It is the finest spectacle the war affords, as far as I can make out." In the end he painted *Gassed,* a handsome frieze-like painting that idealized the horror and obscenity of chemical warfare into a more general and decorative expression of pathos. Sargent's genteel, aestheticized detachment from his subject is astonishing. The passion and folly of the human con-

Classic and Romantic Art

1921. Oil on canvas: decoration in the Dome
of the Rotunda
Courtesy the Museum of Fine Arts, Boston.
Francis Bartlett Donation

*Sargent invented this scenario in which
Apollo, the leader of the Muses, deliber-
ates between the romantic and the classic
impulses. Romantic Art is a young man
standing before the lusty animal god
Pan; Classic Art is a young woman
kneeling in the caress of the wise and
civilizing goddess Athena. Each holds a
lyre that expresses their opposing tem-
peraments and reinforces gender stereo-
types: the man's is rustically fashioned
from a tortoise shell, while the woman's
is an elegant, finely crafted instrument.*

dition are more evident in *Lord Ribblesdale* than in the dozens of blinded soldiers carefully composed in the foreground of *Gassed*.

The London art world entered headlong into change in the 1910s, as a new generation emerged and more art groups than ever before struggled for expression and recognition. Several people used Sargent as a negative example against which to define their own position. Psychologically he beat a retreat to Boston, a smaller pond, a town that still loved him, and an arts establishment that had managed to learn nothing and to acquire nothing from the Armory Show in 1913. In the last ten years of his life he spent more time in Boston than London. When the Museum of Fine Arts commissioned him to decorate its rotunda in 1916, it became the primary focus of his professional attention for the rest of his life. His embrace of Neoclassical style was well suited for the temple-like central space that gave immediate access to very different collections: Asian Art, the Tapestry Hall, and Egyptian Art. There was no overall title or theme to Sargent's project. The motifs of his paintings and bas-reliefs were a personal selection, mostly from classical mythology. For two large niches the artist selected plaster casts of two celebrated classical sculptures in Roman museums: the Capitoline Venus and the

Left:
Studies for figure of Romantic Art (Rotunda of Museum of Fine Arts, Boston)

1917–20. Charcoal on off-white paper, 22 x 28"
Courtesy the Museum of Fine Arts, Boston.
The Sargent Collection. Gift of Miss Emily Sargent and Mrs. Violet Ormond in memory of their brother, John Singer Sargent

Thomas McKeller is recognizable in the beautiful study of the singing head that is sketched in detail at the left.

Right:
Studies for figure of Classic Art (Rotunda of Museum of Fine Arts, Boston)

1917–20. Charcoal on off-white paper, 22 x 28"
Courtesy the Museum of Fine Arts, Boston.
The Sargent Collection. Gift of Miss Emily Sargent and Mrs. Violet Ormond in memory of their brother, John Singer Sargent

Even though the figure in the final painting is female, this drawing confirms that Sargent worked from a male model (Thomas McKeller) to create the pose and the hand gesture.

Sargent used drawings from a model as preliminary images that were reworked into the conventionalized ideal figures that populate his murals in the rotunda. The process is apparent in this drawing. In the upper right corner is a quick sketch of McKeller's head and neck in the pose of Apollo in Classic and Romantic Art. *To the left Sargent copied the outlines of the neck and turned head, then carefully added the hair and idealized features of one of the most famous classical statues: the Apollo Belvedere in the Vatican Museum. He probably copied a photograph or a print of it, although he may have had access to a cast.*

Sargent's studies from female models are generally more prim than those of males. Even though this drawing is primarily a study of the silhouette rather than the form, his tendency towards restraint is apparent, both in his markings and in the image itself. While he struggled to capture bold forms and shapes in men and women he was less engaged by the female body. The only nude that Sargent exhibited widely during his lifetime was a study of an Egyptian woman painted in Egypt in 1891: the subject is viewed from the rear, with her torso twisted to bring her face and one breast into profile. The outlines of the figure are very labored and overworked.

Minerva Giustiniani. When he extended the project over the staircase he regrouped the massive columns flanking it and designed new ornamental railings. Guidebooks and pamphlets provided verbose descriptions of individual characters, myths, and legends, but offered no point of contact with the twentieth century, other than the lesson of unbending respect for tradition. In 1921 Bernard Berenson described Sargent's rotunda to Ralph Curtis as "very lady-like." Given his scholarly love of Renaissance art Berenson was bound to have reservations about Sargent's light neo-Wedgwood eclecticism; his assessment was accurate and much less damning than modernist reactions. In his diary of 1957 Berenson wrote, "The contemptuous indifference toward [Sargent] is sure to pass, and I prophesy he will be appreciated at his value."

Studies of Aphrodite for "Aphrodite and Eros"

Horst. *Dresses by Mary McFadden*

VIII. Aftermath: Placing Sargent in the History of Art

Bernard Berenson's prediction that Sargent will be "appreciated at his value" has come true, and yet "Sargent" will always represent different qualities and shades of meaning for different people. A single perspective should not be expected on this complicated, paradoxical, and elusive historical figure, whose oeuvre is massive, diverse, and uneven. Sargent wanted to be remembered as much more than a portraitist. Portraiture occupied the center of his creativity, but was flanked by the mural decorations and the informal works, most notably the watercolors. His push to leave a permanent legacy on the walls of three cultural institutions in Boston was equaled by a determination to place his watercolors in museums: between 1909 and 1917 he sold eighty-three to the Brooklyn Museum, forty-five to the Museum of Fine Arts, Boston, eleven to the Metropolitan Museum of Art, New York, and eleven to the Worcester Art Museum; he donated ten to the Imperial War Museum, London, in 1910. Even so, he reserved the words "the best thing I have done" for a portrait, using them when he sold *Madame Pierre Gautreau* to the Metropolitan Museum of Art in 1916. Even his most outspoken critics, Fry, Montesquiou, and Watson, all singled out this one work for praise.

The attack on Sargent's reputation was taken up with a vengeance during the Depression, as seen in the harsh words of Lewis Mumford in his 1931 book *The Brown Decades*: "Sargent remained to the end an illustrator. . . . The most adroit appearance of workmanship, the most dashing eye for effect, cannot conceal the essential emptiness of Sargent's mind, or the contemptuous and cynical superficiality of a certain part of his execution." Mumford's heroes—Eakins, Homer, and Ryder—pale beside Sargent when judged in terms of fluency and technical ability, but they had other qualities that were more valuable to Mumford's progressive ideals. Their histories were reconstructed and retold in terms of homespun American concepts, just as Sargent was recast as a total "expatriate" who identified with the aristocratic European types encountered in his art. Nativist bias resulted in a simplistic polarization between

Horst. *Dresses by Mary McFadden*
Photograph for French *Vogue*, March 1983.
[copyright] Horst. Courtesy of *Vogue*, Paris

Long after its creation, Sargent's portrait of the languid and sumptuous Wyndham sisters became the backdrop for a fashion photograph by Horst. The location is the aggressively austere stairwell of the 1980 addition to the Metropolitan Museum of Art's American Wing. Horst's image takes advantage of the parallel strategies of society portraiture and fashion photography. Just as Sargent depicted his subjects in front of Watts's showy portrait of their mother, Horst incorporates the Sargent as a precedent and a status symbol to endorse Mary McFadden's dresses. Sargent promotes the dynastic power of the Wyndham family, and Horst invents similar associations of privilege when foregrounding his client's merchandise. Both men exploit the female body as object and spectacle in their images.

Eakins' unglamorous, hard-bitten American sitters and Sargent's smart, smiling international subjects. The American cult of nature favored the Whitmanesque energy and power of Homer's art to the effete artifice of Sargent's society pictures. Formalist bias set Ryder's elementally simple, poetic images against Sargent's clever impressions of an observed reality.

Sargent's allegiance to the most harmful values of the British upper-class—snobbery and hypocrisy—was criticized by the writer E. M. Forster in his 1925 essay "Me, Them, and You." Forster described a visit to the Sargent Memorial Exhibition at the Royal Academy, where he was overwhelmed by the attitude of the people and the costumes in the portraits: "A pall of upholstery hung over the exhibition. . . . Gazing at each other over our heads, [the portraits] said, 'What would the country do without us? We have got the decorations and the pearls, we make fashions and wars, we have the largest houses and eat the best food, and control the most important industries, and breed the most valuable children, and ours is the Kingdom and the Power and the Glory.'" He admired the charm of Sargent's work, the "gracious" images of Venice, and the handful of portraits in which Sargent was "pleasantly mischievous" at the expense of his sitters; but he was appalled by the gulf that separated "Them" from "Me," and the wider gulf between these parties and "You"—the lower classes. The one significant appearance of working-class subjects in the Sargent Memorial Exhibition was in *Gassed*. Here their representatives were "golden-haired Apollos . . . with bandages over their eyes." Fourteen years later John Sloan, an American socially-concerned artist, urged art students to shun worldly success in his book *The Gist of Art*. He used Sargent as a negative model: "[He painted] an expensive conglomeration of oil paint marks imitating the light and shadow shapes on faces, furniture, and satin dresses. . . . He was decorated and lionized, made a lot of money. And what is his success today?"

The extended impact of this shift in ideology was graphically illustrated by a recent economic study that rated Sargent as the "worst investment" in the period 1635 to 1987: in 1925 the painting *San Vigilio* was auctioned for $35,280 from the artist's estate, and it fetched only $294 in 1952 (both figures adjusted for inflation). However, this was the lowest ebb, and apathy towards Sargent began to change. Frederick A. Sweet's 1954 exhibition and catalogue *Sargent, Whistler and Mary Cassatt* presented these three artists in a positive light as Americans working abroad. Even though they could not be lauded as being essentially and peculiarly American, the disparaging views expressed in recent decades were deemed inaccurate and unnecessary. In Sargent's case Sweet stressed the unfairness of basing an opinion solely on his facility with a

brush. His gifts as an artist also involved the analysis of character through the social signals and psychological nuances communicated by clothes, gestures, and expressions. As responses to fashions and cultural trends his portraits were also a valid commentary on manners and worldliness.

Starting in the 1960s new scholarship has revealed the complexity of Sargent and his work. A pluralistic interest in figurative art as well as abstraction may have prepared the way. There was also a Victorian Revival in the 1960s, a reaction against industrialized culture engulfed by plastic throwaway products, and a naive nostalgia for a less fragmented way of life. In our seemingly less biased times Eakins, Homer, and Ryder are also understood as more complex artistic personalities, who visited or studied in Europe, and developed their own art in relation to European as well as American practices. Finally, Sargent becomes more interesting as a contributor to American culture beyond his own art-making. For example, through his advocacy several superb works of art are now in American museums: El Greco's *Fray Hortensio Paravicino* at the Museum of Fine Arts, Boston; Michelangelo's *Studies for the Libyan Sybil,* at the Metropolitan Museum of Art, New York; and Boldini's *James A. McNeill Whistler* at the Brooklyn Museum. His life and work abroad allowed him to make this kind of gesture.

The *Nude Study of Thomas E. McKeller* is a portrait of one of Sargent's favorite Boston models in the last phase of his career. The painting was in the artist's Boston studio at his death, but unlike so much of the material found there it was neither kept by his sisters nor given to museums. It is doubtful that this work would have been considered, let alone purchased by the Museum of Fine Arts, Boston, until recently. Many interconnecting questions are raised by this painting. They cannot be answered definitively, but they point to the possibilities of future Sargent studies. The richly worked surface of this study demonstrates the survival of Sargent's technical gifts into his sixties. The subject's spiritual revery, enhanced by the light pouring directly down onto his face and chest, is unusual in Sargent's work, and therefore all the more remarkable. I would argue that there is a spiritual feeling and humanity in this work that is lacking in the formalistic Christian murals at the Boston Public Library. Then there are the paradoxical aspects of this work. It is painted over an oil sketch of an eagle that is not completely covered; this layering is visually exciting to modern sensibility, but may mean that it was originally considered unfinished. The painting depicts the man who posed for many of the male and female classical figures in the Museum rotunda. Sargent's idealization of a black body and identity into white archetypes underscores the complexity of racial issues in the United

States. The model's pose allows many readings, including innocent open-ness, sexual invitation, vulnerability, or subjugation. In this most inti-mate work by Sargent, which is also his only oil painting of an African-American, it would be instructive to know what the sitter thought—did he see "himself" or his body as Sargent viewed and con-structed it? The *Nude Study of Thomas E. McKeller* is not closely related to any of the poses that appear in the finished murals. Is it, then, a study for a mural, a portrait, or a spontaneous and informal image of a beautiful male body? If Sargent suffered through sexual inhibition or socially induced shame about homosexuality, he may have been able to express this part of his personality by painting Thomas McKeller.

To conclude this study on an open note I present a selection of posthu-mous comments about Sargent that I find provocative, both individually and as a group. As assessments of Sargent's character, his perceived inter-ests, and his art, they all function on some level as partial portraits.

Vernon Lee (nom de plume of Violet Paget, British writer), 1925
[He was] at bottom a puritan, forever questioning and curbing the divine facility of his gifts, setting them new tasks from a puritan's hatred of yielding to his own preferences, a puritan's assertion of liberty against the wiles of enslaving mannerism, that Delilah. . . . Sargent surely inher-ited his horror of all lines of least resistance [from his father].

Evan Charteris (British writer; biographer of Sargent), 1927
His burly, full-blooded aspect was deceptive: it gave no warrant of the diffidence and gentleness that lay beneath. A stranger would never have suspected that behind such alacrity and power was an almost morbid shrinking from notoriety and an invincible repulsion from public appearances. In this respect he represented a continual paradox.

Cecilia Beaux (American artist), 1930
He was a very shy man, and his almost stammering appeal to me as to what I thought of the problem [in one of his designs] was that of an eager, anxious self-doubter. I saw that his "worldly" appearance, manner, and speech were a sort of armor for his sensitiveness, though not an armor put on by him, for he was homogeneous.

W. Graham Robertson (British artist), 1931
[Like Henry James, Sargent was] plus Anglais que les Anglais, with an added fastidiousness, a mental remoteness that was not English. Both were fond of society, though neither seemed at one with it. Sargent talked

Nude Study of Thomas E. McKeller
1917–20. Oil on canvas, 49½ x 33¼"
Courtesy the Museum of Fine Arts, Boston.
Henry H. and Zoe Oliver Sherman Fund
Unlike his decorations for the Boston Public Library, which were created in London, Sargent did most of the work for the museum rotunda in Boston, where McKeller was his favorite model. For example, his broad-shouldered physique is unmistakable as Apollo in Classic and Romantic Art. *McKeller was a veteran of World War I, and worked in a hotel as a bellman. The straddled pose in this painting does not appear to be a study for a particular fig-ure in the murals, and thus the work might be considered an informal por-trait of the man. It is a tender and superbly executed image of a person in whose body Sargent saw beauty. The painting remained in the artist's Boston studio at his death.*

Nude Study of Thomas E. McKeller

*Nude Male Standing
(Thomas E. McKeller)*

1917–20. Charcoal, 25 x 19"
The Philadelphia Museum of Art.
Given by Miss Emily Sargent and
Mrs. Francis Ormond

*This drawing, like the oil painting of
McKeller, is not closely related to any of
the figures in Sargent murals. Today
both are intriguing and significant as
informal portraits of a favorite model.*

little and with an effort; why he "went everywhere" night after night
often puzzled me.

Bernard Berenson (American connoisseur), 1957
I would not agree [with those who thought that Sargent was] by far the
greatest of contemporaries, and got myself disliked everywhere for stand-
ing aside. I did not fail to appreciate his draughtsmanship, his tech-
nique, his arrangements, as well as his sensory revelation of character. If

he degenerated in London, it was due to sitters who would be done by him. As a man he was good company, although not overexpressive. A musician, a great and selective reader, an appreciator, a loyal friend. Was he a lover of women?

Francis Haskell (British art historian), 1971
He always seems to have responded to power more than to elegance: he is rare among fashionable portraitists in having produced more impressive images of men than of women. The fact that he (like Reynolds) never married may be linked in some way with the nature of his art.

Leon Edel (American writer; biographer of Henry James), 1986
There is abundant evidence that he was a typical Victorian bachelor, whose sexual drive was invested totally in his painting. He was a workaholic who stuck close to his sisters. He kept a proper distance from women, and where other artists prefer nudes, Sargent's preference was for clothed society ladies, with all their jewelry and their crisp finery.

Robert Hughes (Australian art critic), 1986
Sargent was the unrivaled recorder of male power and female beauty in a day that, like ours, paid excessive court to both. . . . In his *Belle Epoque* sirens, in the mild, arrogant masks of his Edwardian gentry, are preserved the lineaments of a world soon to be buried like Pompeii, along with Sargent's own reputation, beneath the ash and rubble of World War I. Of course, he had to be revived. In Reagan's America, you cannot keep a good courtier down.

Andy Warhol (American artist), 1986
[Sargent's London portraits] are great. He made everybody look glamorous. Taller. Thinner. But they all have mood, every one of them has a different mood. . . . The drawings are so beautiful. . . . I guess maybe I change my mind—Sargent's watercolors are just as beautiful as his portraits. They're actually better, aren't they? Watercolors are so hard to do.

Chronology

1856 Born January 12 in Florence to American parents who had left Philadelphia for Europe in 1854.

1868–72 Does copy work in various European museums; receives private instruction in drawing and watercolor.

1873 Enrolls in the Accademia delle Belle Arti, Florence.

1874–78 Studies painting in the atelier of Carolus-Duran in Paris. Competes successfully for a place in drawing classes at the Ecole des Beaux-Arts.

1875 Takes studio at 73 bis rue Notre-Dame-des-Champs, in the Luxembourg section.

1876 First visit to America. Meets relatives and attends Centennial Exhibition in Philadelphia. Does not work professionally on this trip.

1877 Awarded medal for ornament drawing at Ecole. *Miss Frances Sherborne Ridley Watts*, his first submission to annual Salon exhibition, is selected.

1878 Summers in Naples and Capri.

1879 Receives an Honorable Mention at Salon for *Carolus-Duran*. Travels in Spain; copies paintings by Velázquez in the Prado.

1880 Crosses from Spain to Morocco. Copies paintings by Frans Hals in Holland; also studies Rembrandt and Rubens. In Venice, from September through January 1881.

1881 Awarded a second-class medal at the Salon for *Madame Ramon Subercaseaux* and *The Pailleron Children (Edouard and Marie-Louise)*.

1882 Exhibits *El Jaleo: Danse des Gitanes* and *The Lady with the Rose* at Salon. Exhibits in London for the first time, at Royal Academy, Grosvenor Gallery, and Fine Art Society. Returns to Venice in summer.

1883 Moves to new house and studio at 41 Blvd. Berthier, in the Batignolles-Monceau section.

1884 At Salon *Madame Pierre Gautreau* provokes widespread criticism. Undertakes a few portrait commissions in England.

1885 Spends summer in the English village of Broadway and begins work on *Carnation, Lily, Lily, Rose*.

1886 Vacates Paris studio and moves to London. Takes studio on Tite Street in Chelsea.

1887 *Carnation, Lily, Lily, Rose* at Royal Academy, London. Travels to America to paint portraits in Newport, Boston, and New York.

1888 When in Boston his first solo exhibition is presented at St. Botolph Club. In summer paints Impressionist works at Calcot, in the Thames Valley.

1889 Father dies in England. Awarded a Grand Prize at the Universal Exposition, Paris, and named a Chevalier of the Legion of Honor. Paints the dance troupe representing Java at the Exposition. Continues his British Impressionist works at Fladbury, Worcestershire.

1890 Spends ten months in America, painting portraits in New York and New England. Invited to contribute mural decorations to the new Boston Public Library.

1891	Travels in Egypt, Greece, and Turkey. Elected Associate of the National Academy of Design, New York.
1892	*La Carmencita* (1890) purchased by the Musée du Luxembourg, Paris.
1893	Nine works shown at the Chicago World's Fair.
1894	Elected Associate of the Royal Academy, London.
1895	First part of murals installed at Boston Public Library. Visits "Biltmore," the new Vanderbilt estate, to paint architect R. M. Hunt and landscape designer F. L. Olmsted. Signs twenty-one-year lease on two studios on the Fulham Road, London, where he prepares mural decorations.
1897	Elected to full membership of both Royal Academy and National Academy of Design. Begins to teach on an occasional basis at Royal Academy Schools.
1898	Begins series of portraits of the Wertheimer family.
1899	Solo exhibition with over a hundred works at Copley Hall, Boston; Sargent does not attend, but lends works from his personal collection.
1900	More than doubles his living and studio accommodations on Tite Street, London.
1902	When Rodin sees Sargent's eight new portraits at the Royal Academy he calls him "Le Van Dyck de l'époque."
1903	In America for second installation at Boston Public Library. Uses the Gothic Room of Fenway Court, the new house-museum of Mrs. Gardner, as a studio. Paints President Roosevelt at White House.
1905	Forty-seven watercolors included in a solo exhibition at Carfax Gallery, London: the first time he emphasized his work in this medium. In November travels to Syria and Palestine.
1906	Returns from the Near East when his mother dies in London.
1907	Vows to give up portraits in oils. Edward VII recommends him for a knighthood, which he declines because of his American citizenship.
1909	The Brooklyn Museum purchases eighty-three watercolors from an exhibition at Knoedler's, New York.
1911	Takes exception when Roger Fry publishes his name as a supporter of Post-Impressionist art.
1913	Paints Henry James as a seventieth birthday present.
1914	In Austria on vacation when World War I breaks out.
1915	Fifteen works shown in Panama-Pacific International Exposition, San Francisco, including *Madame Pierre Gautreau*.
1916	Returns to America after an absence of thirteen years. Large installation of decorations at Boston Public Library. Sells *Madame Pierre Gautreau* to the Metropolitan Museum of Art, New York. Vacations in the Canadian Rockies. Accepts commission to make decorations for the Museum of Fine Arts, Boston.
1917	Entire year based in Boston. Paints John D. Rockefeller Sr. twice: in Miami and Tarrytown. Paints President Wilson in Washington; the commission from Sir Hugh

Lane was accepted on agreement that ten thousand pounds be donated to the Red Cross.

1918 Spends four months near the battlefront in France as an official British war artist.

1919 Exhibits *Gassed* at Royal Academy. Returns to Boston with last two paintings for Public Library: *The Synagogue* and *The Church.*

1920 In London works on *Some General Officers of the Great War,* a portrait of twenty-two men commissioned for the National Portrait Gallery.

1921 Installs rotunda decorations at Museum of Fine Arts, Boston, and is commissioned to extend them over main staircase.

1922 In Boston to paint two mural panels in the Widener Memorial Library: a memorial to Harvard University's contribution to the war. Boston's Jewish community petitions the State Governor to remove *The Synagogue* from the Boston Public Library because it perpetuates a biased historic image; two years later their cause is defeated in the statehouse.

1923 Nine portraits donated by Asher Wertheimer installed in the National Gallery, London. In Boston November to July 1924 to plan the Museum's staircase decorations.

1924 Seventy-two works shown in retrospective at Grand Central Art Galleries, New York.

1925 Completes painted panels in London and books passage to Boston. Dies in his sleep at his London home, April 15; a post-mortem revealed heart failure caused by arterial sclerosis. His estate sold at auction in London; Christie's divides the property into three sales; the paintings (by Sargent and other artists) realize £176,366.

1925–26 The Museum of Fine Arts, Boston, The Metropolitan Museum of Art, New York, The Royal Academy, London, each mount separate memorial exhibitions.

Selected Bibliography

For an exhaustive guide to all Sargent literature before 1986 consult: GETSCHER, ROBERT H., and MARKS, PAUL G. *James McNeill Whistler and John Singer Sargent: Two Annotated Bibliographies.* New York, 1986.

Monographs and Biographies

BIRNBAUM, MARTIN. *John Singer Sargent. A Conversation Piece.* New York, 1941.

CHARTERIS, THE HON. EVAN, K.C. *John Sargent.* New York, 1927.

DOWNES, WILLIAM HOWE. *John S. Sargent, His Life and Work.* Boston, 1925.

MOUNT, CHARLES MERRILL. *John Singer Sargent, A Biography.* New York, 1955.

OLSON, STANLEY. *John Singer Sargent, His Portrait.* New York, 1986.

ORMOND, RICHARD *John Singer Sargent. Paintings, drawings, watercolors.* New York, 1970.

RATCLIFF, CARTER. *John Singer Sargent.* New York, 1982.

Exhibition Catalogues and Special Studies

ADELSON, WARREN, et al. *Sargent at Broadway: The Impressionist Years.* Coe Kerr Gallery, New York, 1986.

FAIRBROTHER, TREVOR. *John Singer Sargent and America.* New York, 1986.

HILLS, PATRICIA, et al. *John Singer Sargent.* Whitney Museum of American Art, New York, 1986.

HOOPES, DONELSON F. *The Private World of John Singer Sargent.* Corcoran Gallery of Art, Washington, 1964.

LOMAX, JAMES, and ORMOND, RICHARD. *John Singer Sargent and the Edwardian Age.* Leeds Art Galleries, 1979.

McKIBBIN, DAVID. *Sargent's Boston, with an Essay and a Bibliographical Summary and a Complete Check List of Sargent's Portraits.* Museum of Fine Arts, Boston, 1956.

NYGREN, EDWARD J. *John Singer Sargent Drawings.* Corcoran Gallery of Art, Washington, D.C., 1983.

STEBBINS, JR., THEODORE E., et al. *The Lure of Italy.* Museum of Fine Arts, Boston, 1992.

STRICKLER, SUSAN E., et al. *American Traditions in Watercolor.* The Worcester Art Museum, 1987.

SWEET, FREDERICK A. *Sargent, Whistler and Mary Cassatt.* Art Institute of Chicago, 1954.

VOLK, MARY CRAWFORD, et al. *John Singer Sargent's El Jaleo.* National Gallery of Art, Washington, 1992.

Articles and Essays published during Sargent's lifetime

COFFIN, WILLIAM A. "Sargent and His Painting. With Special Reference to his Decorations in the Boston Public Library," *The Century Magazine*, 52 (June 1896), 163–78.

CORTISSOZ, ROYAL. "John S. Sargent," *Scribner's Magazine*, 34 (November 1903), 514–32.

DIXON, MARION HEPWORTH. "Mr. John S. Sargent as a Portrait-Painter," *The Magazine of Art*, 23 (1899), 112–19.

FRY, ROGER. Consult Donald A. Laing, *Roger Fry, An Annotated Bibliography of the Published Writings*. New York, 1979.

JAMES, HENRY. "John S. Sargent," *Harper's New Monthly Magazine*, 75 (October 1887), 683–91.

LA FARGE, JOHN. "Sargent, the Artist," *The Independent*, 51 (April 17, 1899), 1140–42.

SICKERT, WALTER. "Sargentolatry," *The New Age*, 7 (May 19, 1910), 56–57.

STEVENSON, R.A.M. "J.S. Sargent," *The Art Journal*, 40 (March 1888), 65–69.

VAN DYKE, JOHN C. "Sargent the Portrait Painter," *Outlook*, 74 (May 2, 1903), 31–39.

WATSON, FORBES. "Sargent–Boston–And Art," *Arts and Decoration*, 7 (February 1917), 194–97.

Articles and Essays published since Sargent's death

FAIRBROTHER, TREVOR. "The Shock of John Singer Sargent's 'Madame Gautreau,'" *Arts Magazine* 55 (January 1981), 90–97.

——. "Warhol Meets Sargent at Whitney," *Arts Magazine*, 61 (February 1987), 56–71.

——. "Sargent's Genre Paintings and the Issues of Suppression and Privacy," *Studies in the History of Art*, 37 (National Gallery of Art, Washington, 1990), 29–49.

FORSTER, E.M. "Me, Them, and You," (1925), reprinted in *Abinger Harvest* (New York, 1936), 26–30.

PORTER, FAIRFIELD. "Sargent: An American Problem," *Art News*, 54 (1956), 28–31.

REYNOLDS, GARY A. "John Singer Sargent's Portraits: Building a Cosmopolitan Career," *Arts Magazine*, 62 (November 1987), 42–46.

THOMPSON, D. DODGE. "John Singer Sargent's Javanese Dancers," *Antiques*, 138 (July 1990), 124–133.

WEINBERG, H. BARBARA. "John Singer Sargent: Reputation Redivivus," *Arts Magazine*, 54 (March 1980), 104–109.

Acknowledgments

I want to thank Elizabeth Broun and Margaret Kaplan for inviting me to write for this series. I am grateful to Alan Shestack for the Andrew W. Mellon and Rosamund Lamb Curatorial Research Grant that gave me time away from work to prepare this text. Once again Richard Ormond was very generous with his help and advice. Maureen Dezell, John Kirk, Kathryn Potts, and Eric Rosenberg read some or all of the manuscript and made many valuable comments. Kathi Drummy coordinated perfectly, as usual. Finally, I want to thank the following people for their diverse contributions: Julian Barrow, David Beevers, Dwyer Brown, Adrienne Clinton, Odile Duff, Cynthia Fleming, A. D. Fraser Jenkins, Kathy Halbreich, Patricia Hills, Erica Hirshler, Wendy Holohan, Elaine Kilmurray, Karin Lanzoni, John Lutsch, Richard MacDonald, Annette Manick, Maureen Melton, Laura Muir, Stephen Nonack, Jennifer Park, Miriam Stewart, Susan Strickler, Robert Upstone, Lord White of Hull, and Eric Zafran.

Photograph Credits

The author and the publisher thank the museums, galleries, libraries, and private collectors who permitted the reproduction of works of art in their possession and provided the necessary photographs. Other sources of photographs are gratefully acknowledged below (by page number):

Index

Page numbers in *italics* refer to illustrations. Works not specifically attributed are by Sargent. JSS = John Singer Sargent.

155